Anishinaabe-Niimi'iding
An Anishinaabe Ceremonial Dance

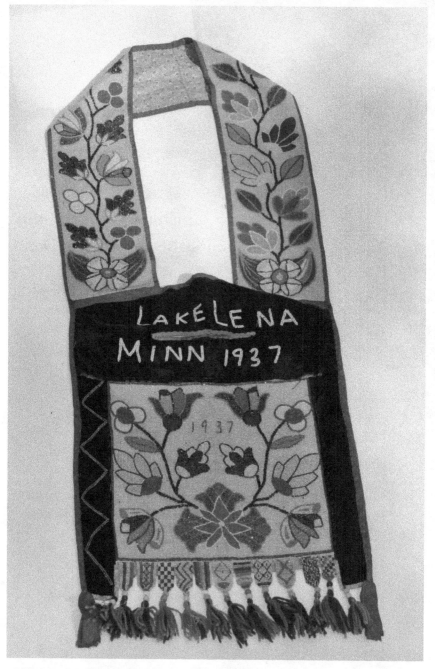

Mii owapii 1937 gaa-miinigoowizid a'aw Ogimaawabiban inow dewe'iganan, Chi-minising gii-onjibaawan. Mii dash inow gashkibidaaganan gaa-ozhi'aajin a'aw Nazhikewigaabawiikwe apii maa gii-pi-dagoshing a'aw dewe'igan omaa Aazhoomog.

It was in 1937 that John Benjamin was given the drum, which came from Isle, Minnesota. Sophia Churchill-Benjamin made this bandolier bag around the time the drum arrived in Aazhoomog.

ANISHINAABE-NIIMI'IDING / AN ANISHINAABE CEREMONIAL DANCE

Lee Obizaan Staples

Chato Ombishkebines Gonzalez

MINNESOTA
HISTORICAL
SOCIETY PRESS

With the editorial assistance of John D. Nichols.

Note: No royalties are paid to the authors or editors.

Originally published as Memoir 23, Algonquian and Iroquoian Linguistics (Winnipeg, Manitoba: 2017).

Minnesota Historical Society Press edition 2023

mnhspress.org

The Minnesota Historical Society Press is a member of the Association of University Presses.

Manufactured in the United States of America

10 9 8 7 6 5 4 3 2 1

♾ The paper used in this publication meets the minimum requirements of the American National Standard for Information Sciences—Permanence for Printed Library Materials, ANSI Z39.48-1984.

International Standard Book Number
ISBN: 978-1-68134-278-8 (paper)

Library of Congress Control Number: 2023935896

Library and Archives Canada Cataloguing in Publication

Obizaan Staples, Lee, 1945– , author
 Anishinaabe-Niimi'iding = an Anishinaabe ceremonial dance / Lee Obizaan Staples & Chato Ombishkebines Gonzalez.

(Algonquian and Iroquoian linguistics, memoir ; 23)
Text in Ojibwe and English.
ISBN 978-0-921064-23-7 (paperback)

 1. Ojibwa language—Texts. 2. Ojibwa language—Dictionaries—English. 3. Ojibwa Dance—Minnesota. 4. Ojibwa Indians—Minnesota—Rites and ceremonies. 5. Ojibwa Indians—Minnesota—Religion. I. Ombishkebines Gonzalez, Chato, 1980– , author. II. Obizaan Staples, Lee, 1945– . Anishinaabe-Niimi'iding. III. Obizaan Staples, Lee, 1945– . Anishinaabe-Niimi'iding. English. IV. Title. V. Title: An Anishinaabe ceremonial dance. VI. Series: Memoir (Algonquian and Iroquoian Linguistics) ; 23

PM851.O258 2017 497'.333 C2017-907604-3

Table of Contents

GE-NAADAMAAGOYAN DA-MIKAMAN ENDAZHINJIGAADEG OMAA

Ani-mookinigaadeg o'ow ozhibii'igan—Migizi

TABLE OF CONTENTS

PREFACE

For the drum communities still active today in Minnesota and Wisconsin, there has been somewhat of a stigma surrounding the recording and documentation of the Big Drum ceremony, its equipment, and song repertoire. Contrary to modern popular belief, a number of accounts have existed for over a century describing everything from the procedures and protocol to the sacred origin stories and songs. Unfortunately, and like many aspects of Anishinaabe culture and ceremony, community outsiders, often at the mercy of their interpreters, have provided all previously published resources on the Big Drum ceremony. Many elders joke on how much nonsense our old timers created for purposes of entertaining themselves while pleasing the white man researchers. As a result, all such second-hand ethnographies should be taken with a grain of salt. As one of my uncles often stated about another author of a well known published drum dance resource, "They never let him in the dancehall".

The book that you hold in your hands is the first of its kind; a first-hand account of the Big Drum ceremony presently conducted in the *Aazhoomog* community, the easternmost village on the Mille Lacs Ojibwe reservation in central Minnesota. Despite the existence of the many documented resources, both published and unpublished, the current Anishinaabe perspective provided in this text, delivered via the medium of the Anishinaabe language, is a priceless contribution for language learners, drum members, and language activists working tirelessly to learn and maintain the sound and mindset, as well as the spiritual lifestyle of the Anishinaabe people.

It should be no surprise that the author of this book is none other than Lee *Chi-obizaan* Staples, a drum-keeper at Aazhoomog, first-language speaker, and a principal authority on the ceremonial life of the Southwestern Ojibwe-Anishinaabe·. Lee Staples's given Anishinaabe name is *Obizaan* though through his extensive work across

Anishinaabe country, he has earned the title *Chi-obizaan* from his students and many of his contemporaries, an honorific of sorts and a testament to his stature in many Anishinaabe communities Those of us lucky enough to work with Obizaan know of his commitment to ensure that our ceremonies and our sacred language *Ojibwemowin* persist for years after any of our lifetimes and long after the printing of this book. Having already published a book on the traditional funeral of the Anishinaabe, Obizaan continues to contribute to the effort, keeping the future generations of Anishinaabe people yet to come foremost in his mind.

The reader of the current volume should be advised that like many of our Anishinaabe ceremonies, there are many variations of the Big Drum ceremony throughout the geographic area where the drum has traveled. The intention of this publication is not to standardize nor prescribe the manner in which each drum community conducts its doings, but rather, to inform those interested in the current drum ceremony held at *Aazhoomog* and to provide a resource for individuals working hard to learn and preserve a long standing traditional ceremony. While the pages presented here specifically detail the drum ceremony hosted twice a year by Obizaan, readers acquainted with the drum dance will notice striking similarities and differences to dances held elsewhere. Readers should keep in mind that this book and its contents represent Obizaan's teachings that he received from the drum keepers in his community that came before him. As I have heard him say many times, "You can only do what your elders taught you."

Readers accustomed to dances held in the more eastern region of Big Drum country will be sure to notice some of the points of difference between the Aazhoomog ceremony and those of their own communities. Perhaps the most striking difference is the participation of the ladies in the dancing. All drum ceremonies held in Minnesota and the more western communities in Wisconsin (Round Lake and Maple Plain) include the ladies dancing, both in the formal daytime ceremony as well as the post-dinner ladies' dance.

Starting at Hertel, Wisconsin and all points east (Lac Courte Oreilles, Lac du Flambeau, Mole Lake, Crandon, Zoar, Wisconsin Rapids), ladies do not dance to the *Bwaan* (Sioux) drums. It should be known that drum members on both sides of the line feel very adamant about this issue with various explanations as to why such variation exists. A review of the published literature on the drum dance reveals that in many places ladies have never danced to these drums (such as at Lac Courte Oreilles, Lac View Desert, Lac du Flambeau, and Zoar), while in other places, such as Mille Lacs, ladies have been dancing for as long as any living elder can remember. It should be noted that in some of these communities the ladies' drums have existed in the past and still do in others. Similar to the Bwaan drums, these drums have designated positions filled by members and a ceremony and song repertoire associated with them. Often included in the classification of "Big Drums", uninformed individuals may associate one for the other in their own explanation of the variation currently observed. Tribal members not affiliated with the drums or their history are quick to judge one community compared to the next without the deeper understanding needed to make such judgments. We are reminded by our old timers, including Obizaan, if the ceremony works at providing the spiritual help that people in a given community need, then they are doing it right. Regardless of the origins for the observed variation in the drum dance, individuals who belong to the drum and follow the way of life that it leads never dispute the power and beauty that each sacred drum carries.

Another factor to keep in mind when considering the history of the drum is the taboo associated with writing and recording. Ultimately stemming from the horrific and traumatizing boarding school experience, reading and writing anything concerning the spiritual life of the Anishinaabe has long been culturally suspect. However, when delving into the oldest records one can easily find examples where cultural informants shared a great deal and out of fear that such things might be lost, even encouraged the

documentation of the ceremonies and the recording of the music associated with them. As the level of endangerment of a culture and a language grows, so does the level of insecurity. How that insecurity manifests itself into a drum community can either result in guarding the ceremony, to death in some cases, or documentation of the ceremony for others. Thankfully, for those of us who are students of Obizaan, we have found a teacher who appreciates reading and writing for what they truly are, tools for teaching, learning, and documentation.

In many ways, Obizaan has been a strong influence in many drum societies as both a cultural stalwart resistant to change, as well as an innovator, making conscious changes to improve the ceremony how he sees fit. For example, when I first began attending his drum dance in Aazhoomog years ago, it was not uncommon to see individuals present who were under the influence of alcohol and drugs. After visiting with individuals older and wiser than myself, I began to understand that such instances were nothing new and for as long as the drums have been here, our people have struggled with such substance abuse. After a review of the documented drum literature, I came to find out that alcohol use in some of the drum communities was almost as old as the drums themselves. However, it was Obizaan who had had enough and began personally escorting individuals under the influence out of the dance hall. As he explains in the text:

Ishke dash giishpin imaa mayaanaadak ayaamagak wenjida bi-biindiged a'aw gegishkang i'iw minikwewin nebowa enigaa'igod a'aw Anishinaabe, mii-go imaa izhi-naangitaawaad ingiw Manidoog, gii-ikidowag ingiw akiwenziiyibaneg.

Those old men said if there is negativity present, especially if people are coming in drunk or under the influence of drugs, the Manidoog will just up and leave.

In addition to his crackdown on intoxication at the dance hall, Obizaan was the first drum keeper in all of Big Drum country to institute a no pleasure-smoking policy inside the dance hall. Now, in many of the dance halls in Minnesota, no cigarette smoking is allowed, no smoking anything other than the tobacco from the drum's pipe. Those affiliated with modern reservation culture and the drum dance know and appreciate just how substantial that little piece of conscious culture change really is. Obizaan has also taken ownership of his own health, by miraculously quitting smoking and choosing to eat a healthier diet.

For cultural outsiders and readers unfamiliar with the drum dance, the reading provided here would be difficult to process. As a result, I have been asked to give some introductory background on the drum dance itself. Although the exact date and origin story are somewhat disputed from community to community, a consensus exists that sometime in the latter half of the 19th century, the Ojibwe were presented a drum from the Dakota as an act of peace and good will. The drum came with instructions regarding its use and care with the specific instruction that the drum should always travel from the west to the east. Some of the teachings regarding the drum included the positions occupied that went with the drum and the order of songs that "belonged" to the drum. Essentially, each drum has a membership, individuals who are selected to various positions at the drum and carry out specific duties associated with the use and care of the drum. On a more spiritual level, each drum member represents a spirit and sits in place of that spirit and partakes in the drum ceremony on their behalf. The drum itself is a direct gift from the Creator who saw the people in need and serves as a direct connection to the Creator. Personal conduct both around and away from the drum along with regular attendance and participation are all a reflection of a member's treatment both toward the drum itself and the individual spirit that each member represents. While each drum has its own roster of drum members, a society if you will, to

belong to one drum is often regarded as belonging to the drum faith itself.

To belong to a drum, often referred to by drum members as "sitting on that drum" or being "on that drum", is one of the highest honors bestowed on individuals of a drum community. To accept a position on a drum is essentially a promise to the *manidoog* that you will keep the drum going and fulfill your obligations to the drum for as long as you live and are able. As a member of a drum, your regular attendance is expected as well as your effort toward providing your offerings. Drum members are expected to bring food to each dance, essentially offerings that drum and community members partake in on behalf of the manidoog. In addition to food offerings for each meal hosted, members also bring gifts and monetary contributions to be passed out after the rendering of the song that goes with their position. Drum members receive blessings and spiritual help based on the effort put forth and the appeal of their offerings by the manidoog. To not give adequate offerings sends a message to the manidoog that the member takes their position at the drum lightly. Drum members are especially discouraged from showing up at a dance empty handed. As Obizaan is famous for saying, *"Gaawiin zheshenik bi-biindigesiin aw Anishinaabe endazhi-niimi'iding"*. Drum members are also encouraged to attended other drum ceremonies and help out where needed. To follow the teachings of the drum and fulfill one's drum obligations is to do good by the drum and to the spirit that the drum member represents. In essence, one shows how much she or he values their own life by the commitment they show to the drum and the position they represent.

Veterans hold special positions at the drum and their membership and participation is vital to the drum dance society. For most drum societies in Minnesota, it is the veterans who provide most of the public speeches and who have earned the right to lift the grief off of those in mourning. As time moves forward and less of our young men enlist in the military, finding suitable veterans to serve as

drum members is becoming more challenging. Other members belonging to the drum have duties specific to their positions. For example, drum warmers or "heaters" are often responsible for the physical care of the drum itself, i.e., moving the drum, repairing the equipment associated with the drum, etc. Though drum membership varies from drum to drum, some drum societies have individuals responsible for the upkeep of the dance hall itself. To be a singer on a ceremonial Big Drum often entails being or belonging to "a stick", drum parlance for the stakes or "drum legs" that hold the drum up in its daytime, suspended position. As Obizaan explains, each stick stands at each of the four cardinal directions. To be asked to serve as a drum member is seldom taken lightly, as a common belief among drum societies is that the spirits select the members of the drum through the existing drum membership.

The song repertoire belonging to each drum is a direct reflection of the drum membership. Some drums have a designated head speaker, and as a result, a "speaker song" is included in the drum repertoire. Songs are rendered in the precise order that they were originally received in, so, being that drum membership can vary from drum to drum, so does the order of songs rendered for each. In addition to the position songs described here, many drums have procedural songs that do not necessarily belong to a particular position but rather are used for various procedures that occur during a given drum ceremony. Anyone familiar with the Big Drum and the many communities that the drum has reached will notice the song repertoire is greatly increased the further away you get from the place of origin. Elders often remark about songs and positions, depending on where you are, as either being added later or lost earlier.

It should be noted that over the course of Obizaan's writing of this book, some of the drum members mentioned in the book have since walked on to the spirit world. Obizaan's partner on the drum and life-long friend and confidant, Larry *Amik* Smallwood, had assisted Obizaan with his drum keeper duties. Highly regarded as an

authority on the music of the Minnesota drum dance societies, Amik carried out his work as a drum keeper with diligence and grace, taken nothing as more serious and important than the drum dance society of the Anishinaabe. Much to our surprise and regret, Amik was called home on April 11th 2017, leaving behind a huge legacy and massive void in the drum community. At the time of writing this preface, Amik's position has remained vacant as a replacement is currently being sought out.

Prior to the passing of Amik, the head *ogichidaakwe*, Linda Shabaiash had also walked on. A pivotal member of Obizaan's drum, Linda was Obizaan's niece and grew up in the same household as he did. Linda represented the epitome of what the head ogichidaakwe should be. Always present with her offerings and knowledgeable of her role within the dance, Linda's passing was a difficult one for the drum community at Aazhoomog. Miigis Gonzalez has since filled the vacancy left by Linda's passing. As time moves forward, the drums have a way of seeking out the ideal members, sometimes surprisingly contradicting the choices of some of the remaining membership.

Another member of the drum, Dave Matrious, who held the position of the East Drum Leg (third stick) on Obizaan's drum, passed away suddenly and unexpectedly. Dave was also the co-drum-keeper of another ceremonial drum at Aazhoomog and was a faithful and active drum participant. Also, mentioned in the sections that follow is the late Merlin Anderson, who took care of the first *Binesi* drum at Mille Lacs. As we all know, when it comes to the loss of one of our knowledgeable elders, like Merlin truly was, we all move a little faster and become just a little more eager in our quest to maintain what we have been given as a people.

Linguists and attentive language students may notice some differences in the speech of Obizaan when compared to dictionaries and language class norms that they are used to. One such case is the extent of palatalization of alveolar stop [d] with the root *wiid=*. While students may be used to the verb *wiidanokiim* 'work with h/',

Obizaan insists on the palatalized form *wiij'anokiim*, which is orthographically represented here with the glottal stop. Another point of noticeable variation includes what linguists commonly refer to as dependent nouns. Such nouns are typically unpronounceable and cannot stand alone without an obligatory personal pronominal prefixed to the noun stem. This class mainly includes body part and kinship terms. Common across the Algonquian language family is the reanalysis of dependent noun stems with the traditional third person form being reanalyzed as the inflectable stem on to which prenominal prefixes are then affixed. Other points of variation, mainly lexical, are sure to please eager language students and linguists alike who have grown to appreciate the beauty in language variation and the individual stylistic features of Obizaan's language. As those of us familiar with Ojibwe dialectology and the variation that exists within know, such cases are common and do not suggest irregularity or any shortcomings of Obizaan or any other speakers who produce such forms. As Obizaan and all of our speakers repeatedly state, "That's how I heard it". Furthermore, many of Obizaan's terms and ways of speaking are extremely old, absent from all of our handy dictionaries and personal corpuses as linguists. Such was the case for the verb *agwaa'izekweshimo* 's/he performs the kettle dance'. After chasing our tails to derive a morphological derivation, I discovered the verb in the old field notes of an anthropologist years ago studying the drum dance where the exact term was used in the exact same context with the translation 's/he does the taking the kettle off of the fire dance'. We often jokingly remark on the speech of Obizaan, *Gete-inwe aw akiwenzii*.

The reader should also be aware of the difference between the written Ojibwe and the translations provided. Often times, rather than provide a direct translation of each Ojibwe sentence, Obizaan would opt to provide an explanation of each paragraph that would frequently include more in the English than what was implied by the Ojibwe. The reader is encouraged to consult both sides of the text as each has significant and substantial information benefiting

our understanding of not only the drum ceremony, but the use of Ojibwe in the discourse surrounding the drum ceremony.

As far as my role on the current book project goes, I did not serve as a reviewer in the same capacity that I did for the developing of the book on the traditional Anishinaabe funeral. Chato *Ombishkebines* Gonzalez, Obizaan's surrogate son and right-hand-man had carefully reviewed the manuscript and oversaw edits directly under the consultation and approval of Obizaan. Chato then sent drafts to John Nichols and met with him for comments on his review, which were then taken back to Obizaan. My role was simply to be a reader for purposes of supplying the preface.

When I was first asked to assist with the book and provide the preface, I shied away and avoided agreeing to do it for as long as I possibly could. I knew of the stigma surrounding such a project, having been raised at Lac Courte Oreilles around our Big Drum ceremonies. As a drum member at Lac Courte Oreilles and at Aazhoomog on Obizaan's drum, I was aware of the damage our historical experience as a people had done on our interpretation of the writing and recording of our ceremonies and the language used within. While initially opting to decline the request, I had been reminded of the reasons I decided on a career and life path toward the maintaining and revitalization of our language. I remembered the night I sat in the drum hall for an evening dance, at a time long before I was a competent speaker of Ojibwe, on an evening where perhaps by chance but most likely by fate, no elders or speakers of the language were in attendance. I remember the empty feeling that seemed to fill the dance hall. It was like the worry and hopelessness about language loss had inflicted each person in attendance. It wasn't long after that night that I decided to dedicate my life to this work.

After traveling around and visiting as many elders and drum communities as I could reach, it became apparent that most drum communities were struggling with regard to language just as we were in my community. In some communities, no fluent native

speakers remained and the entire responsibility of delivering the lengthy speeches had fallen onto the shoulders of other young men of my generation. As I listened to more than one simplified and rehearsed speech often quickly translated into English, I began to fear the realistic possibility of the pidginization of our ceremonial language. The more I became aware of the tremendous pressure we were under, the more I worked at learning, asking questions, and paying attention to detail, not only with regard to language but also to the depth of meaning to the ceremony and the level of complexity within the procedures. Many times I had witnessed people forgetting the procedures regarding the wash-up ceremony, the seating of a new member, and the changing of the drum keepers or the hides on a drum. It then finally dawned on me why this work is so important. Generations from now, long after our fluent native speaking elders have traveled on, the drums in Aazhoomog and throughout Anishinaabe country will have this book as a resource. I could now understand Obizaan's motivation to do such a thing and the level of urgency at which he approaches his work with language documentation. Loosing Amik solidified that feeling in all of us and regardless of what the critics think or think they know, Obizaan will be the first to ask of them, "What are you doing to make sure these teachings live on?"

Geget chi-waasa akwaabi a'aw Chi-obizaan Maakawaadizid. Miigwech miinawaa nagadamawadwaa giij-anishinaabeminaanig niigaan ge-bi-ayaajig.

Michael *Migizi* Sullivan Sr., Ph.D.
23zd Manoominike-Giizis
Odaawaa-Zaaga'iganing

Anishinaabe Niimi'iding
An Anishinaabe Ceremonial Dance

1 GAA-ONJIKAAMAGAK O'OW

Gakina a'aw Anishinaabe gii-miinigoowizi inow Manidoo-dewe'iganan. Mii dash omaa gidani-ayaangwaamimininim giwiizhaaminininim enishinaabewiyeg da-naazikawegwaa ani-aabajichigaazowaad ingiw Manidoo-dewe'iganag. Nebowa omaa ayaamagad ge-naadamaagod a'aw Anishinaabe. Mii omaa wenji-ozhibii'amaan o'ow mazina'igan da-gikendang weweni a'aw Anishinaabe ezhi-manidoowaadak niimi'idiiked ani-aabaji'aad inow Manidoo-dewe'iganan.

1 INTRODUCTION

These Anishinaabe ceremonial drums were given to all
Anishinaabe people. I am encouraging and inviting you who
are Anishinaabe to come to our ceremonial dances when these
drums are being used. There is a lot within these ceremonies
that will help the Anishinaabe. The reason I am doing this
writing is so that the Anishinaabe will be able to get a better
understanding of the spiritual depth of what is available when
these ceremonial drums are being used.

2 AANIINDI WENJIKAAMAGAK GEKENDAMAAN EZHICHIGED I'IW NIIMI'IDIIKED A'AW ANISHINAABE

A'aw akiwenziiyiban Ogimaawabiban gii-izhinikaazo gaa-nitaawigi'id, ogii-kanawenimaan inow gimishoomisinaanin. Mii imaa gii-naadamaageyaan apii gaa-paabaakishimaawaajin inow gimishoomisinaanin. Ingii-ashi-niizho-biboonagiz apii gii-asigooyaan imaa da-dibendaagoziyaan a'aw Manidoo-dewe'igan. Mii iwidi eshkwebid eko-niiwing bedakideg i'iw mitig, mii iwidi gii-asigooyaan da-abiigizigewininiiwiyaan.

Weweni-go ingii-gikinoo'amaag a'aw akiwenziiyiban naa gaye inow owiij'ayaawaaganan Nazhikewigaabawiikwebanen gii-izhinikaazowan eni-izhichiged niimi'idiiked a'aw Anishinaabe, biinish gaye ge-ni-izhichigeyaan abiigizigewininiiwiyaan. Mii gaye endaso-dagwaagig miinawaa endaso-zaagibagaag gii-aayaabajichigaazowaad ingiw Manidoo-dewe'iganag, mii i'iw apane nayaano-giizhigakin naa apane eshkwaajanokii-giizhigakin apii gaa-niimi'idiwaad.

Mii-go apane gii-naazikaagewaad ingiw gaa-nitaawigi'ijig aaniindi-go gii-ni-aabajichigaazowaad ingiw Manidoo-dewe'iganag, mii dash imaa apane gii-paa-wiijiiwagwaa. Mii dash iwidi iko gii-naazikaageyaang iwidi Neyaashiing endazhi-niimi'idiwaad ingiw Anishinaabeg, mii iwidi gaa-izhaayaang. Biinish igo gaye iwidi Minisinaakwaang gii-tanakamigiziwaad, mii gaye iwidi Gwaaba'iganing gii-aabajichigaazowaad ingiw Manidoo-dewe'iganag, mii gaye iwidi gaa-izhaayaang.

Aano-go gii-aya'aansiwiyaan i'iwapii gii-paa-wiijiiwagwaa gii-naazikaagewaad endazhi-niimi'iding, nebowa igo nigezikwendaan gaa-izhichigewaad gii-niimi'idiwaad. Mii dash i'iw wenjikaamagak a'aw mindimooyenyiban ingii-wiindamaag, "Gego anooj omaa gidaa-wii-izhichigesiin megwaa omaa ayaayang endazhi-niimi'idiikeng." Ingii-ig, "Bizaan omaa

2 HOW I LEARNED ABOUT THESE CEREMONIAL DANCES

The old man that raised me, John Benjamin, took care of a ceremonial drum. I was there to help each time he had a ceremonial dance. I was twelve years old when I was put on the drum as a drum member. I was put on as a drum warmer, and sat at the last position on the fourth stick.

That old man and his wife Sophia Churchill-Benjamin thoroughly taught me what was involved when the Anishinaabe had their ceremonial dances, and they taught me my responsibilities as a drum warmer. There are ceremonial dances held every fall and every spring with the ceremonial dances held every Friday and Saturday.

The old people that raised me attended these ceremonial dances on a regular basis and they always took me along. We went to ceremonial dances that were held at Vineland, Minnesota. We also attended ceremonial dances in East Lake, Minnesota. We also went to ceremonial dances held in Sawyer, Minnesota.

Even though I was young when they took me along, I do remember what I saw and heard when we went to these ceremonial dances. It is then that the old lady told me, "Do not mess around while we are at these ceremonial dances." She said, "Just sit there quietly and watch what is being done while the ceremonial dance is going on. The only time you

nanaamidabin da-ganawaabandaman eni-izhichigewaad
naami'idiikejig. Mii eta-go apii ge-bazigwiiyan wii-niimiyan,
maagizhaa gaye waakaa'igaansing wii-ni-izhaayan." Mii iw
nebowa wenji-gezikwendamaan gaa-inaabishinaan gii-paa-
wiiji'iweyaan endazhi-niimi'iding.

Ingoji-go apii gii-ashi-niso-biboonagiziyaan, mii owapii gii-
maajii-aakozid a'aw mindimooyenyiban. Mii iw okanaapined
ezhi-wiinjigaadeg gaa-wenda-aabiinji'igod, biinish gii-ni-
gashkitoosig gegoo wii-ni-izhichiged. Mii dash imaa gii-
naadamaageyaan gii-maajitaayaan gii-chiibaakwaadamaan
a'aw akiwenziiyiban ge-biindigadood imaa azhigwa apii gii-
niimi'idiiked. Mii dash a'aw nizigosiban Nechii'awaasang a'aw
ge-wiin gaa-naadamaaged gii-kashkigwaadang iniw
waabooyaanan ge-aabajitood a'aw akiwenziiyiban da-bagijiged
owapii gii-niimi'idiiked.

Azhigwa dash gaa-ishkwaa-ayaad a'aw akiwenziiyiban, mii
imaa gii-inaakonigewaad wenjida ingiw ogichidaakweg gii-
onaabamigooyaan da-mamooyaan imaa gaa-ondabid a'aw
akiwenziiyiban da-ganawenimag dash a'aw gimishoomisinaan.
Mii iw ashi-zhaangaswaak miinawaa niizhwaasimidana ashi-
niiwin gii-piboonagak owapii imaa gii-asigooyaan.

Ishke dash gomaapii a'aw nizigosiban ingii-wiindamaag gaa-
onji-onaabamigooyaan da-mamooyaan gaa-ondabid a'aw
akiwenziiyiban. Gii-ikido, ogii-minwendaanaawaa gii-
gikendamaan i'iw gidinwewininaan miinawaa agana-go ingii-
maji-izhiwebiz ingii-mino-wiiji'aa a'aw niwiiji-bimaadiziim.
Aano-go gii-tazhiikamaan owapii i'iw minikwewin wenda-
inigaa'igod a'aw Anishinaabe, gii-ikido a'aw nizigosiban, "Gigii-
gikenimin booch da-boonitooyan i'iw giminikwewin gomaapii."

Gaawiin igo wenipanasinoon wii-ni-ganawenimaad inow
Manidoo-dewe'iganan awiya. Ishke nebowa omaa

should get up is when you get up to dance or have to go to the bathroom." Because of that I remember what I saw as we attended these dances.

I was about thirteen years old when that old lady started to get sick. She came down with arthritis and it got so bad for her that she was not able to do things. It was then that I had to start helping and cooking the food that the old man brought to the ceremonial dances. It was also at the time my aunt, Mary Churchill-Benjamin, started to help out by sewing the blankets that the old man put down for his offerings.

When the old man passed away, it was then that the women on the drum made the decision for me to take the position the old man held as the drum keeper. It was in 1974 that they placed me in that spot.

After a period of time my aunt told me why they decided to put me in the spot that the old man held. She said that they liked that I knew how to speak Ojibwe and that I was not a very angry person and that I usually got along well with other people. Even though I was still drinking at the time my aunt said, "I knew you would sober up eventually."

It is not easy for someone to take care of a ceremonial drum. There are several people that we work with as we put on these

niwiij'anokiimaanaanig imaa eginzojig eni-niimi'idiikeng.
Booch igo maamawichigewin da-ayaamagak, gaawiin omaa
majayi'ii daa-wii-ayaamagasinoon. Gaawiin gaye awiya odaa-
wii-maji-inaasiin imaa eginzonijin. Gida-ni-giige'aanaanig
ingiw Anishinaabeg giniigaaniiminaang ge-ni-ayaajig
wawiingeziyang da-ni-bimiwinang a'aw gimishoomisinaan.

ceremonial dances. It is important that we all work together in a good way and not have negativity. People should not talk bad about their fellow drum members. It is our Anishinaabe of the future that will benefit from us doing a good job taking care of the ceremonial drum.

3 MANIDOO-DEWE'IGANAG OMAA MISI-ZAAGA'IGANIING ISHKONIGANING EYAAJIG

Ashi-bezhig omaa Manidoo-dewe'iganag ayaawag omaa ishkoniganing, Misi-zaaga'iganiing ezhi-wiinjigaadeg. Gaawiin gaye ingiw dewe'iganag ayaabajichigaazojig imaa waabanda'iwe-niimi'iding indazhimaasiig. Mii i'iw waa-tazhimimagin inow Manidoo-dewe'iganan gaa-miinigojin inow Manidoon da-ni-apenimod a'aw Anishinaabe da-ni-naadamaagod oniigaaniiming.

Mii ingiw nitam waa-tazhimagig ingiw Binesi-dewe'iganag. Ishke nisiwag ingiw Binesi-dewe'iganag eyaajig omaa ishkoniganing. Mii ingiw ganabaj ishkwaaj gaa-pi-dagoshingig. Mii a'aw nizigosiban Amikogaabawiikweban gaa-wiindamawid a'aw akiwenziiyiban Waasigwan gii-izhinikaazo gaa-pawaanaad iniw Binesiwan gii-pi-wiindamaagoowizid i'iw akeyaa ge-ni-izhi-aabajichigaazonid inow Binesi-dewe'iganan.

Mii dash gaa-ikidod a'aw Amikogaabawiikweban, "Megwaa imaa gii-mamaanjigonigod a'aw Waasigwan inow wayaabishkiiwen gibaakwa'odiiwigamigong, mii iwapii gii-pi-odisigod gii-pi-wiindamaagod inow Manidoon weweni ge-izhichigaanaad a'aw Anishinaabe ani-aabaji'aad iniw Binesi-dewe'iganan, miinawaa gii-pi-gikinoo'amaagoowizid a'aw Waasigwan iniw nagamonan ge-aabajichigaadegin imaa baakishimind a'aw Binesi-dewe'igan." Mii a'aw bezhig gaa-pi-gikinoo'amaagoowizid a'aw Anishinaabe da-ni-apenimod.

Mii dash a'aw gaye Ishkweyaashiban gii-izhinikaazo gii-pi-gikinoo'amaagoowizid da-izhichigaanaad inow Binesi-dewe'iganan gaa-pawaanaajin. Mii a'aw Nechiiwaanakwad genawenimaajin. Mii iwidi Ishkweyaashiban gii-tanakiigwen Gwaaba'iganing. Gaawiin igo aapiji maa niwii-tazhimaasiig i'iw akeyaa enakamigizid a'aw Anishinaabe ani-aabaji'aad. Gaawiin

10

3 THE CEREMONIAL DRUMS THAT ARE HERE ON THE MILLE LACS RESERVATION

There are eleven ceremonial drums that are on the Mille Lacs reservation. I am not talking about those drums that are used in show powwows. I want to talk about the ceremonial drums that that *Manidoog* gave to the Anishinaabe as a means of support in their future.

I want to talk first about the Binesi drums. There are three types of Binesi drums on the reservation. I believe those drums were the last to arrive here. It was my aunt Julie Shingobe who told me that there was this old man by the name of Waasigwan that had a dream describing how these Binesi drums should be used.

Julie went on to say, "It was while Waasigwan was in prison that the Manidoog approached him and described how the Anishinaabe would use these Binesi drums; he was also taught the special songs that go with the Binesi drum when it is being used." That is one type of Binesi drum that Anishinaabe were given to rely on.

Another one who was also taught was the late Ishkweyaash. He dreamt of how to use another type of Binesi drum. That is the drum that Merlin Anderson takes care of today. Ishkweyaash must have come from Sawyer, Minnesota. I am not going to talk too much on how Anishinaabe use these Binesi drums. I do not know too much about these drums.

11

aapiji nigikenimaasiig ingiw Binesi-dewe'iganag.

Awedi dash bezhig a'aw Binesi-dewe'igan a'aw Zaagajiw-
akiweziyiban, mii a'aw gaa-pi-gikinoo'amaagojin iniw
Manidoon ge-izhichigaazonid inow Binesi-dewe'iganan gaa-
pawaanaajin. Mii dash a'aw Giiweyaanakwad genawenimaad
inow Binesi-dewe'iganan noongom. Mii a'aw Zaagajiwiban
inow owiiyawen'enyan nebowa odayaawaan. Ishke dash gaa-
izhi-gikinoo'amawaad inow owiiyawen'enyan, gakina
apinikaazonid inow Binesiwan, ogii-gikinoo'amawaan
wiisiniwin naa asemaan da-biindigadoonid endasing
aayaabajichigaazonid inow Binesi-dewe'iganan gaa-
pawaanaajin a'aw Akiwenziiyiban.

Mii dash a'aw awedi bezhig dewe'igan eyaad omaa
ishkoniganing, mii dash a'aw Ikwe-dewe'igan. Niizhiwag ingiw
ikwewag genawenimaajig iniw Ikwe-dewe'iganan. Nigii-
izhaamin iwidi ayaamagak i'iw zaaga'igan iwidi Bwaan-akiing
imaa gaa-tazhi-gikinoo'amawind a'aw Bwaanikwe i'iw akeyaa
da-ni-aabajichigaazonid inow Ikwe-dewe'iganan. Mii imaa
zaaga'iganiing gaa-apa'iwed a'aw Bwaanikwe gii-
miigaanigowaad ingiw Bwaanag iniw wayaabishkiiwen iniw
zhimaaganishan. Megwaa dash imaa gaazod imaa
zaaga'iganiing, mii iw gaa-izhi-odisigod iniw Manidoon gii-pi-
wiindamaagod da-agwaataad imaa zaaga'iganiing. Mii dash
gaa-izhi-igod da-o-wiisinid da-o-wiidoopamaad iniw
zhimaaganishan imaa besho gaa-ayaanijin. Mii dash inow
Manidoon gaa-izhi-igod, "Gaawiin gegoo gidaa-gotanziin.
Gaawiin gidaa-waabamigosiig megwaa imaa ani-
wiidoopamadwaa ingiw zhimaaganishag." Mii dash owapii gaa-
kiizhi-wiisinid gii-gikinoo'amaagod iniw Manidoon ge-
izhichigaazod a'aw Ikwe-dewe'igan naa gaye nagamonan ge-
aabajichigaadegin imaa Gookomisinaaning.

12

As for the other Binesi drum, it was taught to the late George Boyd how that particular drum should be used. That is the drum that Elmer Nayquonabe takes care of now. George Boyd had many namesakes. He instructed his namesakes, whose names all derived from the Thunder-beings that he had dreamt about, to bring in food and tobacco every time that particular Binesi drum is used.

The other type of drum here on the reservation is the Ladies' drum. There are two female drum keepers that take care of this drum. We went to that lake out there in South Dakota where that Dakota woman was taught how the Ladies' drum would be utilized. It was that lake where the Dakota woman ran to when the Dakota people were under attack by the soldiers. While she hid within that lake, the Manidoog approached her and told her to come out of the lake. Then the Manidoog told her to go and eat with the soldiers that were nearby. The Manidoog told her, "You have no reason to be afraid. The soldiers will not see you as you go eat with them." When she was done eating, that is when the Manidoog gave her all the teachings that go with the Ladies' drum, and also taught her the special songs that go with the drum.

Bebakaan ikidowag ingiw Anishinaabeg noongom. Ishke aanind ingiw gechi-aya'aawijig mii iw ekidowaad, mii a'aw Bwaani-dewe'igan gaa-pi-gikinoo'amaagoowizid a'aw Bwaanikwe megwaa imaa gii-kaazod imaa zaaga'iganiing, gaawiin a'aw Ikwe-dewe'igan. Mii-go booch igo ingiw niizh ingiw dewe'iganag dibishkoo ezhi-manidoowaadiziwaad. Gaawiin niwii-kagwe-debwesiin, mii a'aw Ikwe-dewe'igan maagizhaa gaye a'aw Bwaani-dewe'igan gaa-onjikaad owapii a'aw Bwaanikwe gii-pi-gikinoo'amaagoowizid. Gaawiin nigikenimaasiwaanaan awenen a'aw dewe'igan endazhinjigaazod. Mii dash niin izhi-debisewendamaan i'iw ganawaabandamaan i'iw ezhi-manidoowaadizid Ikwe-dewe'igan aabajichigaazod naa gaye a'aw Bwaani-dewe'igan.

Mii dash a'aw Bwaani-dewe'igan waa-tazhimag, mii a'aw genawendamaageyaang. Amikogaabaw niwiidabimaa ganawendamaageyaang a'aw gimishoomisinaan. Ishke nebowa ayaawag eginzojig nayaabibiitawaawaajin iniw Manidoon waakaabiitawaanijin iniw gimishoomisinaanin.

Mii omaa akawe wii-ni-dazhindamaan waabanda'iwe-niimi'iding ezhi-wiinjigaadeg. Ishke nebowa a'aw Anishinaabe onaazikaan i'iw waabanda'iwe-niimi'iding. Nawaj igo bangiiwagizi a'aw Anishinaabe eni-naazikaaged ani-aabajichigaazowaad ingiw Manidoo-dewe'iganag. Mii-ko imaa ani-mamiikwaandamowaad enakamigizid ani-waabanda'iwe-niimi'idid a'aw Anishinaabe ani-dazhimaawaad minik ingiw waabanda'iwe-niimi'idii-dewe'iganag gaa-piindigejig endanakamigiziwaad naa-go gaye minik inow Anishinaaben agimaawaad gaa-piindigeshimonijin imaa endanakamigiziwaad.

Ishke dash i'iw gaa-onjikaamagak i'iw waabanda'iwe-niimi'idiwin, mii a'aw wayaabishkiiwed bagidinaad inow Anishinaaben eni-izhichigenid o'ow akeyaa. Mii iw gaa-

There are different versions to this story today. Some of the elders say that it was the Bwaani-dewe'igan that the Dakota woman was taught about as she hid in that lake, and not the Ladies' drum. Both of these drums are very sacred. I do not want to debate whether it was the Ladies' drum or the Bwaani-dewe'igan that came from the teachings that were given to the Dakota woman as she hid in the lake. We are not sure which drum was being talked about when the Dakota woman was approached by the Manidoog. I am just happy to see how powerful each of those drums are when they are used, whether it is the Ladies' drum or the Bwaani-dewe'igan.

I am now going to talk about the Bwaani-dewe'igan, which is the one we take care of. Larry Smallwood and I take care of one of these drums. There are a lot of drum members who in turn represent Manidoog that exist around that drum.

Before I talk about the Bwaani-dewe'igan I want to talk about these show powwows. There are many Anishinaabe that go to these show powwows. There are very few Anishinaabe that go to our ceremonial dances. We hear Anishinaabe boast about these show powwows, talking about how many drums were present and how many dancers there were at grand entry.

These show powwows originated from the white man allowing the Anishinaabe to put on these secular show powwows. The white man thought, "Let's allow these Anishinaabe to put these

inendang a'aw wayaabishkiiwed, "Gida-bagidinaanaan a'aw
Anishinaabe da-waabanda'iwe-niimi'idiiked da-
minwaabishinaang wayaabishkiiweyaang." Ishke ingiw
dewe'iganag ayaabajichigaazojig noomaya-go gii-
kiizhichigaazowag, miinawaa mii gaye inow dewe'iganan gaa-
aabaji'aajin a'aw chi-mookomaan ayaapii imaa gaa-
bakite'waad gii-madwewechiged bimaawanidiwaad. Mii a'aw
wayaabishkiiwed gaa-pagidinaad inow Anishinaabe da-
izhichigenid.

Ishke dash gaa-miinigojin inow Manidoon a'aw Anishinaabe
i'iw akeyaa da-inakamigizid da-ni-biindaakoojiged, mii a'aw
wayaabishkiiwed aana-gii-aanishimaad inow Anishinaaben da-
ni-izhichigesinig i'iw akeyaa gaa-izhi-miinigoowiziyang
anishinaabewiyang. Ishke dash a'aw Anishinaabe gii-
kiimoojichige aaniin igo enakamigizid asemaaked gii-
kaadamawaad inow wayaabishkiiwen enakamigizid. Mii dash
mii iw wenji-biingeyenimag a'aw Anishinaabe wenda-
aanoodizid wii-naazikang waabanda'iwe-niimi'idiwin ani-
bagijwebinang gaa-izhi-miinigoowiziyang anishinaabewiyang.
Ingiw Manidoog ingii-miinigonaanig inow Manidoo-
dewe'iganan, gaawiin a'aw Manidoo ingii-miinigosiinaan i'iw
waabanda'iwe-niimi'idiwin ezhi-wiinjigaadeg. Mii a'aw
wayaabishkiiwed gaa-pagidinaad da-waabanda'iwe-
niimi'idinid inow Anishinaaben, gii-kiimoojichige dash a'aw
Anishinaabe gii-aabaji'aad inow Manidoo-dewe'iganan.

powwows on for our entertainment and our viewing pleasure."
Those drums that are used in those powwows were those
recently put together or discarded band drums used by the
white man in their parades. It was the white man that gave
Anishinaabe those kind of powwow drums.

It was the Manidoog that gave the Anishinaabe their
ceremonies, and it was the white man who tried to discourage
the Anishinaabe from practicing their ceremonies the way we
were given them by the Manidoog. The Anishinaabe had to
hold their ceremonies secretly and hide them from the white
man. That is why I am floored by Anishinaabe who are so
driven to attend these secular powwows, discarding what we
were given as Anishinaabe by the Manidoog. The Manidoog
were the ones that gave us the ceremonial drums; the
Manidoog did not give us those show powwows. It was the
white man that allowed the Anishinaabe to have these show
powwows, but they had to hold their ceremonial dances
secretly.

4 BEZHIG A'AW GIMISHOOMISINAAN AYAABAJICHIGAAZOD OMAA AAZHOOMOG

A'aw gimishoomisinaan genawendamaageyaang eyiizh Amikogaabaw naa gaye niin, mii imaa Misi-zaaga'iganiing Chiminising ezhi-wiinjigaadeg gaa-onjibaad a'aw Manidoo-dewe'igan. Mii imaa ashi-zhaangaswaak miinawaa nisimidana ashi-niizhwaaswi gii-piboonagak gii-tagoshimoonod. Mii dash a'aw gayat gaa-kanawenimaad inow Manidoo-dewe'iganan, mii a'aw Amikogaabaw owiiyawen'enyibanen, Netaawaash gii-izhinikaazo a'aw akiwenziiyiban. Gaawiin gii-kashki'ewizisiin weweni da-ni-bimiwinaad inow Manidoo-dewe'iganan. Mii dash i'iw gaa-izhi-inendang da-zhooshkonamawaad inow indedeyibanen a'aw Ogimaawabiban inow Manidoo-dewe'iganan.

Ishke gii-wawiingeziwag gii-pimiwinaawaad inow gimishoomisinaanin genawenimimangijin noongom. A'aw mindimooyenyiban gaa-nitaawigi'id a'aw Nazhikewigaabawiikwe ogii-ayaawaan inow owiij'aya'aan gaa-wenda-minwiijig gii-naadamaagewaad gii-pimiwinaawaad inow gimishoomisinaanin. Mii ingiw gaa-ogichidaakwewijig gaye.

Mii iwidi ayaamagak i'iw noongom oshki-niimi'idiiwigamig, mii iko iwidi gii-padakideg i'iw gete-niimi'idiiwigamig. Namanj dash gaa-izhichigewaagwen ingiw abinoojiinyag imaa, mii dash gaa-izhi-zaka'amowaad i'iw gete-niimi'idiiwigamig. Mii dash gii-chaagideg.

Ishke dash a'aw indedeyiban naa-go gaye gakina imaa gaa-tibendaagozijig gaa-pimiwinaajin inow Manidoo-dewe'iganan gaa-izhi-inaakonigewaad wii-ozhitoowaad i'iw bekaanak niimi'idiiwigamig ge-aabajichigaadeg imaa Aazhoomog. Moozhag igo gii-okwi'idiwag gii-mikamowaad i'iw akeyaa ge-

18

4 ONE OF THE CEREMONIAL DRUMS BEING USED IN AAZHOOMOG

The ceremonial drum that Larry Smallwood and I take care of came from the community of Isle on the Mille Lacs reservation. It arrived in Aazhoomog in year of 1937. The one who formerly took care of the drum was Larry's namesake John Sam. He was no longer able to take care of the ceremonial drum. It was then that he decided to turn the drum over to my father, John Benjamin.

They did an efficient job in taking care of the ceremonial drum that Larry and I take care of today. The old lady who raised me had sisters who worked together with her and helped to take care of the ceremonial drum. They were the *ogichidaakweg* on that drum.

Where the new ceremonial dance hall is today once stood the old ceremonial dance hall. I do not know what the children must have been doing, but they had started the old dance hall on fire and it burned to the ground.

My father and all the drum members who belonged on the drums decided they were going to build a new dance hall in Aazhoomog. They got together on numerous occasions to find a way to collect money to be able to construct a new dance hall.

izhi-asigaabikwewaad da-gashki'ewiziwaad dash da-ozhitoowaad niimi'idiiwigamig.

Ishke dash besho imaa gaa-taayaang gii-ayaamagad i'iw gikinoo'amaadiiwigamig imaa iko gii-gikinoo'amaagozid a'aw Anishinaabe imaa Aazhoomog. Mii dash gaa-adaawewaad i'iw gikinoo'amaadiiwigamig gii-niisaakwa'amowaad, mii dash imaa nabagisagoon gaa-aabaji'aawaajin gii-ozhitoowaad i'iw niimi'idiiwigamig. Mii-go imaa besho gaa-taayaang, mii imaa gii-padakidoowaad i'iw niimi'idiiwigamig. Mii-go imaa ginwenzh gaa-tazhi-niimi'idiwaad. Gomaapii dash ingiw naagaanizijig imaa ishkoniganing ogii-ozhitoonaawaa i'iw niimi'idiiwigamig.

Ishke dash imaa niimi'iding imaa Aazhoomog, mii inow Manidoo-dewe'iganan a'aw Baadaasige miinawaa Gizhibaagwaneb genawendamaagewaajin, mii-go wiinitamawaa apane ezhi-niimi'idiikewaad. Mii a'aw Manidoo-dewe'igan wayeshkad gaa-tagoshimoonod imaa Aazhoomog. Mii dash i'iw nitam wenji-aabajichigaazod a'aw Manidoo-dewe'igan. Mii dash a'aw gaye wiin genawendamaageyaang ani-aabajichigaazod i'iw apii.

Ishke dash awedi bezhig a'aw Manidoo-dewe'igan gii-ayaaban imaa Aazhoomog. Mii dash a'aw gaa-chaagizod. Ishke dash a'aw gaa-kanawenimaajin inow, megwaa imaa gii-niimi'idiyaang, mii imaa gii-pi-dagoshimoonod. Gii-kiiwashkwebii dash, mii dash imaa gii-nishwanaajichiged megwaa imaa gii-niimi'iding. Mii dash imaa gaa-ni-giizhi-niimi'idiyaang, mii dash gii-ni-giiwed. Mii dash gaa-izhi-jaagidenig endaad miinawaa-go inow Manidoo-dewe'iganan gaa-kanawenimaajin.

Moozhag iko gii-naaniimi'idiinsiwiwaad gii-okwi'idiwaad gii-aabaji'aawaad inow gimishoomisinaanin. Mii eta-go apii

Close to our home there was an old school house the Anishinaabe children attended at one time. They purchased that old school house and took it apart and used the lumber to build their new dance hall. The new dance hall was built close to our home. For a long time they held their dances there. Eventually the revenue from the Mille Lacs band was used to build a new dance hall.

When we have our ceremonial dances in Aazhoomog, it is the ceremonial drum that Dave Matrious and Skip Churchill take care of that is used first. That was the ceremonial drum that first arrived in Aazhoomog. That is why they have their dance first. It is then that we have our ceremonial dance.

There was once another ceremonial drum in Aazhoomog. That is the drum that burnt. What happened was that the drum keeper of this particular drum came to our dance under the influence. He was being disruptive during our dance. Once the dance was over he went home. That is when his house burnt to the ground along with the drum that he was taking care of.

They also used to have small dances throughout the year where the ceremonial drums were used. Nowadays the drums

naami'idiikewaajin noongom dagwaagig naa zaagibagaag chi-niimi'iding.

Azhigwa gaa-kiizhiitaang niizh ingiw Manidoo-dewe'iganag gii-aabajichigaazowaad, mii dash imaa gii-okwi'idiwaad gii-piindigajigaazowaad niizh ingiw Manidoo-dewe'iganag imaa eyaajig imaa Aazhoomog. Mii dash ingiw debendaagozijig imaa Manidoo-dewe'iganing genawendamaageyaang naa miinawaa ingiw debendaagozijig awedi bezhig a'aw Manidoo-dewe'igan gii-piindigadoowaad i'iw wiisiniwin miinawaa gii-asemaakeng. Mii dash owapii gii-aabajichigaadeg iniw zhiibiniketaage-nagamonan, anamikodaadii-nagamonan.

Mii dash owapii aabajichigaadeg inow nagamonan gakina imaa eyaajig ezhi-niimiwaad ani-zhiibiniketawaawaad inow Manidoon ani-aayaanjiwebinigaadeg inow nagamonan. Ishke dash a'aw akiwenziiyiban gaa-ikidod, mii imaa ani-wawiinge-ina'oonwewiziwaad ingiw Anishinaabeg i'iw akeyaa gaa-izhi-nanaandongewaad miinawaa gaa-izhi-bagosenimaawaad inow Manidoon apii gii-asemaakewaad imaa gii-ni-aabajichigaazonid inow gimishoomisinaanin. Ginwenzh gaawiin i'iw akeyaa indizhichigesiimin, maagizhaa ingoding da-bi-azhegiiwemagak da-izhichigeyaang i'iw akeyaa miinawaa.

Akawe igo niwii-tazhindaanan iniw zhiibiniketaage-nagamonan. Mii iko ezhi-wiinjigaadegin iniw nagamonan menidoowaadakin. Mii iniw Manidoo-giigidowinan ezhi-wiinjigaadegin. Ishke dash i'iw nitam zhiibiniketaage-nagamon, mii a'aw Niigaani-manidoo gaa-miinaad inow odanishinaabeman da-ondinigenid, mii iwidi gaa-onjikaamagak. Ishke dash eko-niizhing mayaajii'igaadeg anamikodaadii-nagamon, mii a'aw Manidoo omaa akiing eyaad gaa-pi-miinaad inow Anishinaaben gii-shawenimaad. Mii dash i'iw eko-nising i'iw nagamon, mii a'aw Wenabozho ogiigidowin gaa-pi-ina'oonaad inow odanishinaabeman. Ishke dash

are only used once in the fall and once in the spring when they have their big dance.

Once both drums had their dances, they would get together and bring both Aazhoomog drums back into the dance hall. The drum members of both drums brought in their bowls of food and their tobacco. It was at that time that they used the songs known as handshake songs or welcoming songs.

When those songs are being used everyone present gets up to dance and raises their hand to the Manidoog at a certain time during the songs where there is a change of beat. The old man who spoke after each one of these songs said this is when the Anishinaabe would be given all or most of what they asked for as they put their tobacco down during the dance. We have not done this for some time; hopefully someday we will get back to doing that again.

At this time, I want to talk about those handshake or welcoming songs. That is what these ceremonial songs are known as. These songs came from the Manidoog. The first song came from the Head Manidoo to help the people. The second song came from the Manidoo within the earth to also help the people. The third song came from Wenabozho as a gift to the people. The last song, the fourth song, came from the Thunder-beings as their way of also helping the people. That old man, my uncle Albert Churchill, treated those songs respectfully and got up to talk after each song was sung and told the origin of those songs.

eshkwesing eko-niiwing nagamon, mii dash ingiw Binesiwag
gaa-ininamawaawaad inow odanishinaabemiwaan da-
apenimowaad. Ishke dash a'aw akiwenziiyiban a'aw
Mizhakwadoban a'aw nizhishenyiban, weweni ogii-toodaanan
iniw nagamonan gii-pazigwiid endasing gii-kiizhi'igaadeg gii-
ni-waawiindamaaged gaa-onjikaamagak iniw nagamonan.

5 NAANO-GIIZHIGAK OKWI'IDING

I'iwapii chi-niimi'idiikeng, mii-ko omaa bi-dagoshimoonowaad ingiw Anishinaabeg naano-giizhigak ingoji ningodwaaso-diba'iganek omaa okwi'idim niimi'idiiwigamigong. Mii dash asemaa miinawaa wiisiniwin achigaadeg. Gakina dash ingiw debendaagozijig odaa-wiikwajitoonaawaa omaa da-dagoshinowaad. Odaa-wii-mikwenimaawaan inow Manidoon onaabibiitawaawaan wendabiwaad. Weweni odaa-wii-toodawaawaan azhigwa imaa maadakamigak da-bi-dagoshinowaad da-biinaawaad inow odasemaawaan miinawaa ojiibaakwaaniwaa. Gaawiin debinaak odaa-wii-toodawaasiwaawaan inow Manidoon. Mii-go aazhita ge-ni-doodaagowaapan debinaak igo ani-naadamaagowaad inow Manidoon.

Azhigwa ozisijigaadeg i'iw wiisiniwin ingiw ogichidaakweg odaa-agwaaba'aanaawaa i'iw wiisiniwin imaa eteg inow akikoon imaa da-atoowaad imaa boozikinaaganing da-ininamawaawaad dash inow ininiwan da-o-atoowaad dash imaa adoopowining. Mii-ko imaa nandodamaageyaan da-ni-aabajitoowaad wawiinge-onaaganan, gego wiin inow mazina'igani-onaaganan da-aabajichigaadesinoon. Gidaa-wii-mikwendaamin, mii imaa gidasemaanaan eni-izhaad imaa akiing ebiitamang naa-go gaye gakina maajiiging omaa akiing. Ishke mii ingiw epenimoyangig da-ni-naadamaagooyang. Ishke iniw mazina'igani-onaaganan ani-aabajichigaadeg, nebowa igo daa-ni-aabajichigaadewanoon ani-apiitakamigizid megwaa niimi'idiiked a'aw Anishinaabe.

Ishke dash ani-giizhiitaang i'iw niimi'iding, mii i'iw gakina iniw mazina'igani-onaaganan ani-apagiji-ziigwebinigaadeg imaa ani-izhaamagak omaa akiing. Ishke dash imaa, gaawiin gikendaagwasinoon awegonen a'aw wayaabishkiiwed eni-

5 GETTING TOGETHER ON FRIDAY EVENING

At the time of the big dances people usually arrive on Friday at six o'clock at the dance hall. Tobacco and food is offered up at that time. All the drum members should make an effort to be there. They should remember that they represent Manidoog where they are seated. They need to be respectful to those Manidoog they represent by being there at the start of the dance, by bringing their tobacco and their cooking. They should not be disrespectful to those Manidoog that they represent. If they are disrespectful to those Manidoog, the Manidoog in return could do the same by only half-heartedly granting their requests as they put down their tobacco.

When it is time to set the table the ogichidaakweg serve the food in bowls from the kettles and hand them to the men to put on the table. It is at that time that I have requested them to use the regular plates, rather than using paper or plastic plates. We want to remember that our tobacco goes to the earth that we live on and all that grows upon the earth. Those are the powers we rely on to help us as a people. When we use paper plates at our dances we use a lot of them throughout the dance.

When the dance is over, those used paper plates are hauled to the dump or landfill and into the earth. It is hard to tell what chemicals the white man has put into those paper plates. It is at that time that we are being disrespectful to the earth we live on

dagonang imaa wezhichigaadeg iniw mazina'igani-onaaganan.
Mii imaa ani-inigaachigaadeg i'iw aki ebiitamang
anishinaabewiyang.

Mii gaye ge-ni-ganawaabandang a'aw Anishinaabe
inigokwekamig ingiw mitigoog gaashkiga'igaazojig ani-
nisindwaa da-onjikaamagak imaa ozhichigaadeg dash iniw
mazina'igani-onaaganan. Ishke dash a'aw Anishinaabe ani-
asemaaked, mii imaa gaye inow odasemaan eni-izhaanid inow
mitigoon. Ishke Mitigwaabiiwinini izhinikaazo a'aw Manidoo
eni-ayaad inow bebezhig inow mitigoon. Ishke ani-
aabajitooyang iniw mazina'igani-onaaganan gidaa-
inigaa'aanaan a'aw Manidoo gaye epenimoyang.

Ishke dash naano-giizhigak okwi'idiwaad ingiw
debendaagozijig imaa gimishoomisinaanin, mii imaa ani-
niigaaninaawaad inow odasemaawaan asaawaad imaa
gimishoomisinaan asemaa-makakoonsing. Ishke dash imaa
asemaakeng, mii ingiw nitam genawendamaagejig inow
gimishoomisinaanin esaajig inow odasemaawaan azhigwa gaa-
kiizhi-ozisijigaadeg i'iw wiisiniwin.

Ishke iko ingoji baa-naazikaageyaan endazhi-niimi'idid a'aw
Anishinaabe, gaawiin gaabige imaa indasemaam indasaasiin
imaa asemaa-onaaganing a'aw gimishoomisinaan maagizhaa
gaye gookomisinaan waa-aabajichigaazod. Baanimaa ingiw
genawendamaagejig inow Manidoo-dewe'iganan gaa-
paakishimimind miinawaa gakina eginzojig gii-asaawaad inow
odasemaan, mii dash bijiinag ani-asag indasemaam gaye niin.

Ishke dash mii i'iw ge-ni-baabiitoowaapan gakina imaa eyaajig
akawe dash wiinitamawaa ingiw ogimaag oda-asaawaan inow
odasemaawaan, mii dash ingiw debendaagozijig gaye wiinawaa
da-asaawaad inow odasemaawaan, mii dash i'iwapii bijiinag
gakina imaa eyaad da-ni-biindaakoojigepan.

28

as Anishinaabe.

The Anishinaabe need to also remember the many trees that were cut down and killed to make those paper plates. Also, when Anishinaabe have their ceremonies their tobacco goes to the trees. The Manidoo that exist in every one of those trees is known as *Mitigwaabiiwinini.* When we use paper plates we are doing harm to that Manidoo we depend on.

On Friday nights it is the drum members who put their tobacco first in the drum's tobacco box. It is the drum keepers who are the first to put their tobacco after the food has all been placed at the table, then the rest of the drum members follow.

Whenever I go to other ceremonial dances I do not put my tobacco in the drum's tobacco box as soon as I enter the dance hall. It is not until after the drum members of that particular drum put down their tobacco that I put down my tobacco.

Everyone should wait until the drum keepers put down their tobacco, and then the drum members will put down their tobacco. It is at that time that everyone else can put down his or her tobacco.

Mii dash a'aw opwaaganiiwinini ezhi-mooshkina'aad inow
gimishoomisinaan inow odoopwaaganan. Mii dash imaa
niibawid izhinoo'waad inow opwaaganan bebezhig
ayizhinoo'amawaad inow Manidoon waakaabiitaminijin
Manidoo odakiim, biinish ishpiming Manidoo naagaanizid
miinawaa dabazhish Manidoo omaa akiing eyaad.

Mii dash imaa babaamiwinaad inow opwaaganan. Mii dash
wiinitamawaa genawendamaagejig inow gimishoomisinaanin
da-wiikwamaawaad da-naabishkaagewaad inow asemaan. Mii
dash gaye ezhiwidamawaad inow opwaaganan inow
genawendamaagenijin inow Manidoo-dewe'iganan
wiinitamawaa da-naabishkaagewaad. Mii dash imaa
wiinitamawaa eginzojig da-naabishkaagewaad. Gaa-kiizhiitaad,
mii dash gakina imaa ezhi-naabishkaagewaad inow asemaan.

Mii dash imaa ani-apagizomind a'aw asemaa miinawaa
wiisiniwin gaa-kiizisijigaadeg. Mii iko imaa a'aw ogichidaa gaa-
inagimind da-ni-gaagiigidod. Ishke dash imaa ayaasig, mii a'aw
bezhig genawenimaad inow gimishoomisinaan eni-gaagiigidod.
Booch a'aw ogimaa da-ni-gagwejimaad inow odoogichidaaman,
awenen ge-ni-gaagiigidod. Gaawiin daa-michi-bazigwiisiin
a'aw ogimaa da-ni-gaagiigidod. Akawe imaa weweni odaa-
doodawaan inow odoogichidaaman da-gagwejimaad, "Awenen
ge-gaagiigidod?"

Mii dash omaa bangii wii-ni-dazhindamaan gaa-izhi-
gaagiigidowaad ingiw akiwenziiyibaneg. Mii-ko gaa-ikidowaad,
"Mii iw gii-kizhibaashkaad a'aw gimishoomisinaan inow
odoopwaaganan iwidi eni-inaabasod a'aw asemaa enabiwaad
ingiw Manidoog, naa-go gaye mii-go iwidi dibishkoo ge-ni-
inikaamagak i'iw wiisiniwin gaa-achigaadeg. Ishke mii imaa
weweni gidoodawaanaan gimishoomisinaan a'aw asemaa naa
wiisiniwin etooyang owapii gii-wiindamang da-ni-
baakishimind a'aw gimishoomisinaan." Mii dash imaa ani-

It is then that the pipe man fills the drum's pipe. Then, as he is standing there, he points the pipe to each of the four directions acknowledging each of those Manidoog that sit around the earth. Then he points the pipe up to the Head Manidoo and then points the pipe down to the Manidoo in the earth.

Now he takes the pipe around. The pipe goes to the drum keepers next, from there the pipe goes to the visiting drum keepers from a distance. Then from there it goes to the drum members of this particular drum. After that the drum's pipe is passed to everyone else in the dance hall.

It is then the tobacco and the food are offered up to the Manidoog. It is usually the *ogichidaa* that does the talking. If the ogichidaa is not there, it is one of the drum keepers that does the talking. The drum keeper has to go and ask his ogichidaa who is going to talk for the tobacco and the food. The drum keeper should not just go ahead and get up and talk. He needs to treat his ogichidaag with respect and ask, "Who is going to talk for the food and tobacco?"

I am going to mention a little about what these old men talked about when they got up to talk. This is what they said, "The drum's pipe has gone around and the tobacco has gone to where those Manidoog sit and likewise the food also will go to where those Manidoog sit. We are treating those Manidoog respectfully in offering our food and tobacco to them on this day, which we had selected to have our dance." It is also then that he is asking for help that all goes well for the Anishinaabe and that they like what they see as we do our ceremony that

nandodamaaged ani-gaagiigidod, da-ni-maminosed ani-
naadamaagoowizid a'aw Anishinaabe naa-go gaye da-ni-
minwaabamigooyang weweni doodamang i'iw gaa-izhi-
miinigoowiziyang anishinaabewiyang. Gaawiin bezhigwang
izhi-gaagiigidosiin awiya. Mii eta-go i'iw anooj akeyaa ge-izhi-
minosed a'aw Anishinaabe nandodamaaged, naa-go gaye
weweni ani-giizhiitaang waa-ni-izhichigeng omaa ani-
bitaakoshkanziwang gegoo.

Mii dash o'ow gaye abiigizigewinini eyaad daa-maada'ookii
iniw baaga'akokwaanan bangii-go omaa ge-ni-nagamowaapan
naa niimiwaapan imaa eyaajig. Oda-minwendaanaawaa ingiw
Manidoog ani-noondawaawaad inow gimishoomisinaanin ani-
aabajichigaazonid. Mii dash imaa da-ni-giizhiitaang i'iw naano-
giizhigak okwi'iding.

Mii dash ingiw abiigizigewininiwag ani-maamiginaawaad inow
gimishoomisinaanin gemaa gaye asaawaad imaa ogiji-
adoopowining. Geyaabi-go da-baakishing gabe-dibik da-ayaad
imaa niimi'idiiwigamigong. Gaawiin da-giiwewinaasiin,
baanimaa gii-kiizhakamigak da-giiwewinaa.

they gave us. There is not one certain way to talk at these dances. They only ask for good things to happen to the Anishinaabe and that we complete this ceremony without running into any barriers.

It is at that time that the drum warmer could pass out the drumsticks so that they could sing a few songs and those attending could dance. The Manidoog will be happy to hear the drum being used. That will finish what happens on Friday nights at our dances.

The drum warmers then pick the drum up and place him on top of the table. The drum will stay open all night at the dance hall. The drum is not taken home at that time. It is not until the dance is completely over that he is taken home.

6 ISHKWAAJANOKII-GIIZHIGAK OKWI'IDING GIGIZHEBAAWAGAK

Mii iw dabwaa-maajitaang i'iw ishkwaajanokii-giizhigak, wewiib owiikwajitoonaawaa ingiw abiigizigewininiwag da-dagoshinowaad imaa waa-tanakamigak. Mii dash imaa badakijigaadeg iniw okaadan a'aw gimishoomisinaan. Mii dash iwidi ningaabii'anong nitam da-achigaadeg i'iw mitig. Mii iw netamising. Mii dash eko-niizhing i'iw mitig, mii i'iw giiwedinong badakijigaadeg. Mii dash eko-nising iwidi da-achigaadeg waabanong akeyaa. Mii dash i'iw eshkwesing iwidi zhaawanong da-achigaadeg. Mii dash imaa agoonindwaa ingiw miigwanag ezhibii'igaazowaad ge-ani-agoonindwaa. Booch gaye a'aw abiigizigewinini weweni da-dakobinaad inow miigwanan imaa mitigong. Ishke giishpin bangishing bezhig a'aw miigwan megwaa imaa endanakamigizing, booch da-chi-diba'igeng da-okosijigeng, naa da-ni-gaagiigidong da-gaagiizomindwaa ingiw Manidoog.

Mii dash imaa ishkwaajanokii-giizhigak okwi'iding imaa midaaso-diba'iganek a'aw asemaa naa wiisiniwin achigaadeg. Mii gaye debinaak wii-ni-izhichigesigwaa gakina ingiw debendaagozijig da-bi-dagoshinowaapan da-biindigadoowaapan ojiibaakwaaniwaan. Mii-go gakina ba-naazikaagejig biindigadoowaapan i'iw wiisiniwin, gaawiin eta-go memwech debendaagozijig.

Ishke dash gaa-ikidowaad ingiw mindimooyenyibaneg, "Gaawiin imaa zheshenik niwii-ni-bi-biindigesiin imaa manidoowichiged a'aw Anishinaabe." Mii-go booch gii-piindiganaawaad iniw odakikowaan misawaa igo gii-tibendaagozisigwaa inow Manidoo-dewe'iganan ayaabajichigaazonijin.

6 GETTING TOGETHER ON SATURDAY MORNINGS

Before everything starts on Saturday the drum warmers arrive at the dance hall. At that time the legs of the drum are stood up. The western leg is the first leg to go up. It is the number one spot. The second stick stands to the north. The third stick is placed on the east side. The last or fourth stick is placed in the south. Then the feathers are hung on the legs and are they are marked in the order that they hang. The drum warmers must properly tie those feathers onto the legs. If one of the feathers should fall during the course of the dance a sizable offering must be made to the Manidoog and someone must get up to speak, asking that the Manidoog look down on us with compassion even though this has happened.

And then everyone gets together at ten on Saturday morning to put down his or her food and tobacco. The drum members should also make an effort to be there and to bring their cooking and tobacco. Everyone in attendance can bring in food; it is not only the drum members that should bring in food.

What the old ladies said was, "I do not want to come in empty-handed without my cooking to whatever ceremony Anishinaabe are having." They made sure they brought in their kettle of food whether they belonged on the drum or not.

Ishke dash noongom ezhichigewaad nebowa ingiw
Anishinaabeg, aanind ingiw ikwewag mii eta-go imaa
daawanabiwaad dibishkoo akawaabandamowaad da-
ashamindwaa. Weniban iko da-biindigadoowaad
ojiibaakwaaniwaan. Gaawiin i'iw mewinzha gii-izhichigesiim.
Booch igo imaa gii-piindigadoowaad i'iw wiisiniwin.

Ishke dash gaa-ikidowaad ingiw akiwenziiyibaneg, gaawiin
gawizisiin a'aw Anishinaabe bi-biindigadood i'iw wiisiniwin.
Ishke dash imaa da-gii-ashamoonsipan, awashime dash imaa
inendang wii-pi-biindigadood i'iw wiisiniwin ininamawaad
inow Manidoon. Mii imaa wendiniged ani-zhawendaagozid ani-
naadamaagoowizid weweni imaa a'aw Anishinaabe bi-
doodawaad iniw Manidoon.

Mii-go imaa ani-asemaakeng miinawaa weweni
izhinoo'igaazod a'aw opwaagan miinawaa, mii-go gaye a'aw
ogichidaa ani-gaagiigidod ani-apagizomaad inow asemaan
miinawaa i'iw wiisiniwin. Mii dash i'iw ani-giizhiitaang ani-
gigizhebaa-ashangeng, mii-go ani-giiweng ani-naajigaadeg i'iw
wiisiniwin ge-aabajichigaadeg da-ashangeng ani-onaagoshig,
naa gaye ani-naadiwaad obagijiganiwaa waa-atoowaad ani-
okosijigeng.

What happens today with a lot the Anishinaabe is that some Anishinaabe women come in with their mouths wide open, expecting to be fed. They arrive there without their food. This did not happen a long time ago. They always brought in their food.

The old men used to say that when people brought their food into a ceremony it was not in vain. That is the food they could have fed their family, but instead they chose to bring it in and offer it up to the Manidoog. It is from there that those Manidoog show their compassion and give help to those who brought in food.

The tobacco is offered once again and the pipe is pointed to where those Manidoog sit. The ogichidaa gets up to talk and offers up the food and the tobacco to the Manidoog. When they are finished feeding everyone breakfast, everyone goes home to get the food for the evening meal and also they get their offering that they will put in the bundle.

7 ISHKWAAJANOKII-GIIZHIGAK ANI-ISHKWAA-NAAWAKWEG

Mii iw ingo-diba'iganek da-wii-tagoshinowaad ingiw eginzojig naa gaye ingiw nayaazikaagejig, wewiib igo da-ni-maajitaang ingoji-go niizho-diba'iganek da-maajitaang. Onzaam nebowa ge-izhichigeng eyaamagak. Booch da-wii-kiizhiitaang dabwaa-bangishimod a'aw giizis, mii owapii iko ani-mamigaadeg iniw okaadan imaa ani-agoojigaazod a'aw gimishoomisinaan. Aaningodinong, mii owapii wenabi'ind awiya asind imaa da-dibendaagozid imaa dewe'iganing, maa minik igo dazhitaam izhichigeng i'iw. Ayaapii iko wawezhi'aawag ingiw gaa-wanitaasojig gaa-wani'aajig inow besho enawemaawaajin. Ginwenzh igo dazhitaam izhichigeng i'iw.

Mii dash owapii ogichidaa bazigwiid da-ni-wiindamaaged wii-aabajichigaadeg iniw nagamonan eyaamagakin inow gimishoomisinaanin. Mii dash omaa maanoo akawe ingiw debendaagozijig waadabindangig iniw mitigoon ingiw niimi'iwewininiwag da-wawenabiwag. Booch imaa da-wiidabindamowaad i'iw mitig wendabiwaad. Gego awiya imaa odaa-zhiigwaakwanaasiin inow niimi'iwewininiwan imaa wendabinid. Bizhishigwaamagak imaa ge-ondabipan awiya, mii a'aw abiigizigewinini ge-baa-maada'oonaapan iniw baaga'akokwaanan da-onaabamaad awenen ge-o-wawenabid imaa bizhishigwaamagak.

Mii dash owapii da-maajii'igaadeg iniw nagamonan debendaagwakin inow gimishoomisinaanin. Niishtana ashi-bezhig ayaamagadoon iniw nagamonan. Mii dash owapii debendaagozijig gakina bebezhig ani-bapazigwiitamowaad onagamoniwaan.

Ishke gaye ingiw akiwenziiyibaneg gaa-ikidowaad, azhigwa ani-baakishimind a'aw gimishoomisinaan wenjida agoojing

38

7 WHAT HAPPENS ON SATURDAY AFTERNOON

At one o'clock all the drum members and visitors should try to arrive so that the dance can get started as soon as possible prior to two o'clock. There is a lot that has to be done at these dances. We have to finish before the sun goes down, at which time the drum is taken down off his legs. At times this is when an individual is seated as a drum member. It takes a good amount of time to seat this person. Every now and then people who have lost a close relative are put through the grief ceremony. This ceremony also takes a long time.

It is at this time that the ogichidaa stands up and tells the people that the special songs that belong on the drum will be used. The drum members who have been designated singers should be allowed to sit at their sticks at the spot in which they were seated. No one should jump in there and squeeze the singers out of their spots. If there is an open seat at the drum for someone else to sit down, it is the drum warmer that will pass out the drumsticks to fill those vacant spots.

It is then that these special songs that belong on the drum are sung. There are twenty-one of these songs. At this time each one of the drum members gets up and dances to their particular song.

The old men also said that, especially when the drum is hanging up on his legs, the Manidoog are there up above the

imaa okaading, mii imaa ishpiming endanaajimindwaa ingiw
Manidoog ayaawaad. Mii imaa wenzaabamaawaad
wenjitawaawaad odanishinaabemiwaan ani-niimi'idiikenid.

Ishke dash giishpin imaa mayaanaadak ayaamagak wenjida bi-
biindiged a'aw gegishkang i'iw minikwewin nebowa
enigaa'igod a'aw Anishinaabe, mii-go imaa izhi-naangitaawaad
ingiw Manidoog, gii-ikidowag ingiw akiwenziiyibaneg.

Ishke dash gaye booch imaa maamawichigewin da-ni-
ayaamagak. Gaawiin odaa-wii-maji-inaasiwaawaan ingiw
debendaagozijig iniw imaa waadabimaawaajin ani-
aabajichigaazod a'aw gimishoomisinaan. Giishpin majayi'ii
imaa ayaamagak ani-giikaandiwaad ingiw debendaagozijig,
mii-go imaa gaye da-ni-naangitaawaapan ingiw Manidoog.

Ishke gaye aanind ingiw Anishinaabeg gaa-pimiwinaajig iniw
gimishoomisinaanin, mii-go gaa-izhi-wani'aawaad iniw
Manidoo-dewe'iganan gaa-kanawenimaawaapanen. Mii dash
i'iw ganabaj gaa-onji-izhiwebiziwaad, gaawiin i'iw
maamawichigewin gii-ayaamagasinini, megwaa imaa gii-
tanakamigiziwaad gii-niimi'idiikewaad. Mii iw ge-onji-
ayaangwaamizid a'aw Anishinaabe wenaajiwaninig akeyaa da-
ni-naanaagadawendang, megwaa imaa ani-aabajichigaazod
a'aw gimishoomisinaan.

40

drum. It is from there that they watch and listen to their Anishinaabe as they hold their dance.

Those old men said if there is negativity present, especially if people are coming in drunk or under the influence of drugs, the Manidoog will just up and leave.

Everyone has to work together. The drum members must not say bad things about the ones they sit with on the drum. If the negativity is there, and they are arguing amongst each other, here too the Manidoog will just up and leave the dance.

There are also Anishinaabe that have lost their drums. I believe this is why they lost their drums; they did not work together when they put on their dances. This is why Anishinaabe need to really make sure that they only have good thoughts while the ceremonial drum is being used.

8 MANIDOO-GIIGIDOWINAN GAA-ACHIGAADEGIN OMAA GIMISHOOMISINAANING

Mii omaa wii-ni-dazhindamaan iniw Manidoo-giigidowinan gaa-achigaadegin da-ni-aabajichigaadeg omaa gimishoomisinaaning genawendamaageyaang eyiizh Amikogaabaw naa gaye niin omaa Aazhoomog. Niishtana ashi-bezhigwanoon Manidoo-giigidowinan, mii iniw naamikamowaajin debendaagozijig Manidoo-dewe'iganing.

Ishke dash i'iw nitam maajii'igaadeg, mii a'aw Niigaani-manidoo ogiigidowin. Ishke dash ginwenzh ishkweyaang ingii-maajii-daniz endazhi-niimi'iding, gaawiin wiikaa nimbi-waabamaasiin awiya da-niimikang i'iw nagamon omaa akeyaa. Mii eta-go iwidi Odaawaa-zaaga'iganiing gii-waabandamaan bazigwiitamowaad i'iw nagamon niimikamowaad. Ishke bebakaan ingii-gikinoo'amaagoowizimin. Gaawiin nimbabaamendanziin i'iw, Manidoo ayaa nenaa'isidood giishpin ani-wanichiged a'aw Anishinaabe. Ganabaj aanind ayaawag ingiw dibishkoo ezhichigejig imaa agaami-ziibing, gaawiin dash wiikaa indizhaasiin imaa endazhi-niimi'idiwaad.

Mii dash eko-niizhing, mii a'aw genawenimaad inow Manidoo-dewe'iganan bezigwiitang. Mii imaa ani-naabishkawaad ani-naadamawaad a'aw bezhig a'aw naagaanizid a'aw Manidoo.

Mii dash i'iw eko-nising ani-maajii'igaadeg, mii a'aw awedi bezhig genawendamaaged gimishoomisinaanin eni-bazigwiitang; gaye wiin a'aw eni-naabishkawaad inow Manidoon. Mii i'iw nagamon bezigwiitang a'aw Amikogaabaw. Mii iwidi iko izhaayaan Odaawaa-zaaga'iganiing endazhi-niimi'idiikewaad, mii ingiw bezigwiitangig ingiw genawendamaagejig inow niizh inow gimishoomisinaanin iwidi eyaawaawaajin. Mii-go gaye ingiw biiwideg

8 THE SONGS THAT ARE USED ON THE CEREMONIAL DRUM

I want to talk about those special songs that are designated to be used on the ceremonial drum that Larry Smallwood and I take care of in Aazhoomog. There are twenty-one of those songs that the drum members get up to dance to.

The first song that is sung belongs to the Head Manidoo. I have been around the dances for a long time, and I have never seen anyone get up and dance to that song. It is only in Lac Courte Oreilles that I have seen the Anishinaabe get up and dance to that song. We all have been taught differently. I do not worry about it, because there is a Manidoo that will correct anything where Anishinaabe may make mistakes. There may also be some across the river in Wisconsin that dance to that song, but I have not gone to any of their dances.

The second song that is sung is the drum keeper's song. As he gets up he is dancing on behalf of one of the Head Manidoog.

The third song that is sung is the other drum keeper's song that he will get up to dance; he too represents one of the Head Manidoog. That is the song that Larry Smallwood dances to. At their dance in Lac Courte Oreilles that is the song both of their own drum keepers get up and dance to. That is also the song that the visiting drum keepers get up and dance to at the same time.

43

genawendamaagejig inow Manidoo-dewe'iganan ezhi-
bazigwiitamowaad i'iw nagamon.

Mii dash iniw niiwin eni-maajii'igaadeg, mii iniw
onagamoniwaan ingiw ogichidaag. Niiwin imaa ayaawag. Ishke
ingiw ogichidaag gii-onabi'aawag, mii ingiw zhimaaganishag
agaaming gaa-paa-ayaajig. Maagizhaa gaye gii-
maakishkoozowag miskwi gii-waabandamowaad. Mii ingiw
eni-gaagiigidojig ani-apagizomaawaad inow asemaan,
bagijiganan, miinawaa wiisiniwin. Mii-go imaa ani-
bazigwiiwaad ani-gaagiigidowaad aaniin igo enakamigak imaa
niimi'iding.

Mii dash eko-ishwaaching nagamon, mii a'aw chi-
baaga'akokwaan bemiwidood. Ayaamagad i'iw chi-
baaga'akokwaan memood ani-gigishimod dash.

Mii dash a'aw eko-zhaangaching nagamon, mii a'aw niigaani-
niimi'iwewinini onagamon. Ishke owiidabimaaganan
odayaawaan. Mii iwidi wendabiwaad naagaaniimagak i'iw
mitig iwidi ningaabii'anong eyaamagak. Mii dash ingiw
naamikangig i'iw nagamon.

Mii dash eko-midaaching nagamon maajii'igaadeg, mii dash
ingiw niimi'iwewininiwag niizhing wendabijig ingiw eko-
niizhing mitig badakideg iwidi giiwedinong. Mii ingiw
naamikangig i'iw nagamon.

Mii dash i'iw eko-ashi-bezhigong nagamon maajii'igaadeg, mii
ingiw niimi'iwewininiwag eko-nising wendabijig
bezigwiitangig i'iw nagamon. Mii dash iwidi
wiidabindamowaad i'iw mitig bedakideg iwidi waabanong.

The next four songs belong to the ogichidaag. There are four ogichidaag. These ogichidaag placed on the drum are men who were in the armed services and went abroad. Maybe they had been wounded or saw blood during the wars. They are also the speakers who will speak for the tobacco, offerings, and the food. They also get up and speak for anything else that may be going on at the dance.

The eighth song belongs to the big stick. There is a ceremonial drumstick that he carries as he dances his song.

The ninth song belongs to the head singer, and he has a partner that he sits with. They sit at the first stick, which is located in the west. They are the ones that dance that song.

The tenth song that is sung belongs to those singers that sit at the second stick, which is located in the north. They are the ones who dance that song.

The eleventh song belongs to the singers who sit at the third stick. The third stick is the one that stands in the east.

Mii dash i'iw eko-ashi-niizhing nagamon. Mii ingiw eshkwebijig
niimi'iwewininiwag naamikamowaad. Mii iwidi endazhi-
bazigwiiwaad i'iw zhaawanong mitig iwidi wiidabindiwaad.

Mii gaye ayaa a'aw opwaaganiiwinini, mii iw naamikang eko-
ashi-nising nagamon. Mii a'aw genawenimaad
gimishoomisinaan odoopwaaganan. Aaningodinong baa-
izhaayaan endazhi-niimi'idiikeng, niwaabamaag iko
dekonaawaad inow opwaaganan niimiwaad
opwaaganiiwininiiwiwaad. Gaawiin niinawind
indizhichigesiimin omaa akeyaa omaa Manidoo-dewe'iganing
genawendamaageyaang.

Mii dash owapii maajii'igaadeg ingiw abiigizigewininiwag
onagamoniwaan. Ishke dash i'iw eko-ashi-niiwing eyaamagak
i'iw nagamon, mii a'aw niigaani-abiigizigewinini onagamon. Mii
gaye wiin iwidi ani-wiidabindang naagaanakideg iwidi
ningaabii'anong eyaamagak.

Azhigwa dash eko-ashi-naaning i'iw nagamon maajii'igaadeg
mii dash a'aw abiigizigewinini eko-niizhing wendabid
bezigwiitang. Mii iwidi wiidabindang i'iw mitig iwidi
giiwedinong eyaamagak.

Mii dash i'iw eko-ashi-ningodwaaching nagamon, mii dash
imaa eko-nising wendabid abiigizigewinini naamikang. Mii
dash iwidi waabanong eyaamagak mitig waadabindang.

Mii dash i'iw eko-ashi-niizhwaaching nagamon, mii eshkwesing
abiigizigewininiiwi-nagamonan. Mii dash a'aw abiigizigewinini
eshkwebid bezigwiitang i'iw nagamon iwidi waadabindang
zhaawanong mitig eyaamagak.

The twelfth song is for singers who sit last at the fourth stick. They stand up from the south where they sit together.

There is also a pipeman who dances the thirteenth song. He is the one who takes care of the drum's pipe. Sometimes I go to dances and I see their pipeman carrying the pipe as they dance. We were not taught to do that here on the drum that we take care of in Aazhoomog.

The next four songs belong to the drum warmers. The fourteenth song belongs to the head drum warmer. He also sits with the first stick that stands in the west.

The fifteenth song belongs to the drum warmer who sits at the second stick. He sits with the stick that stands in the north.

The sixteenth song belongs to the drum warmer who sits in the third spot. He sits with the stick that is in the east.

The seventeenth song is the last song of the drum warmers. This song belongs to the drum warmer who sits with the fourth stick in the south.

Mii dash gaye niiwiwag ingiw abiigizigewininiwag. Mii ingiw genawenimaajig gimishoomisinaanin abiigizwaawaad owapii banangwewenid iniw gimishoomisinaanin. Mii gaye owapii chi-niimi'iding agoonaawaad gimishoomisinaanin omaa okaading naa gaye miigwanan agoonaawaad. Mii ingiw ba-maamiginaajig iniw gimishoomisinaanin izhiwinaawaad iwidi waa-tazhi-niimi'iding naa gaye giiwewinaawaad ani-giizhi-niimi'iding.

Ishke dash giishpin bi-nishwanaajichiged awiya maagizhaa gaye giiwashkwebiid o-wawenabid iwidi ani-wiidabimaad negamonijin, mii inow abiigizigewininiwan ani-mamaagod i'iw baaga'akokwaan igod bakaan iwidi da-o-wawenabid, maagizhaa-go gaye da-giiwed ani-giiwenaazha'ogod.

Mii gaye ingiw iko gaa-wiindamaagejig aaniin minik geyaabi iniw nagamonan ge-aabajichigaadegin owapii ge-giizhi-niimi'iding.

Ishke iwapii gii-abiigizigewininiiwiyaan gimishoomisinaan genawendamaageyaang, ishke ani-aanikoosijigaadeg iniw nagamonan ishkwe-ayi'ii, mii owapii gii-wiindamaagooyaan, mii owapii gii-inindwaa ingiw abiigizigewininiwag da-niimiwaad da-zazekidoowaad da-zazegibagizowaad enigok da-niimiwaad ani-ishkwesing ani-aanikoosijigaadeg iniw nagamonan.

Mii iwidi Odaawaa-zaaga'iganiing, mii eta-go ingiw abiigizigewininiwag bezigwiitangig ani-aanikoosijigaadeg i'iw nagamon. Mii-go wawaaj gaye ingiw abiigizigewininiwag waasa wenjiijig, mii ge-wiinawaa ezhi-niimikamowaad ani-aanikoosijigaadeg iniw nagamonan. Gaawiin igo gakina iniw nagamonan ani-aanikoosijigaadesinoon negamowaajin. Mii igo imaa dibishkoo ingiw niimi'iwewininiwag odaanoozimaawaan iniw abiigizigewininiwan da-zazekidoonid da-chi-niiminid da-

48

There are four drum warmers. They are the ones who take care of the drum and heat the drum when the drum sounds flat. Also at the time of the big dance, they hang the drum on his legs and they also hang the feathers on the legs. They are also the ones who come pick up the drum and take it to the dance site and also the ones who take the drum home when the dance is over.

If someone comes in and disrupts the dance or maybe is under the influence of alcohol and goes and sits by the drum with the intention of singing, it is the drum warmer who can take the drumstick away from him and tell him to go sit elsewhere, or ask him to leave and go home.

It has always been one of the drum warmers who tells how many more songs will be sung to end the dance.

When I was a drum warmer on the drum that we take care of now, I was told to dance the tails of the songs. All drum warmers are encouraged to dance the tails and to really go to it and dance hard. It is something that all drum warmers are supposed to do at the tails of the songs.

Over at the dances in Lac Courte Oreilles it is only the drum warmers who get up and dance the tails of the songs. Those drum warmers from a distance also join in the dancing of the tails of the songs. Not all of the songs have a tail added to it. What the singers are doing is encouraging and pushing the drum warmers to dance as hard as they can and for them to quit dancing on beat, to not overstep and miss that last beat. The drum warmers also compete with one another to see who

miikwa'aminid weweni ani-ishkwaa'amaazowaad ingiw
niimi'iwewininiwag da-onzaamibagizosinig iniw
abiigizigewininiwan azhigwa imaa ani-ishkwaa'amaazowaad.
Mii imaa gaye ani-gagwe-aada'odiwaad awenen nawaj waa-
sazekidood niimid. Niwenda-minwaabamaag iko
ezhichigewaad i'iw akeyaa. Minawaanigoziwag gakina imaa
genawaabijig izhichigeng i'iw.

Ayaamagad i'iw nagamon nandwewemind a'aw
abiigizigewinini da-abiigizwaad inow gimishoomisinaanin
banangwewenid megwaa imaa niimi'iding. Mii dash a'aw
abiigizigewinini ezhichiged, akawe imaa gizhibaashimo inow
gimishoomisinaanin, mii dash iwidi ani-noogitaad wendabid o-
mamaad inow dewe'iganan megwaa imaa nagamowaad ingiw
niimi'iwewininiwag o-abiigizwaad dash imaa agwajiing. Mii-go
gaye megwaa abiigizond imaa agwajiing a'aw
gimishoomisinaan, mii-go ge-izhi-nagamowaad ingiw
niimi'iwewininiwag. Maagizhaa gaye imaa michisagong gemaa
gaye odapabiwiniwaa baaga'akokwewag.

Mii dash owapii maajii'igaadeg i'iw giiwose-nagamon ezhi-
wiinjigaadeg. Mii imaa gizhibaashimod a'aw oshkaabewis, mii
dash imaa ezhitaad megwaa imaa niimid dibishkoo-go
mitigwaabiin odakonaan ani-mamood dash i'iw bikwak
dibishkoo-go nisaad inow awesiinyan. Azhigwa gaa-kiizhi-
gizhibaashimod inow gimishoomisinaanin, mii dash iwidi
jiibaakwewigamigong ani-mamaad inow akikoon i'iw
jiibaakwaan booch gaye wiiyaas da-gii-tagodeg. Mii dash iwidi
zhaawanong akeyaa asaad inow akikoon. Mii dash i'iw ezhi-
baakaakonang i'iw gibaabowe'igan imaa akikong, mii dash
owapii ingiw niimi'iwewininiwag ishkwaa'amowaad i'iw
giiwose-nagamon. Mii iw eko-ashi-ishwaaching nagamon.

dances the hardest and the best. I enjoy watching them do this. Everyone is happy to see that happen and it makes the dance more enjoyable.

There is also a song that calls for the drum warmer to heat the drum up if it sounds flat during the dance. This is what the drum warmer does: first he dances around the drum and stops at the stick at which he has been seated and from there he picks the drum up even while the drummers are singing and takes the drum outside to heat it by the fire. While the drum is outside being heated, the drummers can continue to sing either hitting the floor with their drumsticks or the bench they are sitting on as they continue singing the song.

The next song that is sung is that which is known as the hunter's song. What happens is the *oshkaabewis* dances around the drum and moves as if he was carrying a bow while he is hunting and reaches back to pull out an arrow and acts as if he is killing an animal. Once he has completely danced around the drum, he then goes into the kitchen and picks out a kettle that has meat in it. He then comes back into the dance area and places that kettle on the south side of the drum. As soon as he removes the cover from the kettle, the singers quit singing the hunter's song. That is the eighteenth song.

Mii dash i'iw eko-ashi-zhaangaching nagamon maajii'igaadeg,
mii dash i'iw agwaa'izekweshimo-nagamon. Mii dash iwidi
waabanong akeyaa niibawid a'aw oshkaabewis
inaasamigaabawid imaa akikong akeyaa abinid. Mii dash imaa
ani-aabajichigaadeg agwaa'izekweshimo-nagamon. Mii dash
imaa endasing ani-aayaanjiwebinigaadeg i'iw nagamon, mii
dash imaa dibishkoo ani-aabajitood oninjiin ani-agwaaba'ang
i'iw wiisiniwin ininamawaad bebezhig iniw Manidoon
waakaabiitaminijin o'ow Manidoo odakiim. Ishke dash imaa
gaawiin memwech apagizonjigaadesinoon i'iw wiisiniwin
azhigwa gaa-ozisijigaadeg. Mii-go imaa gii-ni-giizhiikang a'aw
oshkaabewis gii-ni-agwaa'izekweshimod, mii-go iwidi gakina
gaa-inikaamagadinig i'iw wiisiniwin gakina enabiwaad ingiw
Manidoog.

Gaawiin memwech maada'ookiisiim i'iw wiisiniwin gaa-ateg
imaa akikong gaa-kiizhiikawaajin a'aw oshkaabewis. Ingii-pi-
waabandaan a'aw Anishinaabe ani-maada'ookiid i'iw
wiisiniwin azhigwa gaa-kiizhiitaad a'aw oshkaabewis. Mii dash
omaa niinawind gaawiin indizhichigesiimin omaa akeyaa.

Mii a'aw oshkaabewis wezisinaaganed naa wiisiniwin etood
apii wii-ashangeng. Mii eta-go ininiwag iko omaa gaa-atoojig
i'iw wiisiniwin imaa adoopowining. Mii dash winawaa ingiw
ikwewag agwaaba'amowaad i'iw wiisiniwin imaa eteg imaa
akikoon, mii dash imaa atoowaad boozikinaaganing
ininamawaawaad inow oshkaabewisan naa maagizhaa gaye
inow ininiwan nayaadamaagojin, wiinawaa dash atoowaad
imaa agiji-adoopowining.

Ishke dash imaa biindigajigaadeg i'iw wiisiniwin a'aw
Anishinaabe waa-ininamawaad inow Manidoon, mii a'aw
oshkaabewis wezisidood i'iw imaa anaakaning. Ogijayi'ii dash
atood imaa anaakaning wiisiniwin naa minikwewin naa gaye
giishpin biindigadoogwen waa-apigaabawid ba-nanaandonged.

The nineteenth song that is sung is called the food offering song. The oshkaabewis stands in the east facing the kettle. That is when they use the food offering song. Every time there is a change in the beat of song the oshkaabewis uses his hands to act as if he is scooping the food out of the kettle and hands it to each of the Manidoog that sit in the four directions around the earth. When the food is placed on the table shortly after, it is not necessary for someone to talk and send the food to the Manidoog. Once the oshkaabewis has finished dancing the song, he has already sent the food off to all those Manidoog where they sit.

It is not necessary at that time to pass out the food from that kettle that the oshkaabewis has danced around. I have been at other dances where the food from that kettle is passed out immediately, but we do not do that at our dances.

It is the oshkaabewis who sets the table and places the bowls of food on the table. It has always been only the men who put those bowls of food on the table, and it is the women who scoop the food out of the kettles into the bowls, which they in turn hand over to the oshkaabewis and any other male helpers that he may have to put the bowls on the table.

When Anishinaabe bring in bowls of food that they want to offer up to the Manidoog, it is the oshkaabewis that places a mat on the floor. On top of this mat he places the bowl of food along with the drink and anything else that they want to offer the Manidoog for additional support.

53

Mii dash owapii ani-niimi'indwaa ingiw ogichidaakweg. Mii
imaa ani-waakaashimowaad inow gimishoomisinaanin. Ishke
dash niwii-ni-dazhindaan enabiwaad ingiw ogichidaakweg.
Ishke onaabibiitawaawaan Manidoon ekwewinijin. Ishke dash
a'aw ogichidaakwe naagaanabiitawaajin inow ikwewan, mii
wiineta ayaad imaa wendabid. Ishke dash mii inow Manidoon
nayaabibiitawaajin a'aw Wenabozho iniw ogookomisan, mii
a'aw Gookomisakiinaan ezhi-wiinind.

Mii imaa wendabid a'aw Bebiskiniyaashiikwe. Ishke dash inow
odedeyibanen, Noodin gii-izhi-wiinaa a'aw akiwenziiyiban, mii
dash a'aw gaa-pawaanaad inow odaanisan
Bebiskiniyaashiikwen dakonaminid i'iw mitig megwaa
niiminid imaa wendabinid. Mii dash imaa gaa-
onjikaamagadinig ani-gigishimod i'iw mitig. Gaawiin
izhichigesiiwan inow oniigaani-ogichidaakwemiwaan
eyaawaajig inow Manidoo-dewe'iganan dibishkoo
genawendamaageyaang, mii dash imaa wiindamaageyaan
wenji-izhichigeyang dakonang i'iw mitig giniigaani-
ogichidaakweminaan.

Ishke dash gaa-ikidod a'aw akiwenziiyiban Mizhakwadoban,
ishwaachiwan inow Manidoon ekwewinijin
nayaabibiitawaawaajin ingiw ogichidaakweg. Mii inow
ayaanikebiitaagojin a'aw naagaanizid ogichidaakwe.
Niiwewaan imaa ayaawag ingiw ogichidaakweg wendabijig.
Ishke dash imaa neniizh wiidabindiwag imaa niiwin
ayaamagak wendabiwaad ingiw ikwewag. Mii dash ingiw
eshwaachijig nayaabibiitawaajig inow Manidoon ekwewinijin.

Ishke dash a'aw akiwenziiyiban gaa-ikidod, gaawiin igo gakina
ogii-gikenimaasiin ezhi-wiinjigaazonid inow Manidoon
nayaabibiitawaawaajin wendabiwaad ingiw ogichidaakweg.
Aanind dash ogii-gikenimaan. Ishke dash a'aw ogichidaakwe
naagaanabid imaa niiwewaan imaa gii-asindwaa, mii dash

It is then that the song is sung where the ogichidaakweg get up to dance around the drum. I want to talk about the order in which these ogichidaakwe sit. As they sit they represent female Manidoog. The ogichidaakwe that sits at the head of all the women sits alone and does not have a partner; she represents Wenabozho's grandmother. Wenabozho's grandmother is also known as *Gookomisakiinaan*.

That is where Linda Shabaiash sits. Linda's dad Joe Shabaiash had dreamt of his daughter carrying a special stick as she danced in her spot. That is why she carries a stick when she dances. The other head ogichidaakwe from other drums similar to ours do not have a stick that they carry. That is why I am explaining why our head woman carries a stick.

The old man Albert Churchill said that there are eight female Manidoog that the rest of the ogichidaakwe represent. They are the ones who sit after the head ogichidaakwe. There are four pairs of ogichidaakwe. The women sit two by two together to occupy four positions. These eight women represent eight female Manidoog.

The old man said that he did not know the names of all the female Manidoog that the ogichidaakweg represent. He did say that he knew the names of some of them. The first ogichidaakwe of those four sets represents the Manidoo known as *Giganaan*; some Anishinaabe know her as the moon.

inow Manidoon nayaabibiitawaajin Giganaan ezhi-wiinimind, naa gaye aanind Anishinaabe ezhi-wiinaad dibiki-giizisoon.

Miinawaa bezhig a'aw ogichidaakwe onaabibiitawaan inow Nabaanaaben, naa gaye aanind inow anangoon onaabibiitawaawaan. Naa gaye mii i'iw gaa-ikidod a'aw akiwenziiyiban, a'aw ogichidaakwe eshkwebid niiwewaan ayaawaad ingiw ogichidaakweg, mii inow Gaagige-oshkiniigikwen nayaabibiitawaajin.

Ishke ingiw ikwewag bebezhig onaabibiitawaawaan iniw Manidoon. Miinawaa iwidi ishkwe-ayi'ii ayaawag ingiw ikwewag gaa-ogichidaakwe-agiminjig i'iwapii gii-wawezhi'indwaa naa gaye aanind gii-pawaanaawag imaa da-dibendaagoziwaad imaa Manidoo-dewe'iganing. Mii dash gaye baandigadoojig ojiibaakwaaniwaa ingiw ogichidaakweg gakina. Mii i'iw ezhi-bazigwiiwaad i'iw akeyaa enabiwaad ingiw ogichidaakweg ani-waakaashimowaad ani-niimikamowaad i'iw onagamoniwaa.

Mii dash gaye iko omaa ani-aabajichigaadeg i'iw gijipizon-nagamon ezhi-wiinjigaadeg. Ishke bebezhig ingiw gimishoomisinaanig ogii-pi-wiijiindaanaawaa ogijipizoniwaa. Bezhig dash gii-onaabamaa ge-ganawendang i'iw gijipizon. Nebowa dash gii-wanichigaadewanoon iniw gijipizonan. Ayaawag isa wiin igo geyaabi eyaangig ogijipizoniwaa. Mii dash ingiw naamikangig i'iw nagamon. Aanind mii-go gakina ezhi-bazigwiiwaad imaa eyaajig niimikamowaad gaye wiinawaa i'iw gijipizon-nagamon. Gaawiin dash niinawind indizhichigesiimin. Mii eta-go eyaangig iniw gijipizonan naamikangig i'iw nagamon.

Gakina gaye ingiw bebezhig debendaagozijig odayaanaawaa nagamon bezigwiitamowaad, mii iw onagamoniwaa iniw

56

Another ogichidaakwe represents the Mermaid Manidoo, and some of the others represents the female stars. The old man also said that the last ogichidaakwe represents *Gaagige-oshkiniiigikwe.*

Each one of those eight women represents a Manidoo. There are also ogichidaakwe that sit in at the tail end of these eight ogichidakweg, they were also considered ogichidaakwe when they went through a grief ceremony and there are also some that dreamt about belonging to the drum. The ogichidaakwe are also the ones who bring in the cooking. They get up in the order they sit and dance to their song.

It is at this time that the feather belt song is used. Each one of these ceremonial drums came with their belts. One person was selected as the one who would take care of this belt. A lot of these belts were lost. But there are some who still have those belts in their possession. They are the ones who dance this song. At some dances everyone gets up to help dance this song. We do not do that at our dances. It is only those that have those belts that get up to dance when we have our ceremony.

Each one of the drum members has a song that they get up and dance to. It is the song that belongs to the Manidoo that they

Manidoon nayaabibitawaawaajin. Gakina ingiw ininiwag imaa debendaagozijig azhigwa gaa-ni-giizhiitaawaad ani-niimikamowaad onagamoniwaa, mii imaa weweni ani-doodamowaad i'iw onagamoniwaa baa-maada'ookiiwaad iniw meshkwadooniganan ani-diba'amowaad iniw onagamoniwaa.

Mii iko gaye aaningodinong eni-izhichigeng, mii imaa ani-gaagiigidowaad ingiw ininiwag azhigwa gaa-ni-giizhiitaawaad ani-niimikamowaad onagamoniwaa, mii dash imaa weweni nawaj ani-doodamowaad onagamoniwaa. Aaniish naa manidoowaadadoon iniw. Gaawiin debinaak izhichigesiiwag. Mii iko gaye gaa-inind azhigwa ani-niimikang onagamon debendaagozid, "Enigok niimin! Gida-minwaabamig a'aw Manidoo nayaabibiitawad. Mii imaa ge-ondinigeyan da-ni-naadamaagoowiziyan.

Weweni gaye gidaa-zazegaa' baazikaman imaa wenjida apii niimikaman i'iw ginagamon. Mii gaye da-minwaabamik a'aw Manidoo nayaabibiitawad. Mii gaye imaa waabanda'iweyan ezhi-apiitendaman imaa gii-asigooyan wendabiyan.

Ingoji gaye baa-naazikaageyan endazhi-niimi'idid a'aw Anishinaabe, ani-noondaman i'iw maajii'igaadeg i'iw ginagamon naamikaman, mii-go imaa ge-izhi-bazigwiiyamban da-niimiyamban. Mii-go imaa miinawaa waabanda'iweyan ezhi-apiitendaman imaa gii-asigooyan. Zhinawa'oojiganan wii-piizikaman azhigwa niimikaman i'iw ginagamon, geget gida-minwaabamig a'aw Manidoo nayaabibiitawad. Gida-giige'idiz naa-go gaye ingiw gidinawemaaganag imaa debinaak ezhichigesiwan."

Ishke dash gaye ingiw ogichidaakweg azhigwa ani-giizhiitaawaad ani-waakaashimowaad, mii-go gaye wiinawaa weweni diba'amowaad i'iw onagamoniwaa baa-

58

represent in their position. After each of the men dance their particular song they show their respect for that song and will pass out money to pay for their song that they had just danced.

What some of the men will do is that they will get up and talk after they had danced their song as a way for them to show additional respect to the song they had danced to. After all, those songs are sacred. They want to show their total respect. Drum members have always been told, "Dance as hard as you can when you dance your song. The Manidoo you represent will really enjoy seeing you dance hard to that song. It will also be a source of help for you.

You should dress nicely when it comes time to dance your song. That Manidoo will also enjoy seeing that you dressed nicely. By doing that you are also showing the respect and high regard you have for the position in which you have been seated.

Whenever you are out attending other dances and you hear your song being sung, you should get up and dance. Here again you are showing your appreciation for the position you were given. If you choose to wear bells when your dance your song, the Manidoo you represent will enjoy seeing you do that. You are helping yourself and your relatives by doing a thorough job in showing your respect for the spot you have been given."

When the ogichidaakweg finish dancing their song they too pay for their song by handing out cloth to visiting women and also those women who have come a distance.

maada'oonaawaad i'iw gidagiigin miinawaa
meshkwadooniganan inow ikwewan ba-mawadishiwenijin ba-
naazikaagenijin miinawaa waasa wenjiinijin.

Ishke a'aw debendaagozid ani-gagwaadagizid maagizhaa gaye
weweni ani-mamaajiisig, odaa-onaabamaan awiya ge-
naadamaagojin. Mii-go gaye imaa da-asaapan imaa da-
ondabinid wiikaa gegoo ani-izhiwebizid oniigaaniiming. Mii-go
ge-ni-doodawind dibishkoo a'aw onabi'ind awiya gakina ingiw
debendaagozijig miinawaa gakina eyaajig da-ni-maamiinind
gegoo maagizhaa gaye meshkwadooniganan waabooyaanan,
mii dash gaye weweni da-ni-ganoonind. Mii dash igo imaa da-
dibendang imaa wendabinid nayaadamawaajin gegoo ani-
izhiwebizinid.

If a drum member is having health problems where they may not be able to move well, they could select a helper. They will be seated in that same position if something were to happen to that drum member in the future. The person who is being placed there as a helper will be treated in the same manner as one who has been selected to fill a spot. All the drum members and those attending will give him or her items such as money or blankets, and also someone will speak to them. If something should happen to the one they are helping they will automatically have that position.

9 OKOSIJIGENG

Mii dash owapii okosijigeng ezhi-wiinjigaadeg. Mii imaa ningaabii'anong akeyaa ani-dazhwegisidood i'iw maamandoogwaason a'aw genawendamaaged inow gimishoomisinaanin miinawaa asemaa-onaagan imaa achigaadeg. Mii dash imaa atood i'iw obagijigan iniw waabooyaanan geshkigwaadegin miinawaa iniw odasemaan. Mii dash gaye owiidabimaaganan dibishkoo eni-izhichiged ani-atood gaye wiin iniw obagijiganan.

Mii dash gaye gakina ingiw debendaagozijig gaye wiinawaa iniw geshkigwaadegin waabooyaanan naa odasemaawaan bagijigewaad. Ani-giizhiitaawaad gakina eginzojig ani-bagijigewaad, mii dash imaa gakina ingiw gaa-pi-naazikaagejig iniw odasemaawaan asaawaad gaye wiinawaa naa-go gaye waabooyaanan geshkigwaadegin odatoonaawaan maagizhaa gaye meshkwadooniganan odasaawaan giishpin inendamowaad.

Mii dash iniw bimiwanaanan izhichigaadeg owapii. Mii imaa agimindwaa minik gaa-pi-dagoshingig inow dewe'iganan genawendamaagejig. Mii dash o'ow minik okosijiganan ezhichigaadegin. Azhigwa ani-giizhi-niibidesijigaadeg iniw bimiwanaanan, mii dash imaa agijayi'ii asemaa naa gaye meshkwadoonigan imaa achigaazod.

Mii dash a'aw opwaaganiiwinini ani-mooshkina'aad inow gimishoomisinaan odoopwaaganan. Azhigwa gaa-ni-mooshkina'aad, mii dash imaa ayizhinoo'waad iniw opwaaganan iniw Manidoon waakaabiitamonijin Manidoo odakiim. Mii iwidi nitam izhinoo'waad iwidi waabanong weweni doodawaad iniw Manidoon iwidi gaa-gikinawaadabi'injig, mii dash gaye iwidi zhaawanong

62

9 WHEN THE BUNDLE IS MADE

This is when the bundles or offerings are made. The drum keeper lays out a quilt on the west side of the drum and also the tobacco box is placed there. This is when he puts his offerings down, his quilts and also his tobacco. His partner also does that same and lays down his offerings such as his hand-sewn quilts and his tobacco.

Also all of the drum members put down their hand-sewn quilts and their tobacco as their offering. When all the drum members are done putting down their offerings, all the other people in attendance can put down their quilts or money and tobacco if they wish to make an offering.

That is when bundles are created from all the offerings. That is when a count is made of all the drum keepers who are in attendance. That is the number of bundles that are created. As soon as these bundles are created and placed in a row, money and tobacco is placed on each bundle.

From there the pipeman goes on to fill the drum's pipe. Once he has filled the pipe, he points the pipe in the directions that the Manidoog sit around the earth. The first one he points to is the Manidoo who was seated in the east. Then he goes on to point the pipe to the Manidoog that sit in the south. When he finishes he points the pipe to the west for those Manidoog to accept the tobacco. He then goes on to point the pipe in the

izhinoo'waad iniw opwaaganan ani-giizhiitaad, mii dash iwidi
ningaabii'anong izhinoo'waad iniw Manidoon gaye wiinawaa
da-odaapinigewaad, mii dash gaye iwidi giiwedinong
izhinoo'ond opwaagan gaye wiinawaa ingiw Manidoog eyaajig
da-odaapinaawaad iniw odanishinaabemiwaan
odasemaawaan. Mii dash owapii a'aw opwaaganiiwinini iwidi
waabanong enaasamigaabawid. Azhigwa gaa-kizhibaabinaad
inow opwaaganan, mii dash iwidi ishpiming izhinoo'waad iniw
opwaaganan, weweni doodawind a'aw Manidoo ishpiming
eyaad naa gaye gakina Manidoog ishpiming eyaajig. Azhigwa
ani-giizhiitaad, mii dash imaa dabazhish izhinoo'waad. Mii
dash imaa weweni doodawind Manidoo omaa akiing eyaad
miinawaa weweni doodawindwaa ingiw Manidoog
debaajinjigaazojig omaa akiing.

Mii dash i'iw ani-gizhibaawinaad iniw opwaaganan a'aw
opwaaganiiwinini, mii iw nitam imaa izhiwinind a'aw
opwaagan naagaanabid a'aw genawendamaaged iniw
gimishoomisinaanin zaka'igaazod a'aw opwaagan. Mii dash
a'aw gaye iniw owiidabimaaganan ininamawind iniw
opwaaganan. Mii dash imaa ani-maajiijigaazod a'aw opwaagan,
ininamawindwaa ingiw genawendamaagejig iniw Manidoo-
dewe'iganan gaa-pi-dagoshingig, weweni gaye wiinawaa da-
naabishkaagewaad.

Mii dash azhigwa ani-giizhiitaad opwaaganiiwinini, mii dash
imaa ininamawaad iniw opwaaganan inow debendaagozinijin
imaa gimishoomisinaaning. Gaa-ni-giizhiitaang, mii dash imaa
gakina gaa-pi-naazikaagejig ininamawindwaa iniw
opwaaganan. Giishpin gaa-chaagaakizosigwen a'aw opwaagan,
mii dash iwidi o-ininamawaad inow genawendamaagenijin
inow gimishoomisinaanin, mii dash a'aw ge-ziikaapwaad iniw
opwaaganan.

north where those Manidoog sit and they will accept the Anishinaabe's tobacco. It is at that time when the pipe has gone around to all the Manidoog, the pipeman stands facing the east and points the pipe up to the Manidoo up above and to all the Manidoog that exist above us. When he is done doing that, he points the pipe down to the earth and also offers it to the Manidoog that exist within the earth.

When the pipe is done going around to all the Manidoog, he takes the pipe to the head drum keeper first to light the pipe. He then takes the pipe to the drum keeper's partner. The pipe then is taken to all the visiting drum keepers who are there so they can accept the tobacco on behalf of the Manidoo they represent.

When the pipeman is done with that he goes on to offer the pipe to all the drum members. When he is finished with the drum members he then offers the pipe to everyone else in attendance. If there is still tobacco remaining in the pipe, he will return the pipe to the drum keeper who will smoke the remaining tobacco in the pipe.

Azhigwa dash gaa-ni-maadaabasod a'aw asemaa, mii dash a'aw
bezhig a'aw ogichidaa ezhi-niibawid imaa ani-gaagiigidod ani-
apagizondamawaad inow Manidoon odanishinaabemiwaan
inow odasemaawaan naa biinish obagijiganiwaan. Ishke dash
ingiw akiwenziiyibaneg, mii imaa gii-nanaandomaawaad iniw
Manidoon da-miinigoowizid a'aw Anishinaabe mino-ayaawin
miinawaa mino-mamaajiiwin. Ishke dash gaye mii imaa gii-
kaagiizomaawaad iniw Binesiwan weweni da-bimi-ayaanid
aaniindi-go a'aw Anishinaabe ani-oodetood da-ni-
nichiiwichigesinig.

Mii gaye imaa ani-apagizondamawindwaa ingiw Manidoog
iniw asemaan naa bagijigan ingiw Manidoog gaa-pi-
wiindamaagejig da-ni-mikwenimindwaa ani-asemaaked a'aw
Anishinaabe, mii owapii ani-dazhinjigaazowaad. Ishke i'iw chi-
zaaga'igan i'iw Misi-zaaga'iganiing ezhi-wiinjigaadeg, Manidoo
ayaa imaa zaaga'iganiing gaa-pi-wiindamaaged da-ni-
mikwenimind asemaakenid inow Anishinaaben wii-
naadamaaged gaye wiin. Biinish gaye iwidi Minisinaakwaang
iwidi chi-waabashkikiing, Manidoo gaye wiin iwidi ayaa, mii
a'aw gaa-pi-wiindamaaged da-mikwenimind wii-naadamaaged
gaye wiin.

Ishke ingiw akiwenziiyibaneg gii-ni-dazhimaawaad iniw
asemaan, mii imaa gii-nanaandongewaad bakaan iwidi ingoji
da-izhaamagak wayaabandanziwang, i'iw aakoziwin ezhi-
wiinjigaadeg. Eshkam gaye noongom ingiw eni-gaagiigidojig,
mii imaa ani-nanaandomaawaad inow Manidoon da-
naadamaagenid agana-go da-ni-onzaamiikanzig a'aw
Anishinaabe i'iw minikwewin naa anooj ayaabajitood i'iw
wenda-noomage-apaginigod a'aw bemaadizid. Naa gaye mii
imaa da-nandodamaagewaad da-bi-azhegiiwemagak gaa-izhi-
miinigoowiziyang anishinaabewiyang da-inweyang. Mii dash
imaa anooj nendodamaageng wenaajiwang da-miinigoowizid
a'aw Anishinaabe da-ni-maminosed.

Now that the tobacco has gone out, one of the ogichidaag will get up and talk to send the Anishinaabe's tobacco and their offerings to the Manidoog. When the old men talked at this time they asked the Manidoog to give the Anishinaabe good health and good movement. They also asked the Thunder-beings to go over in a good way wherever Anishinaabe live, so that there not be storms.

The tobacco and offerings are sent to the Manidoog that have asked to be remembered when Anishinaabe offered their tobacco. Those Manidoog were talked about at this time. There is a Manidoo in Mille Lacs Lake that asked to be remembered when Anishinaabe offer their tobacco, and that he too will help the Anishinaabe. There is also a Manidoo in the swamp by East Lake. He too asked to be remembered when Anishinaabe offered their tobacco, that he too will help.

When those old men talked, they would ask that the sicknesses that we cannot see go elsewhere. Nowadays more and more frequently the speakers are asking that the Anishinaabe leave the drugs and alcohol alone, especially the hard drugs. They are also asking that our language come back to the people. This is when the various good things are asked to be given to the Anishinaabe so that they are able to live a good life.

Ishke dash endaso-zaagibagaag miinawaa endaso-dagwaagig ani-aabajichigaazowaad ingiw Manidoo-dewe'iganag, nebowa iwidi Anishinaabe inow odasemaan miinawaa wiisiniwin naago gaye obagijiganan ani-asigisininig iwidi enabiwaad ingiw Manidoog. Ishke dash mii omaa wenjikaamagadinig a'aw Anishinaabe ani-naadamaagoowizid omaa ishkoniganing.

Azhigwa gaa-ni-giizhiitaad gaa-ni-gaagiigidod, mii dash imaa ani-maada'oonindwaa inow Manidoo-dewe'iganan genawendamaagejig gaa-pi-dagoshingig. Mii dash imaa ani-bazigwiiwaad ani-miigwechiwitaagoziwaad, miinawaa ani-maada'oonaawaad iniw gaye wiinawaa nayaadamaagowaajin miinawaa nayaabibiitawaajig gaye wiinawaa iniw Manidoon imaa Manidoo-dewe'iganan genawendamaagewaajin. Mii dash imaa ani-naabishkaagewaad, mii-go iwidi weweni ani-dagoshimoonagak i'iw bagijigan.

Aanind iko gaye odani-maajiidoonaawaa i'iw bimiwanaan, mii dash iwidi bijiinag niimi'idiikewaad, mii dash imaa ani-maada'oonaawaad inow debendaagozinijin imaa gimishoomisinaanin genawendamaagewaajin. Mii dash weweni iniw bagijiganan ani-dagoshimoonagak enabiwaad ingiw Manidoog.

Mii dash imaa waa-ni-dazhindamaan ani-bagijiged a'aw Anishinaabe. Ishke gaawiin debinaak odaa-doodawaasiin iniw Manidoon ani-atood imaa gegoo ani-okosijigeng imaa niimi'idiiked a'aw Anishinaabe. Ishke weweni ani-doodawaad inow Manidoon a'aw Anishinaabe, mii-go gaye wiinawaa aazhita weweni da-doodaagod. Ishke a'aw Anishinaabe odaawiikwajitoon maamandoogwaasonan da-atood imaa okosijigeng.

Ishke minochige a'aw Anishinaabe i'iw maamandoogwaason atood imaa okosijigeng. Ishke maa minik igo imaa

As the ceremonial drums are used every spring and every fall, a lot of the Anishinaabe's tobacco, food, and offerings collect where the Manidoog sit. This is a source of help for the Anishinaabe on the reservation.

When the speaker is done talking, the bundles are passed out to the visiting drum keepers. That is when they will get up and give a talk to give thanks for the bundle they received. They will also pass out items of the bundle to his or her drum members who will accept the items on behalf of the Manidoo they represent on that particular drum. When they accept these items they then in turn go to the Manidoog whom they represent.

There are some who take the bundles with them, and when they have their dance that is when they pass the bundle out to their drum members. That is when the offering of the bundle arrives where the Manidoog sit.

I want to talk about the Anishinaabe's offerings. The Anishinaabe should not throw any old thing into the bundles at these dances; they need to treat the Manidoog with respect. When the Anishinaabe put their total effort into what they are giving the Manidoog, the Manidoog in return will put all their effort in helping the Anishinaabe. Anishinaabe should really try to put hand-sewn quilts into the bundles.

The Anishinaabe are really doing a good job by putting a hand-sewn quilt into the bundle. The person who sewed that quilt

nanaamadabi a'aw geshkigwaasod. Ishke dash anooj da-gii-
paa-izhichigepan a'aw Anishinaabe, mii dash imaa awashime
inendang a'aw Anishinaabe wii-nanaamadabid imaa ani-
gashkigwaadang waa-atamawaad inow Manidoon. Mii i'iw
debagindamowaad ani-waabandamawaawaad inow
odanishinaabemiwaan, akawe imaa ani-noogitaawaad weweni
ani-doodawaawaad iniw Manidoon, debinaak ani-
doodawaasigwaa. Mii imaa wenjikaamagak naadamaagoowizid
a'aw Anishinaabe weweni doodawaad inow Manidoon. Nawaj
ani-apiitendaagwadini iniw maamandoogwaasonan atood apii
dash adaawed awiya i'iw waabooyaan.

Mii-go gaye meshkwadoonigan da-achigaazopan imaa
okosijigeng. Ishke iko ingiw akiwenziiyibaneg nigii-
noondawaag ani-dazhimaawaad inow meshkwadooniganan
ani-aabaji'aad a'aw Anishinaabe ani-bagijiged. Ishke dash gaa-
ikidowaad, gaawiin gidaa-gashkitoosiimin gegoo da-ni-
izhichigeyang ayaawaasiwang a'aw meshkwadoonigan. Ishke
dash imaa minochige a'aw Anishinaabe awashime imaa wii-
ininamawaad iniw meshkwadooniganan iniw Manidoon da-gii-
aabaji'aapan wiin. Mii imaa ge-ondiniged a'aw Anishinaabe da-
zhawenimigod inow Manidoon.

put a lot of time into making that quilt. They could have been out doing all sorts of other things, but instead they decided to take the time to sit and sew a quilt they will offer to the Manidoog. The Manidoog will measure your commitment to our ways by watching the time and effort you put into what you give them, by stopping whatever else you have going on in your life to make a good offering to the Manidoog and not just putting down whatever you find lying around. The Manidoog are the Anishinaabe's source of help. Treat them with respect and put down a hand-sewn quilt versus one that someone bought.

Money can also be put into the bundle. What I have heard the old men say is that there is nothing that we are able to do without the use of money. There are Anishinaabe who are willing to sacrifice their dollars and offer them up to the Manidoog, when they themselves could have used the money. That too is a source of help for the Anishinaabe to get help from the Manidoog.

10 ISHKWAAJANOKII-GIIZHIGAK ONAAGOSHI-ASHANGENG

Mii-go gaabige ani-giizhiitaang okosijigeng, mii-go imaa ani-ozhiitaang ani-ashangeng. Ishke gaawiin giiwesiiwag ingiw ikwewag da-jiibaakwewaad. Gayat imaa ogii-pi-biindiganaawaan inow odakikowaan. Azhigwa dash gaa-kiizisijigaadeg i'iw wiisiniwin, gaawiin memwech ani-gaagiigidosiin awiya da-ni-apagizondang i'iw wiisiniwin. Aaniish naa a'aw oshkaabewis ogii-ni-giizhiikaan owapii gii-agwaa'izekweshimod.

Mii imaa ani-nandodamaageng ingiw biiwideg waasa wenjiijig wiinitamawaa da-wiisiniwaad, ani-doodaagooyang iko ani-naazikaageyang bakaan ingoji endazhi-niimi'idiiked a'aw Anishinaabe. Miinawaa ingiw gechi-aya'aawijig wewiib da-ashamaawag gaye wiinawaa.

Mii iko omaa a'aw oshkaabewis baa-nandomaad inow nitam ge-wiisininijin, inow waasa wenjiinijin, naa gechi-aya'aawinijin da-wiisiniwaad wiinitamawaa. Aaningodinong baa-naazikaageyaan endazhi-niimi'idiiked a'aw Anishinaabe, azhigwa dagoshinaan imaa adoopowining wii-wiisiniyaan, mii i'iw gaabige imaa gii-apagizod a'aw abinoojiinh ani-makamid i'iw apabiwin da-gii-wawenabiyaambaan. Gaawiin niwii-ayaanziin i'iw akeyaa da-ni-izhiwebak omaa.

Maagizhaa aanind gaawiin oda-minwendanziin da-ni-waabandang eni-ozhibii'igeyaan, ishke nebowa ayaamagad i'iw wiisiniwin maajid a'aw Anishinaabe wenjikaamagadinig anooj iniw inaapined, ziinzibaakwadowaapined, ishpiming izhaamagadinig omiskwiim, naa ode'ing naa anooj inaapined, naa biinish iko niboowised.

10 SATURDAY EVENING MEAL

As soon as all the bundles are done, that is when preparations are made for the evening meal. Our ogichidaakwe do not go home to cook at that time. They had brought their cooking in earlier in the day. Once the food has been placed on the table, it is not necessary to talk and send the food out to those Manidoog. The oshkaabewis took care of that when he danced around the kettle.

It is at this time that everyone is reminded that those who come from a distance should eat first, similar what is done to us when we go to a dance somewhere. Also they are told that the elders should be fed first.

The oshkaabewis usually goes around and invites those who have come a distance to eat first along with any elders; they should be the first to eat. Sometimes when I go to other dances as soon as I get to the table to eat a young child will jump ahead of me and steal the chair that I could have sat on. I do not want that to happen here when we have our dances.

Some people may not like to see what I am writing here, but there are a lot of foods that are harmful to the Anishinaabe and are causing different illnesses such as diabetes, high blood pressure, heart trouble and even strokes.

Aano-go a'aw Anishinaabe ezhi-zaagi'aad inow zaasakokwaani-
bakwezhiganan, mii iw bezhig i'iw miijim ge-
naniizaanenimaapan nebowa da-amwaasig. Gaawiin inow
zaasakokwaanan ingii-miinigosiinaanig ingiw Manidoog da-
inanjigeyang. Mii eta-go wenji-ayaad noongom a'aw
zaasakokwaan maa minik igo imaa gigii-kaagwiinawi-
ondinigemin ge-miijiyang. Mii a'aw wayaabishkiiwed gaa-
miinaad inow Anishinaaben inow bibine-bakwezhiganan
azhigwa imaa ishkoniganing gii-izhi-gaanjwebinaad da-
danakiinid. Mii dash imaa wenjikaamagadinig nesigojin a'aw
Anishinaabe noongom.

Mii-go gaye ezhi-naniizaanendaagoziwaad ingiw
napodinensag, aano-go ezhi-minwenimaad a'aw Anishinaabe
inow napodinensan. Mii dash imaa ani-ayaangwaamimagwaa
ingiw jaabaakwejig da-gashkitoowaad da-biindigadoowaad
wenjida ge-minokaagod a'aw Anishinaabe da-ni-miijid,
wenjida ingiw Manidoog gaa-miinaawaad inow
odanishinaabemiwaan da-inanjigenid i'iw wiiyaas
wenjikaamagak ingiw awesiinyag bagwaj eyaajig, miinawaa
a'aw giigoonh, mii-go gaye manoomin, naa i'iw bagwaj editeg
mayaajiiging. Mii a'aw Gete-anishinaabe gaa-inanjiged, ishke
dash ginwenzh gii-ni-bimaadiziwag.

Even though the Anishinaabe really love their fry bread, that is one food that we should be aware of and not eat a lot of. The Manidoog did not give us fry bread to eat. The reason we have fry bread today is because for a long time we had nothing else to eat. The white man gave us flour in our rations when we were forced onto reservations to live. That is where the Anishinaabe got those things that are killing them today.

We also need to be aware of macaroni even though that is another Anishinaabe favorite. It is here that I am encouraging those that are cooking to try to bring in healthy foods that will benefit the Anishinaabe when they eat it, especially the foods that we were given to eat by the Manidoog such as the meats that come from the animals in the wild, the fish, wild rice, and those foods that grow in the wild. That is what our ancestors ate, and as a result a lot of them lived a long time.

11 IKWE-NIIMI'IDING

Gomaapii dash gaa-ishkwaa-wiisining, mii dash imaa da-ikwe-niimi'iding. Akawe dash ingiw ogichidaakweg da-niimiwag, mii imaa niiwin iniw waakaashimoo-nagamonan ani-aabajichigaadeg. Ishke dash azhigwa aabiding gaa-kizhibaashimowaad inow gimishoomisinaanin ingiw ogichidaakweg, mii dash ingiw ikwewag da-naadamawaawaapan da-gizhibaashimowaad gaye wiinawaa. Mii gaye imaa da-ni-zhaabowewaapan gakina ingiw ikwewag megwaa imaa niimikamowaad niiwin nagamonan naa gaye ani-apiichitaang ikwe-niimi'iding. Ani-giizhiitaawaad ingiw ogichidaakweg ani-waakaashimowaad, mii dash imaa ani-baa-waawiizhaangewaad maagizhaa i'iw waabooyaan i'iw maamandoogwaason omiinaawaan ge-ni-wiijishimotawaawaajin.

Azhigwa miinawaa ani-maajii'igaadeg i'iw ikwe-nagamon, mii imaa aazhita da-miinaawaad maamandoogwaason gayat gaa-pi-wiizhaaminjig azhe-diba'amawaawaad gaa-pi-wiizhaamigowaajin. Ishke ayaanzig i'iw maamandoogwaason, meshkwadooniganan aazhita odaa-miinaan gaa-pi-wiizhaamigojin, midaaswaabik maagizhaa gaye niishtana daswaabik iko ani-maamiigiwe a'aw Anishinaabe ani-diba'ang i'iw waabooyaan gaa-pi-miinind apii gii-pi-wiizhaamind.

Mii imaa ani-ayaangwaamitaagoziyaan gego anooj imaa odaa-ni-biindigadoosiin ge-ni-aabajitood a'aw Anishinaabe ani-wiizhaanged. Aabiding gii-izhaayaan endazhi-niimi'iding i'iw onaagaans nwaakaamagak ingii-miinigoo wiizhaamigooyaan. Mii i'iw endazhindamaan, gaawiin ingwadinoo i'iw manoomin, zhiiwaagimizigan, naa i'iw manidoominensikaan wii-miigiwed awiya.

76

11 SIDESTEP DANCE

After the evening meal is when we have the ladies' dance or sidestep dancing. Before we start, there are four special songs that the ogichidaakweg will dance. Once the ogichidaakweg have made a complete circle dancing around the drum, the other ladies in attendance are able to join in and could also help finish dancing those four special songs. All the ladies can do their backup singing as they dance those four songs and continue it throughout the evening of sidestep dancing. When the ladies finish dancing those four special songs, then the sidestep dancing starts where those that are going to dance go out and give a hand sewn quilt to the person that they plan to dance with.

When the next sidestep song is sung, the ones who had been invited to dance the previous song will in return give a quilt back in repayment for the quilt they had been given in the previous dance. If the person does not have a quilt to give back, in return the person can give money; ten or twenty dollars is usually given in the payment for the quilt they had been given during a sidestep song.

This is where I want to stress to those who plan to do the sidestepping to not bring miscellaneous items to give out during the sidestepping. Once when I was attending a dance I was given a plastic cup to dance with the person. That is what I am talking about when I say miscellaneous items; it is okay to bring wild rice, maple syrup, and beadwork to give out during the dance.

Ishke i'iw gidagiigin ani-aabajichigaadeg, mii ingiw mindimooyenyibaneg gaa-ikidowaad, booch i'iw nisonik da-akwaamagadini i'iw gidagiigin ge-miigiwengiban wiizhaanged awiya. Ishke dash ingiw mindimooyenyibaneg gaa-ikidowaad de-minik imaa da-ayaamagadini i'iw gidagiigin da-waabooyaanikepan awiya. Ishke dash ingiw mindimooyenyibaneg gaa-ikidowaad, nawaj i'iw agaasaamagak i'iw gidagiigin maagiweng imaa, gaawiin gegoo da-inaabadasinoon. Mii gaye gaa-ikidong, gaawiin a'aw inini daa-miinaasiin gidagiigin da-wiizhaamind. Nibi-waabandaan ishkweyaang ingiw ininiwag, gaawiin ogii-odaapinanziinaawaa i'iw gidagiigin aana-wii-maamiinindwaa ani-wiizhaamindwaa.

Mewinzha iko ingiw Anishinaabeg, mii imaa gii-miigiwewaad inow bebezhigooganzhiin megwaa ikwe-niimi'iding imaa ani-aabajichigaazod a'aw gimishoomisinaan. Ogii-aabajitoonaawaa mitigoons gii-wiizhaamaawaad inow waa-miinaawaajin inow bebezhigooganzhiin. Mii dash iw ani-miinigoowizid awiya i'iw mitigoons, mii imaa ani-wiindamaagoowizid ani-wiizhaamind wii-miinind inow bebezhigooganzhiin.

Ishke dash a'aw mindimooyenyiban gaa-nitaawigi'id, mii-go apane gii-asigisidood i'iw manidoominensikaan gaa-kashkigwaadang. Mii dash i'iw wenjida gaa-kashkigwaanaajin iniw gashkibidaaganan ezhi-wiinjigaazonijin. Mii dash gaa-ikidod, "Aaniin gaye ba-wiizhaamigooyaang bebezhigooganzhii da-miinigoowiziyaang, mii iniw ge-ni-aabajitooyaangin da-azhe-wiizhaangeyaang owapii gii-wiindamaagoowiziyaang a'aw bebezhigooganzhii wii-miinigoowiziyaang imaa ikwe-niimi'iding. Mii imaa maa minik i'iw manidoominensikaan gii-asigisidooyaang weweni da-de-diba'igeyaang giishpin a'aw bebezhigooganzhii miinigooyaang."

Ishke dash imaa ikwe-niimi'iding azhigwa gaa-ishkwaa'amaazong i'iw ikwe-nagamon, mii dash imaa

If cloth is going to be used during the sidestep dancing, the old ladies said it must be at least three yards long. Those old ladies said that three yards of cloth is the right amount of cloth for someone to make a quilt. The old ladies said that if the cloth were shorter than that, the cloth would be worthless to them. They also said that a man should not be given cloth during the sidestep dancing. I have seen in the past where men would refuse to accept cloth that someone was trying to give them to invite them to dance a sidestep.

A long time ago the Anishinaabe used to give horses away during the sidestep dancing at our ceremonial dances. They used a small stick when they wanted to give someone a horse during the sidestep song. When someone was given a stick they were being told that they would be given a horse for that song.

That old lady who raised me always had her collection of beadwork that she had made. She used to sew bandolier bags especially for this purpose. She used to say, "What if we are asked to dance a sidestep and someone wants to give us a horse, we can use these bandolier bags at that time when someone wants to give us a horse. That way we would have enough beadwork together to efficiently repay someone if we are given a horse."

Sometimes during the dance the sidestep song would end while those who wanted to dance are too late to get in the

niibawiwaad ingiw gaa-ishkweyaangejig ani-baabiitoowaad
da-maajii'igaadeg i'iw ikwe-nagamon miinawaa. Mii dash
azhigwa ingiw Anishinaabeg eyaajig ezhi-biibaagiwaad,
"BWAANAG! BWAANAG!", wawiyazh imaa izhi-wiinindwaa
ingiw gaa-ishkweyaangejig, mii dash ezhi-baapiwaad ingiw
Anishinaabeg eyaajig.

Ishke dash a'aw nizigosiban Amikogaabawiikweban nigii-
wiindamaag, mii imaa gii-ni-aabajichigaadeg bizhikiiwi-
nagamon. Ishke dash ingiw niimi'iwewininiwag gaa-
maajii'amowaad i'iw nagamon, mii dash ingiw gaa-
ishkweyaangejig gii-niimiwaad. Ishke mii imaa bizhiking gii-
izhitaawaad megwaa imaa niimiwaad dibishkoo-go imaa niizh
ingiw bizhikiwag niimiwaad mawine'ondiwaad iniw
oninjiiwaan odaabajitoonaawaa waabanda'iwewaad a'aw
bizhiki odeshkanaad.

circle to dance and are standing there waiting for the next sidestep song to start. That is when everyone there will yell out "BWAANAG! BWAANAG!", teasing those who are late, and then everyone gets a good laugh.

My aunt Julie Shingobe told me that when someone was late for a song like that the singers would use a song known as a buffalo song. Once the singers started the song, those who were late would dance. That is when they would dance like a buffalo and use their hands to form horns and charge after each other as if they were buffalo fighting.

12 ASHAMINDWAA GAA-PI-NAAZIKAAGEJIG DABWAA-NI-GIIWEBIZOWAAD

Mii dash imaa megwaa niimi'iding ani-dibikak, mii imaa ashamindwaa gaa-pi-naazikaagejig imaa niimi'iding. Gaawiin memwech ojiibaakwaaniwaa ingiw ikwewag odatoosiinaawaa. Mii i'iw anooj ani-maamiijid awiya ani-maamiganjiged, mii i'iw eshangeng owapii. Maagizhaa bakwezhigan ziindaakosijigaadeg i'iw wiiyaas, waashkobang, bakwezhigaansag, editegin, mii i'iw eshangeng, naa gaye menwaagamig echigaadeg da-minikweng.

Mii dash omaa apii ani-bazigwiing ani-miigwechiwi'indwaa gaa-pi-dagoshingig gaa-pi-naazikaagejig omaa naa gagwedweng isa weweni igo da-ni-dagoshinowaad endaawaad. Mii gaye owapii ani-wiindamaaged iwapii ge-ni-aabajichigaazod a'aw gimishoomisinaan miinawaa.

Mii dash igo geyaabi ani-niimi'iding ani-giizhi-wiisiniwaad. Mii dash gomaapii a'aw bezhig a'aw abiigizigewinini ezhi-wiindang aaniin minik geyaabi nagamonan ge-ni-aabajichigaadeg da-giizhi-niimi'idiwaad dash. Mii dash imaa ani-aabajichigaadeg i'iw ishkwaataa-nagamon. Mii dash ani-giizhiitaang.

12 FEEDING THOSE WHO ARE ATTENDING BEFORE THEY LEAVE TO GO HOME

Sometime during the night at the dance everyone is fed again. It is not necessary for the women to put out cooked food during this time. It is usually snack food that is served at that time. It is usually sandwiches, sweets, cookies, and berries that are served and also soda to drink.

At this time someone will get up to talk to thank everyone for coming to the dance and the Manidoog are asked to watch over everybody and that they have a safe journey home. It is also during this time that we let the people know when our next dance will be.

When they are done eating the dance will continue. At some point one of the drum warmers will designate how many songs will be used until the dance is over. This is when the ending song is used and then the dance is over.

13 ONABI'IND AWIYA

Mii dash omaa wii-ni-dazhindamaan onabi'ind awiya da-aginzod imaa Manidoo-dewe'iganing. Azhigwa gaa-ishkwaa-ayaad awiya gaa-tibendaagozid imaa dewe'iganing, ingoji-go maagizhaa ingo-biboon baabii'om bijiinag onaabamind isa imaa da-wawenabi'ind imaa bizhishigwaamagak imaa gaa-ondabid a'aw gaa-ishkwaa-ayaad. Gaawiin ginwenzh da-bizhishigwaamagasinoon gaa-ondabid awiya. Booch igo imaa wewiib da-wii-achigaazo awiya ge-ni-bazigwiitang i'iw nagamon imaa eyaamagak. Booch da-niimikigaadeg, weweni da-doodawind a'aw Manidoo nayaabibiitawind imaa.

Ishke dash mii imaa ani-maamawichigewaad ingiw debendaagozijig onaabamaawaad miinawaa inaakodamowaad imaa waa-asind bizhishigwaamagak gaa-ondabid a'aw gaa-ishkwaa-ayaad. Gaawiin gaye i'iw memwech besho gaa-inawemaajin a'aw gaa-ishkwaa-ayaad da-onaabamaasiin. Mii-ko imaa esind a'aw Anishinaabe mino-bimaadizid ani-mino-doodawaad iniw owiiji-bimaadiziiman, biinish gaye gaa-pi-waabanda'iwed i'iw ishkweyaang izhi-ayaangwaamitood miinawaa ezhi-apiitendang i'iw niimi'idiiked a'aw Anishinaabe.

Mii dash ezhichigeng, maagizhaa gaye bezhig a'aw ogimaa o-zaginikenaad iniw waa-onabi'iminjin da-dibendaagozinid imaa dewe'iganing. Giishpin dash ikwewid a'aw waa-asind imaa bizhishigwaamagak, mii a'aw ani-aabaji'indwaa ogichidaakweg. Mii dash a'aw ogichidaakwe naagaanabiitawaajin iniw ikwewan gemaa gaye a'aw ogichidaakwe iko gaa-wiidabimaajin inow gaa-ishkwaa-ayaanijin, mii a'aw bezhig ge-o-zaginikenaad inow ikwewan da-onabi'aad da-ogichidaakwewinid imaa gaa-ondabid a'aw gaa-ishkwaa-ayaad.

13 WHEN SOMEONE IS SEATED ON THE DRUM

This is where I am going to talk about when someone is seated to belong on a ceremonial drum. When someone has passed on who belonged on the drum, we usually wait around a year before someone is selected to be seated in the vacant position where the person who has passed on had been seated. A position should not stay vacant for long. Someone has to be placed in that spot soon as possible so that someone is available to dance the song that goes with that position. Someone has to be available to dance that song to treat the Manidoo in that position respectfully.

Ideally all the drum members will agree and select someone to fill the position left vacant by the person who passed on. It is not necessarily a close relative to the deceased that is selected to fill that position. Usually the person who is selected for this position is one who is kind-hearted and treats his fellow Anishinaabe with respect, and also in his past has shown his dedication and respect by his active participation in the ceremonial dances.

What happens is either one of the drum keepers will go over and take the person who will be seated by the arm. If it is a woman who will be seated, this is where the ogichidaakweg are used. The head ogichidaakwe or the ogichidaakwe that sat with the deceased, goes over and grabs the woman who will be seated in the vacant spot by the arm.

Ishke dash azhigwa gaa-ani-zaginikenaad iniw waa-
onabi'iminjin, mii imaa akawe aabiding imaa ani-
gizhibaawosewaad iniw gimishoomisinaanin, mii dash bijiinag
iwidi onabi'ind waa-ondabid da-aginzod imaa dewe'iganing.
Mii dash gakina debendaagozijig ani-maamiinaawaad,
maagizhaa gaye waabooyaanan gemaa gaye
meshkwadooniganan wenabi'ind. Mii-go gaye gakina gaa-pi-
naazikaagejig endazhi-niimi'iding izhi-maamiinaawaad gegoo
gaa-oshki-onabi'iminjin. Mii dash owapii ani-bazigwiid a'aw
bezhig ogichidaa ani-ganoonind a'aw gaa-onabi'ind. Ishke dash
imaa enind, "Mii imaa da-ni-ayaangwaamitooyan weweni da-
ni-bimiwidooyan imaa wendabi'igooyan. Ishke gidaa-wii-
mikwendaan Manidoo ginaabibiitawaa imaa gii-asigooyan, mii
dash i'iw ge-onji-ayaangwaamitooyan imaa wendabiyan. Ishke
gaye gaa-onji-onaabamigooyan, gigii-waabamigoo izhi-mino-
bimiwidooyan i'iw gibimaadiziwin, naa miinawaa weweni eni-
doodawad giwiiji-bimaadiziim. Ishke mii iw ge-ni-izhichigeyan
weweni gidaa-ni-doodawaag ingiw debendaagozijig imaa
dewe'iganing. Ishke imaa wendabiyan ginaabibiitawaa a'aw
Manidoo, mii-go gaye gakina ingiw waadabimajig eginzojig
onaabibiitawaawaan iniw Manidoon gaye wiinawaa. Ishke ani-
maji-inadwaa waadabimajig imaa eginzojig imaa dewe'iganing,
mii inow meji-inimajin iniw Manidoon nayaabibiitawaawaajin.
Ishke gidaa-wii-wawiingezimin da-ni-bimiwinang a'aw
gimishoomisinaan, maamawichigewin imaa da-ayaamagak,
aaniin igo apii niimi'idiikeyang. Ishke gidaa-ni-giige'aanaanig
ingiw giniijaanisinaanig, goozhishenyinaanig miinawaa
enendaagoziyang ani-aanikoobijigeyang da-ni-aabiji-ayaanid
inow gimishoomisinaanin da-ni-apenimod a'aw Anishinaabe
oniigaaniiming. Ishke booch i'iw maamawichigewin imaa da-
ayaamagak ani-bimiwinang a'aw gimishoomisinaan."

Ishke ingiw akiwenziiyibaneg gaa-ikidowaad, ani-
gashki'ewizisig a'aw Anishinaabe ani-bimiwinaad inow
gimishoomisinaanin, mii iw iwidi waabanong da-ni-

Once they go over and grab the one they want to seat at the drum, they will walk that person around the drum once and take them to the position they will fill and seat them there. Then all the drum members will gift that person who is being seated with blankets or money. Then everyone who is in attendance at the dance gifts the individual with a blanket or money. It is at that time that one of the ogichidaa gets up to talk to the newly selected seated drum member. At this time the new drum member is told, "It is important to take special care of the spot where you have been seated. You will want to remember that you represent a Manidoo in the spot where you have been seated, that is why it is important for you to take special care of your position. You were selected because others saw something good in the way you carry on your life and how you treat others respectfully. What you want to do is treat your fellow drum members respectfully. You represent a Manidoo in the position where you are seated, just like the other drum members who also represent Manidoog in their positions. When you talk bad about the drum members that you sit with on the drum, it is the Manidoog that they represent that you are talking bad about. We have to take care of the drum as efficiently as possible, we have to work together whenever we have our dances. It is our children, our grandchildren, and our great-grandchildren who will benefit from our drum always being here in the future. We have to work together in taking care of this ceremonial drum."

Those old men said that if the Anishinaabe were not able to carry on with these drums, the drums will be taken toward the east and given away, they can never come back this way again.

izhiwijigaazod a'aw gimishoomisinaan da-ni-miigiweng,
gaawiin dash daa-bi-azhegiiwesiin. Mii iw ge-ni-
mikwendamang da-ni-ayaangwaamiziyang da-ni-
wawiingeziyang da-ni-bimiwinang a'aw Manidoo-dewe'igan.

Mii dash gaye imaa ani-dazhinjigaazod gaa-ondabid a'aw gaa-
ishkwaa-ayaad, mii imaa ani-wiindamawind imaa esind, "Geget
gii-wawiingezi a'aw gaa-ishkwaa-ayaad gii-ni-bimiwidood
imaa gaa-ondabid, miinawaa gaawiin wiikaa gii-panizisiin gii-
ni-aayaabajichigaazonid inow gimishoomisinaanin. Mii gaye
giin ge-ni-wiikwajitooyan da-ni-izhichigeyan. Ishke imaa ani-
wawiingeziyan ani-naabibiitawad a'aw Manidoo imaa
wendabiyan, gida-ni-giige'idiz biinish da-ni-giige'adwaa
giniijaanisag miinawaa goozhishenyag."

Awanjish awiya gaa-onabi'ind gii-asind imaa da-dibendaagozid
imaa gimishoomisinaanin, gaawiin daa-ikwabi'aasiin. Ishke
awanjish gaa-onabi'ind awiya, mii imaa naabibiitawaad iniw
Manidoon. Ishke ikwabi'ind awiya imaa wendabid, mii imaa
dibishkoo ani-ikwabi'imind ani-maazhi-doodawimind inow
Manidoon nayaabibiitawaajin.

Mii omaa wii-ni-wiindamaageyaan a'aw akiwenziiyiban gaa-
kanawenimaad inow gimishoomisinaanin naa gaye inow
owiij'ayaawaaganan gaa-inaajimotawiwaad. Giishpin awiya
wii-ikwabi'idizod omaa gii-onabi'ind imaa dewe'iganing da-
dibendaagozid, geget daa-chi-diba'ige. Mii i'iw ekoozid minik
i'iw bagijiganan ge-atood naa gaye ge-ininamawaad inow
Manidoon owapii wii-ikwabi'idizod.

Ishke dash gii-ikidowag a'aw akiwenziiyiban naa gaye a'aw
mindimooyenyiban, gaawiin wiikaa gii-pi-waabanjigesiiwag
miinawaa gaawiin gaye ogii-pi-noondanziinaawaa i'iw wiikaa
da-izhichiged a'aw Anishinaabe da-ikwabi'idizod imaa
dibendaagozid imaa Manidoo-dewe'iganing. Mii imaa

This is what we have to remember as we work to the best of our ability in taking care of this drum.

As the speaker talks to the newly seated drum member he talks about the person who has sat there previously, "He did a really good job at holding that position and was always present when the drum was being used. This is what you should work toward doing in your position. If you do a good job in filling that position representing that Manidoo in that spot, you will be benefiting yourself, your children, and your grandchildren."

Once someone has been seated on a ceremonial drum he cannot be removed. Once someone is seated they represent a Manidoo. If someone were to be removed from their position it is just like you are removing that Manidoo and being disrespectful to that Manidoo who the person seated there represents.

I want to talk about what the old man John Benjamin who previously took care of the drum and his wife Sophia Churchill-Benjamin talked about. They said if someone wants to remove himself as a drum member they have to make a huge offering. The offerings that they give to the Manidoog to remove themselves from their position must stand as tall as they stand.

The old man and the old lady said that they have never seen or heard of anyone removing themselves from their positions on the drum. It is the same as if they are abandoning the that they represent.

Anishinaabe-Niimi'iding

Manidoo dibishkoo ani-naganaad inow Manidoon
nayaabibiitawaajin wendabid.

14 WAWEZHI'IND AWIYA

Nebowa imaa ayaamagad gaa-ni-dagosijigaadeg ani-
niimi'idiiked a'aw Anishinaabe ge-ni-naadamaagod. Mii dash
i'iw wawezhi'ind awiya waa-ni-dazhindamaan.

Ishke awiya eni-ishkwaa-ayaad i'iw bimiwanaan
ozhichigaadeni. Mii imaa eni-gashkapijigaadenig aanind iniw
biizikiganan gaa-ishkwaa-ayaad. Mii dash iwidi owapii
nanaa'inigaazod, mii imaa ani-miinind a'aw Bwaani-
dewe'iganan genawendamaaged. Ishke ingiw Bwaani-
dewe'iganag, mii eta-go ingiw eyaangig i'iw nagamon ge-ni-
niimikang a'aw wesidaawendang. Ishke dash a'aw
wedewe'iganid, mii iw gaye ani-miinind gakina-go iniw
obiizikiganan gaa-ayaaminid inow gaa-ishkwaa-ayaanijin.

Ishke dash mii iw gomaapii ezhi-okwi'idiwaad debendaagozijig
inow Bwaani-dewe'iganan waa-aabajichigaazonijin. Mii dash
imaa owapii ani-maada'oonindwaa iniw biizikiganan gakina
debendaagozijig imaa dewe'iganan. Ishke dash maagizhaa
azhigwa bezhig i'iw gikinoonowin gaa-pimisemagak, mii-go
imaa nandomindwaa imaa chi-niimi'iding ingiw besho gaa-
inawemaajig inow gaa-aanjikiinijin. Ishke dash mii imaa
zhaawanong iw akeyaa abid a'aw gimishoomisinaan, mii imaa
da-niibide-achigaadenig apabiwinan. Mii dash imaa ani-
zaginikenindwaa ingiw waa-wawezhi'injig, aabiding dash imaa
ani-gizhibaawose'indwaa iniw gimishoomisinaanin, mii dash
iwidi o-wawenabi'indwaa gii-achigaadeg iniw apabiwinan
imaa zhaawanong akeyaa.

Mii dash owapii ani-giziibiiginindwaa. Mii imaa ani-
gaasiinigaadeg miinawaa ani-webaabaaweg aanind
owasidaawendamowiniwaa. Mii dash gaye weweni ani-
doodawindwaa ani-nazikwe'igaadenig owiinizisiwaan. Ishke

14 WASHING AWAY THE GRIEF

There is a lot included in with these dances that will help the Anishinaabe. What I want to talk about is the grief ceremony where people are washed up at the ceremonial dance.

When someone passes away, a bundle is made. In that bundle some of their clothing is wrapped up. After the burial the bundle is given to a drum keeper who takes care of what is known as a Bwaani-dewe'igan. It is only the Bwaani-dewe'iganag that have the song that the person who has lost a close relative will dance. The drum keeper will also take the remainder of the clothing of the deceased.

After a period of time those that belong to the drum that will be used will get together. It is at that time the clothing is passed out to all the drum members. Maybe after a year has passed, the close relatives will be asked to come to the dance. At that time chairs will be placed on the south side of the drum in a row. Then the ones being washed up will be taken by the arm, walked around the drum once, and seated in those chairs that have been placed on the south side of the drum.

It is at that time that they are washed up. That is when some of their grief and sorrow is washed off. As a way to assist them their hair is also combed. Along with this they also put ribbons in the hair of the women being put through this ceremony.

dash ingiw ikwewag zenibaanyan achigaazowan imaa owiinizisiwaang. Naa gaye iko aaningodinong inow ininiwan wiiwakwaan obiizikoonaawaan, mii dash imaa zenibaanyan odakobinaawaan imaa owiiwakwaaniwaang. Ishke gaye ezhichigewaad maagizhaa gaye ogoodaas, maagizhaa gaye babagiwayaan obiizikoonaawaan iniw ikwewan wewezhi'aawaajin. Miinawaa inow ininiwan babagiwayaan obiizikoonaawaan.

Mii dash imaa ani-maamawichigewaad gakina imaa eyaajig imaa endazhi-niimi'iding ani-maamiinaawaad gegoo inow wewezhi'aawaajin, maagizhaa waabooyaanan, maagizhaa gaye odayi'iimaanan, naa meshkwadooniganan. Mii dash iw azhigwa gaa-ni-giizhiitaawaad, mii dash imaa ani-aabajichigaadeg iniw nagamonan gaa-achigaadegin. Mii dash imaa ani-bazigwiiwaad gakina ingiw ogichidaag ani-waakaashimotawaawaad iniw gimishoomisinaanin aabiding. Mii dash iwidi waabanong ani-dagoshimoonowaad, mii dash ingiw niswi ogichidaag eshkwebijig ani-noogitaawaad ani-niibidegaabawiwaad imaa waabanong akeyaa. Mii dash wiin a'aw naagaaniid ogichidaa ani-maajaad geyaabi ani-niimikang i'iw nagamon, mii imaa ani-waakaashimotawaad inow gaa-onabi'iminjin miinawaa waa-wawezhi'iminjin. Mii dash imaa ani-noogitaad imaa enaasamabinid gaa-niigaanabi'imind inow wewezhi'iminjin. Mii dash imaa daanginaad imaa naawigatig miskobii'waad. Mii dash imaa gakina ani-doodawaad bebezhig inow wewezhi'iminjin.

Mii dash imaa ani-giizhiitaad, mii imaa a'aw ogichidaa ani-aajimodakwed ani-wiindamaaged wenji-gashkitood ani-miskobii'waad naawigatig inow wesidaawendamonijin. Mii dash imaa wendinang a'aw ogichidaa gii-waabandang i'iw miskwi, megwaa iwidi gii-miigaading gii-paa-ayaad. Mii dash imaa ani-wiindamaaged gaa-waabandang gii-paa-ayaad iwidi

They also put hats on the men and attach ribbons to those hats. Also they put a dress on the woman they are dressing up or maybe a shirt. They also put a shirt on the man who is being put through this ceremony.

Then what happens is that everyone in attendance at the dance works together in helping the grieving by giving him or her a blanket, maybe an item of clothing, or maybe money. After they have finished giving them gifts, the songs used in this ceremony are sung. It is the ogichidaag that dance these songs and dance around the drum once. When they get to the east side of the drum the three ogichidaag who sit last, stop there and stand in a row. And then the head ogichidaa will continue to dance, and dances around those who were seated to be put through this ceremony. The ogichidaa will then stand in front of the first one to be washed up. He then puts a red mark on his or her forehead. He then does the same to the rest of them seated there.

After the ogichidaa finishes his part he will tell why he is able to put the red mark on the forehead of the ones who are grieving. The ogichidaa gets the right to put the red marking on the face of those grieving from when he saw blood while he was at war. He tells what he saw while he was at war and talks about the wounds he suffered while he was overseas.

endazhi-miigaading naa gaye ani-dazhindang i'iwapii gii-
maakishkoozod.

Mii dash eko-niizhing ogichidaa wiinitam ani-gizhibaashimod
imaa gii-onabi'indwaa ingiw wewezhi'injig. Mii dash imaa eko-
niizhing ogichidaa ani-noogitaad enaasamabinid. Mii dash imaa
i'iw meskwaag ani-daanginibii'amawaad iwidi onowaang
namanjinikaang akeyaa. Mii dash i'iw gaye wiin azhigwa ani-
giizhiitaad ani-aajimodakwed gaye wiin.

Mii dash a'aw eko-nising wendabid a'aw ogichidaa gaye wiin
a'aw gizhibaashimod wenabinid wewezhi'iminjin, mii dash
imaa ani-noogitaad enaasamabinid wendabinid inow
wewezhi'iminjin. Mii dash imaa odaamikanaawaang ani-
daanginibii'amawaad i'iw meskwaag. Mii dash i'iw gaye wiin
azhigwa ani-giizhiitaad ani-aajimodakwed gaye wiin. Mii dash
a'aw eshkwebid ogichidaa gaye wiin ani gizhibaashimod, mii
dash imaa ani-noogitaad gaye wiin da-ni-daanginibii'amawaad
iwedi bezhig napaaj akeyaa onowaawaang. Mii dash gaye wiin
ani-aajimodakwed.

Mii dash owapii bezhig a'aw ogichidaa imaa ganoonaad iniw
wesidaawendaminijin. Ishke mii-ko imaa akeyaa ezhi-
wiindamawindwaa wesidaawendangig: "Ishke
giwaabandaanaawaa, mii-go imaa gakina eyaajig ani-
maamawinikeniwaad ani-naadamaagooyeg ani-
zhawenimigooyeg. Ishke ingiw Manidoog geget ogii-
shawenimaawaan iniw odanishinaabemiwaan gii-
miinigoowizid o'ow akeyaa da-ni-naadamaagoowizid a'aw
Anishinaabe ani-wasidaawendang. Ishke dash gaye bebezhig
ingiw ogichidaag iniw Manidoon onaabibiitawaawaan. Mii iniw
Manidoon nayaabibitawaawaajin, gigii-naadamaagowaag.
Ishke dash i'iw weweni gidaa-ni-bagidenimaawaa gaa-wani'eg.

Now it is time for the ogichidaa that sits in the second spot to get up and dance around those that are being dressed up. The second ogichidaa stops in front of those that are being put through the ceremony. He puts his red marking on the left cheek of those seated there. When he finishes he also stands there and tell why he is able to put his red mark on those grieving.

The ogichidaa that sits third also dances around them, and stops in front of them where they are seated. He too puts a red marking on them, but this time on their chins. When he finishes he also stands there and tells why he is able to put his red mark on those grieving. The fourth ogichidaa also does the same. He puts his red marking on them, but this time on their right cheek. When he is done he also gets up and talks and tells why he has the ability to place a red mark on them.

Then at this time one of the ogichidaag will get up and talk to those who are being put through this ceremony. Here are some of the things that they say to help those who are mourning: "You have seen what everyone has done for you here. All of those in attendance at the dance have put their hands together to help you and to show the compassion they have for you. The Manidoog have showed the love they have for their Anishinaabe by giving them this ceremony to help them with their grieving. Each of the ogichidaag represents a Manidoo. It is those Manidoog that they represent that have helped you during the course of this ceremony. As a result, you should be able to let your relative go. It is a beautiful and happy place that he or she has gone to."

Ishke geget onaajiwanini naa gaye minawaanigwendaagwadini iwidi gaa-izhaad."

Mii dash owapii ani-aabajichigaadeg iwedi bezhig i'iw nagamon gaa-achigaadeg omaa. Mii imaa da-ni-naadamaagoowiziwaad dash ingiw wesidaawendangig. Ishke dash mii imaa nawaj ani-bangisidoowaad owasidaawendamowiniwaa. Gaawiin isa wiin igo gakina odaa-ni-bangisidoosiinaawaa. Mii dash imaa ani-zaginikenindwaa ani-niimiwaad dash ingiw wesidaawendangig. Mii-go gakina imaa eyaajig ani-bazigwiiwaad ani-naadamaagowaad. Giishpin a'aw debendaagozid wawezhi'ind, ani-giizhi-niimiwaad, mii dash imaa da-zaginikenind da-onabi'ind iwidi gaa-ondabid. Mii-ko ingiw akiwenziiyibaneg gaa-ikidowaad, giishpin wawezhi'aasiwind imaa debendaagozid imaa gimishoomisinaaning, mii-go da-ashaweshing a'aw gimishoomisinaan.

It is at this time that the other song that has been put there to help those that are grieving is used. As a result, those who are put through this ceremony are helped with their grief. It is at that time they will drop the additional grief that they may carry. They cannot drop all of the grief but most of it. This is when a drum member will hold their arm as they dance to this song. Everybody that is at the dance gets up and helps. If one of those being put through this ceremony is a drum member, as soon as they are finished dancing he will be taken by the arm and sat in his spot where he was seated. Those old men said that if a drum member is not put through this ceremony after they lost a close relative, the drum will not sit right and will tilt.

15 GIIWENIGENG

Azhigwa gaa-ingo-biboonagak gaa-ishkwaa-ayaanid inow besho odinawemaaganiwaan, mii dash i'iw nebowa Anishinaabe ezhichiged, mii iw giiwenigeng ezhi-wiinjigaadeg. Mii dash inow odinawemaaganan gaa-ishkwaa-ayaad, mii-go imaa asigisidoowaad odayi'iimaanan miinawaa waabooyaanan, anooj ge-ni-aabajitood a'aw gaa-aanjikiid. Mii dash i'iw chi-bimiwanaan ozhitoowaad. Ginwaabiigadini bimiwanaan ozhitoowaad.

Mii dash imaa zagaakwa'igaadeg zagaakwa'igaansan aabajichigaadeg. Mii dash imaa niiwin dasing zagaakwa'igaadeg i'iw bimiwanaan iwidi akeyaa enabiwaad ingiw niiwin ingiw Manidoog wayaakaabiitangig aki. Mii dash imaa ani-biindigajigaadeg imaa endazhi-aabajichigaazod a'aw gimishoomisinaan. Mii o'ow azhigwa gaa-pangishimog, mii owapii ani-baakiiginigaadeg i'iw bimiwanaan.

Mii iwidi owapii ani-giizhiganikewaad ingiw gidinawemaaganinaanig, mii owapii azhigwa omaa gaa-onaagoshig omaa o'ow aki ebiitamang anishinaabewiyang. Mii dash iwidi zhaawanong akeyaa achigaadeg i'iw bimiwanaan. Mii dash ezhi-bazigwiid ogichidaa ani-gaagiigidod, mii iw ani-apagizondamawaad Manidoon iniw asemaan gaa-pi-biindiganaawaajin ingiw naandaa'iwejig iniw odayi'iimaanan.

Mii dash iwidi apagizondamawindwaa inow asemaan gakina enabiwaad ingiw Manidoog miigwechiwi'indwaa gii-shawenimaawaad iniw odanishinaabemiwaan gii-miinigoowiziyang gashkitooyang da-niindaa'ang a'aw gidinawemaaganinaan anooj igo gegoo da-ni-aabajitood. Mii dash gaye iwidi ani-apagizonjigaazod a'aw asemaa ani-ininamawind a'aw Manidoo genawenimaad iniw

15 SENDING ITEMS TO A RELATIVE THAT WE HAVE LOST

After a year has passed since a family has lost their close relative, what a lot of Anishinaabe do is a ceremony called *Giiwenige*. What the relatives of the deceased do is they collect items of clothing, blankets, and anything that can be used by the deceased. A large bundle is created out of those items. It is usually a long bundle that is made.

The bundle is pinned up with safety pins. The safety pins are placed in four areas coinciding with the four directions where the Manidoog sit. The bundle is brought into a ceremonial dance. Once the sun has set, that is when the bundle can be opened.

Once the sun has set here on earth, it is daylight over there for our relatives. The bundle is placed on the south side of the ceremonial drum. Then one of the ogichidaag gets up and speaks and sends the tobacco brought in by the relatives to the Manidoog.

Then the tobacco is sent to where all the Manidoog sit, thanking them for the compassion they have shown the Anishinaabe by giving us the ability to send items to our relatives who have passed on. The tobacco is also sent to that Manidoo over there that takes care of our relative over there and the tobacco also goes to his helpers. Also, when the bundle

gidinawemaaganinaanin iwidi eyaanijin, biinish gaye ani-
biindaakoonimind inow odooshkaabewisiman. Mii dash iwidi
ani-apagizondang iniw biizikiganan azhigwa ani-
baakiiginigaadeg i'iw bimiwanaan ani-wiindamawindwaa
ingiw Manidoog ezhinikaazod a'aw mekwenimind. Azhigwa
dash iwidi ani-dagoshimoonagak, mii ingiw oshkaabewisag o-
nandomaawaad inow mekwenimind.

Ishke dash iko ani-gaagiigidowaad ingiw akiwenziiyibaneg, mii
iw gaa-ikidowaad, "Gaawiin i'iw bimaadiziwin
ninandodamawaasiwaanaanig, mii-go ezhi-
inigaawendamowaad giishpin i'iw akeyaa inendang awiya. Mii
eta-go weweni ani-doodawind a'aw mekwenimind." Mii dash
gaye nanaandonged ani-gaagiigidod da-zhawendaagoziwaad
besho enawendaasojig ani-ayaangwaamitoowaad gaa-izhi-
gikinoo'amaagoowiziyang da-ni-izhichigeyang naa weweni ani-
doodawaawaad odinawemaaganiwaan iwidi gaa-izhaanijin.
Weweni odaa-wii-ni-ganawenimigowaan inow Manidoon
oniigaaniimiwaang, mino-ayaawin da-miinigoowiziwaad
miinawaa da-ni-maminosewaad oniigaaniimiwaang.

Mii dash gaye iwidi ge-ni-inaabasod a'aw asemaa a'aw
Giganaan, mii a'aw ge-ni-nanaa'isidood giishpin imaa gegoo
ani-waniikeng ani-waniwebinigeng. Ishke dash azhigwa imaa
ani-baakiiginigaadeg i'iw bimiwanaan, mii imaa gakina awiya
da-ni-maada'oonind eyaad. Mii dash imaa ani-
wiindamawindwaa eyaajig, "Gego gidaa-wii-kotanziinaawaa
waa-paa-ininamaagooyeg odayi'iimaanan, gidaa-inigaa'aawaa
a'aw mekwenimind giishpin i'iw akeyaa awiya inendang."

Mii imaa gaye ani-wiindamawindwaa, "Wewiib gidaa-ni-
aabajitoonaawaa iniw gaa-maada'oonigooyegin. Ishke giishpin
minokanziwan i'iw obiizikigan gaa-o-ininamaagooyan, wewiib
igo bekaanizid gidaa-o-miinaa ge-minokang miinawaa wewiib
da-ni-aabajitood."

is opened, the clothing will go over there and the Manidoog will be told who is being remembered. As soon as the clothing arrives over there, the helpers go out and call on the one that is being remembered.

When the old men used to speak at this time, they would say, "We are not asking our relatives to come back to life, they would feel bad if someone thinks that way. We are only doing good to our relative over there." The speaker also asks for compassion for the close relatives that are here for following what we have been taught to do and for doing a good thing for their relatives that have passed on. May the Manidoog take good care of the relatives in their future and to give them good health and that things go well for them in their future.

The tobacco will also go to that Manidoo known as Giganaan, who is the moon. She is the Manidoo that will correct everything that was omitted or if an error was made during this talk. Once the bundle is opened the items inside are passed to everybody. Then everybody is told, "Do not be afraid of the clothing that have been passed out to you, you would not be doing good to that person that is being remembered if someone would think that way."

They are also told, "You will want to use these items that have been passed out to you. If you should not fit an article of clothing passed out to you, you will want to pass it on to another person who can fit that clothing so it can be used right away."

Mii dash imaa niiwin ingiw ogichidaag aabajichigaazowaad, mii
dash imaa ani-aabajichigaadeg iniw nagamonan gaa-
achigaadegin i'iw akeyaa da-ni-inaabadak. Azhigwa aabiding
gaa-gizhibaashkawaawaad gimishoomisinaanin ingiw
ogichidaag, mii dash imaa aabiding waakaashimotamowaad
i'iw bimiwanaan, mii dash iwidi niibidegaabawiwaad
waabanong niswi ingiw ogichidaag iwidi waabanong. Mii dash
imaa a'aw naagaaniid a'aw ogichidaa geyaabi ani-niimikang
i'iw nagamon ani-gizhibaashimotang i'iw bimiwanaan. Mii
dash imaa ani-noogibagizod imaa waabanong akeyaa ani-
gidiskaakwanang iniw zagaakwa'igaansan.

Mii dash bebezhig ezhichigewaad ani-niimikamowaad
onagamoniwaa. Ani-niimikamowaad onagamoniwaa, mii dash
imaa da-noogibagizowaad etenig iniw zagaakwa'igaansan ge-
mamoowaajin. Mii imaa ani-gidiskaakwanamowaad iniw
zagaakwa'igaansan gii-sagaakwa'igaadenig i'iw bimiwanaan.
Mii dash a'aw eshkwebid a'aw ogichidaa azhigwa mamood
iniw zagaakwa'igaansan imaa bimiwanaaning, mii dash owapii
ani-baakiiginigaadeg i'iw bimiwanaan, mii dash ani-
maada'ookiing.

Gaawiin imbi-waabandanziin i'iw akeyaa da-izhichigeng omaa
Aazhoomog, aano-go mii-go ge-izhichigeyaangiban wii-
ayaawigooyaang i'iw akeyaa da-ni-naadamaageyaang.

It is in this ceremony that all four of the ogichidaag are used along with the songs that have been put there to be used at this time. Once the four ogichidaag as a group have danced around the ceremonial drum, they then go on to dance around the bundle once, then the three ogichidaag that sit last will stop and line up in the east. The head ogichidaa continues to dance on and dances around the bundle one more time. Then he will stop dancing in the east and unpin the safety pins.

That is also what the remaining ogichidaag will do; each will dance their song. Each one of them as they are dancing their song will stop at the pins that they will remove. It is then that they will remove the pins on the bundle. Once the fourth ogichidaa has removed the pins, the bundle is then officially opened and passed out.

I have not seen this done here in Aazhoomog, but if we were asked to do this we would agree to help out in this way.

16 MIKWENIMIND AWIYA GAA-AANJIKIID

Mii gaye iko ezhichiged a'aw Anishinaabe ayaapii, mii imaa
asemaan naa wiisiniwin naa-go gaye meshkwadooniganan
asaad, maagizhaa gaye biindaakwaanan maagizhaa gaye
opwaagaansan biindiganaad imaa endazhi-niimi'iding ani-
mikwenimaad iniw odinawemaaganan gaa-ni-aanjikiinijin.

Mii dash a'aw oshkaabewis iwidi anaakaning waabanong
akeyaa dazhwegisidood. Mii dash imaa agijayi'ii i'iw wiisiniwin
miinawaa minikwewin maagizhaa gaye aniibiish naa-go gaye
imaa biindaakwaan, opwaagaansag, meshkwadoonigan
maagizhaa-go gaye odayi'iimaanan waa-ni-niindaa'ind a'aw
mikwenimind.

Mii dash a'aw gaa-pi-biindigadood i'iw onaagan ani-
gizhibaashkawaad iniw gimishoomisinaanin, mii dash iwidi
asemaan asaad a'aw gimishoomisinaan asemaa-onaaganing.
Mii dash imaa eshkosed a'aw asemaa o-ininamawaad waa-
kanoodamaagojin. Mii dash imaa weweni ani-wiindamawaad
anishinaabewinikaazonid iniw mekwenimaajin, naa gaye ani-
wiindamawaad gakina i'iw naandaa'aad iniw
odinawemaaganan iwidi eyaanijin.

Mii dash ani-gaagiigidod a'aw ogichidaa, mii iwidi
apagizondamawaad inow Manidoon iniw asemaan,
miigwechiwi'indwaa ingiw Manidoog gii-shawenimaawaad
inow odanishinaabemiwaan gii-miinaawaad da-gashkitoowaad
da-niindaa'aawaad iniw odinawemaaganiwaan ge-
aabajitoonid.

Mii gaye iwidi a'aw asemaa ani-apagizondamawind a'aw
Manidoo eyaad iwidi genawenimaad inow
gidinawemaaganinaanin, naa-go biinish ani-asemaakawindwaa

106

16 REMEMBERING ONE WHO HAS PASSED ON

What Anishinaabe will do on occasion is bring tobacco, food, money, and maybe even snuff or cigarettes into the ceremonial dance to remember a loved one who has passed on.

What happens is the oshkaabewis lays out a mat on the east side of the drum. The oshkaabewis then puts down the food, the drink, possibly tea, and also the snuff, or cigarettes, and money, along with any clothing they want to send to the relative they are remembering.

Then the one who brought in the bowl of food walks around the ceremonial drum and puts tobacco into the drum's tobacco box. Then he gives the remaining tobacco to the one he has selected to talk for him. It is then that he will also let the ogichidaa know the Anishinaabe name of the one he is remembering, and tell him about all the items he is sending to his relative.

Then the ogichidaa goes on to talk and sends the tobacco over to the Manidoog, thanking them for the compassion they have shown for their Anishinaabe by giving them the ability to send food and items to their relatives.

The tobacco is also sent to the Manidoo that is over there who takes care of our relatives and the tobacco is also sent to his helpers. The ogichidaa sends that food over to that place our

iniw odooshkaabewisiman. Mii dash a'aw ogichidaa ani-
apagizondang i'iw wiisiniwin iwidi ayaawaad
gidinawemaaganinaanig.

Azhigwa ani-dagoshimoonagak iwidi, mii dash iwidi
nandomind a'aw mekwenimind. Mii-go gaye iniw
odinawemaaganan gaa-odisaajin biinish gaye gaa-odisigojin
iwidi da-wiidoopamigod.

Ishke dash nebowa ayaawan inow ge-wiidoopamigojin,
gaawiin gaye makandamawaasiin. Baanimaa gii-
tebisewendamowaad, mii dash owapii da-
gwiinawaabandamowaad i'iw wiisiniwin. Waasa iko
izhaamagad i'iw wiisiniwin, mii iw gaa-onji-ikidowaad ingiw
akiwenziiyibaneg, gaawiin memwech chi-nebowa i'iw
wiisiniwin da-achigaadesinoon ani-niindaa'iweng.

Mii dash gaye akiwenziiyibaneg gaa-ikidowaad, gaawiin i'iw
bimaadiziwin ginandodamawaasiwaanaan, mii-go izhi-
inigaawendamowaad giishpin awiya i'iw akeyaa inendang. Mii
eta-go imaa weweni ani-mikwenimind ani-doodawind
gidinawemaaganinaan eyaad iwidi.

Mii dash gaye imaa ani-gaagiigidod ani-nandodamaaged da-ni-
zhawendaagoziwaad ingiw besho enawendaasojig weweni ani-
doodawaawaad odinawemaaganiwaan. Ishke wenji-
izhinizha'igaadeg i'iw wiisiniwin iwidi izhi-gwayak, gaawiin
omaa daa-bi-azhegiiwesiin awanjish gii-aazhoged i'iw ziibi
ayaamagak.

Ishke dash gaye a'aw Anishinaabe i'iw wiisiniwin atood ani-
bimi-giizhigadinig bakaan igo izhi-gaagiigido a'aw
endazhindang i'iw wiisiniwin. Ishke imaa giizhiganikeng omaa

108

relatives go when they leave this world.

Once the food and items have arrived over there, their relative that is being remembered is told that food has arrived. Along with that also, all of his relatives that are over there with him, including those that were already there when he changed worlds and those who have arrived later, will share in that meal with him.

He will have a lot of relatives that will share in a meal with him; they will not be taking any food away from him. It is not until they are all content that they will no longer see the food. A little food goes a long way in that world. It is the reason our old men said it is not necessary to send a whole lot of food over there.

Our old men also said, we are not asking our relative for life when we send food. Our relatives would feel bad if someone thinks that way. We are only trying to remember and do good to our relative that is over there.

The speaker goes on to ask for good things to happen for the close relatives who are following our teachings by remembering their relatives who have passed on. The reason that the food is sent directly over there is that once our relatives crossed that river over there, they cannot come back.

When the Anishinaabe puts down food during the day remembering their relatives, there is a particular way of talking about the food. When it is daylight here on earth, it is

akiing ebiitamang, mii iwidi niibaa-dibikokewaad
gidinawemaaganinaanig. Mii dash a'aw ani-gaagiigidod
azhigwa ani-achigaadeg i'iw wiisiniwin giizhiganikeyang, mii
imaa ani-wiindamaaged a'aw Manidoo iwidi eyaad obi-
izhinizha'waan odooshkaabewisiman da-bi-naadiwaad i'iw
wiisiniwin. Bijiinag dash giizhiganikewaad iwidi, mii dash a'aw
ani-wiindamawind a'aw mekwenimind, mii-go gaye
odinawemaaganan iwidi eyaanijin da-bi-wiidoopamigod ani-
odaapinamowaad dash i'iw wiisiniwin.

Ishke dash azhigwa ani-giizhiitaad ani-gaagiigidod, mii dash
a'aw gaa-pi-biindigadood i'iw wiisiniwin ani-mamaad iniw
biindaakwaanan gaa-asaajin, gemaa gaye opwaagaansan, naa-
go gaye giishpin gaye biizikiganan gaa-atoogwen, naa biinish
inow meshkwadooniganan gaa-asaagwenan. Mii dash imaa o-
ininamawind awiya ge-naabishkaaged, mii dash weweni da-ni-
dagoshimoonagadinig gakina naandaa'iwed.

nighttime over there where our relatives are. When the speaker speaks for food that has been put down during our day, he tells the Manidoo over there to send his helpers here to come get the food. And when it is daylight over there, the one being remembered is told along with all his relatives that are over there with him to come share in a meal with him and accept the food.

When the speaker is finished, the one who brought in the food will go and grab the snuff, or maybe cigarettes, or maybe clothing, and money. He then goes out and hands those items to individuals who are there; by doing so, those items arrive over there to where our people are.

17 NANDO-BIMAADIZIIKED AWIYA

Ishke dash mii imaa ani-apa'iwed a'aw Anishinaabe wii-ni-naadamaagoowizid gegoo ani-izhiwebizid, wenjida i'iw nando-bimaadiziiked ezhi-wiinjigaadeg. Zanagadini i'iw aakoziwin aanind a'aw Anishinaabe maagaadang. Ishke dash da-wenda-mashkawaamagad, giishpin imaa ayaamagak maamawichigewin miinawaa i'iw wenaajiwang ani-naadamaagewaad ingiw eyaajig. Mii dash imaa gaye wiinawaa eginzojig dibishkoo da-ni-maamawinikeniwaad ani-naadamawaawaad inow Anishinaaben imaa ba-nando-bimaadiziikenid.

Ishke dash owapii bi-biindigadoowaad i'iw wiisiniwin miinawaa inow asemaan imaa ani-baakishimind a'aw gimishoomisinaan. Biinish gaye aanind imaa obiindigadoonaawaa i'iw wiisiniwin gaye megwaa imaa abid a'aw gimishoomisinaan iwidi endaayaan.

Ishke dash ezhichigeng: ani-biindigadoowaad i'iw wiisiniwin nando-bimaadiziiked awiya, mii a'aw oshkaabewis imaa atood jiigayi'ii imaa gimishoomisinaanin, mii imaa naawayi'ii naagaanakideg i'iw mitig ningaabii'anong miinawaa mitig iwidi giiwedinong bedakideg, mii imaa achigaadeg i'iw wiisiniwin.

Mii dash a'aw baandigadood i'iw wiisiniwin, mii imaa ani-waakaashkawaad inow gimishoomisinaanin asaad inow odasemaan imaa asemaa-onaaganing. Eshkosed dash a'aw asemaa, mii imaa bi-ininamawaad waa-kanoodamaagojin.

Mii dash a'aw eni-gaagiigidod, mii imaa ani-apagizondamawaad inow Manidoon waakaabiitawaanijin inow gimishoomisinaanin, ani-wiindamawaad weweni inow

17 ASKING FOR GOOD HEALTH

This is when a lot of the Anishinaabe will run to our ceremonial drums for help with any serious health issues they may be facing, especially when it is life-threatening. Some of the Anishinaabe are fighting serious illnesses. Help is available through these drums when there is a community effort where the community members work together asking for help for the one who is facing serious illness. This is also where the drum members have to work together and have positive thinking, asking for positive results for the ones facing serious illnesses.

Some of the Anishinaabe will bring their tobacco and food in at the ceremonial dance. Others will bring their food directly to my house where the ceremonial drum resides.

This is what is done during the course of this particular ceremony: the oshkaabewis will put the food next to the drum in between the first stick, which stands in the west, and the stick that stands to the north.

The one that brings in the food goes around the drum clockwise and puts tobacco in the drum's tobacco box. The remaining tobacco goes to the one he has selected to speak for him.

The speaker then gets up to talk and sends the tobacco to those Manidoog that sit around the drum. He goes on to tell them in a good way the name of the individual that the food and tobacco

113

Manidoon ezhinikaazod a'aw etamawind i'iw wiisiniwin naa
biinish enaapined miinawaa ani-wiindamaaged
bagosenimindwaa ingiw Manidoog da-naadamawaawaad inow
ayaakozinijin.

Ishke dash a'aw eni-gaagiigidod, mii imaa ani-wiindamaaged,
gaawiin gegoo obwaanawitoosiinaawaa ingiw Manidoog
enendamowaad wii-ni-izhichigewaad. Ishke dash odaa-wii-
naadamaagoon iniw Manidoon imaa waabanda'iwed ani-
apenimod i'iw akeyaa gaa-izhi-miinaad inow Anishinaaben da-
ni-izhichigenid. Akawe imaa weweni gii-ni-noogitaad gii-ni-
dazhiikang i'iw wiisiniwin weweni imaa wii-pi-biindigadood
wii-ininamawaad inow Manidoon. Ishke dash gaye a'aw eni-
gaagiigidod, mii imaa iko ani-wiindamaaged, mii imaa gaa-
tazhi-bazigwadinind a'aw Anishinaabe gii-mino-ayaasig.
Apegish dash gaye wiin dibishkoo i'iw akeyaa ani-
naadamaagoowizid. Ishke dash ani-giizhi-gaagiigidod, mii dash
imaa ani-naabishkaageng i'iw wiisiniwin gii-achigaadeg.

Ishke dash mii ingiw nitam ba-naabishkaagejig i'iw wiisiniwin,
mii dash ingiw genawendamaagejig gimishoomisinaanin
maagizhaa gaye gookomisinaanin. Ishke dash mii i'iw wenji-
izhichigewaad i'iw akeyaa, mii ingiw genawendamaagejig inow
Manidoo-dewe'iganan onaabibiitawaawaan Niigaani-
manidoon. Mii dash i'iw nitam iwidi ge-ni-izhaamagak i'iw
wiisiniwin wenda-mashkawaadizijig ingiw Manidoog
bagosenimindwaa da-naadamawaawaad inow
baandigadoonijin i'iw wiisiniwin.

Azhigwa dash gaye wiinawaa eginzojig ani-naabishkaagewaad
i'iw wiisiniwin, mii iwidi ge-inikaamagak gaye i'iw wiisiniwin
inow Manidoon nayaabibiitawaawaajin. Mii dash gaye gakina
eyaajig da-ni-naabishkaagewaad ani-maamawichigeng ani-
naadamawind a'aw onaagan gaa-piindigadamawind.

are being put down for, and also the nature of his or her illness, and also adds what they desire of the Manidoog for the one who is sick.

The speaker goes on to say that there is nothing that those Manidoog are not capable of doing if they so wish. He also asks that those Manidoog look down favorably on the individual for relying on what those Manidoog gave the Anishinaabe to do to address serious illnesses, and that the Manidoog see that the individual has taken time to prepare the food to bring in and to offer to the Manidoog. As the speaker goes on to talk, it is customarily here that he goes on to tell that this is where the Anishinaabe came to be helped, it is from there that a lot of them were lifted up and their illness removed. He also adds that he hopes that the individual is helped in the same manner. When he is finished talking, that is when the food is accepted.

The ones that come first to accept or take the food are those that are visiting drum keepers. The reason this is done is that all these drum keepers represent the leading Manidoog, and as a result the food will go to those Manidoog that are especially powerful with hopes that the Manidoog help the one that has brought the food in.

When the drum members get up to accept the food, the food that they take in will go to the Manidoog that they represent in the position they are seated at. Then everyone else who is in attendance at the dance will also accept the food. This community effort helps the one that the dish has been brought in for.

18 WII-O-ZHIMAAGANISHIIWID AWIYA

Mii gaye o'ow akeyaa gaa-izhi-miinigoowiziyang da-ni-
aabajichigaazod a'aw gimishoomisinaan. Mii imaa ani-
aabajichigaazod azhigwa oshki-aya'aa wii-shimaaganishiiwid.
Ishke a'aw oshki-aya'aa i'iw wiisiniwin naa asemaan
obiindiganaan imaa endazhi-niimi'idiiked a'aw Anishinaabe.

Mii imaa ningaabii'anong akeyaa da-dazhwegisidood anaakan
a'aw oshkaabewis. Mii dash imaa atood agijayi'ii wiisiniwin naa
minikwewin. Mii dash imaa gizhibaawosed imaa
gimishoomisinaanin asemaan imaa asaad imaa
gimishoomisinaan asemaa-onaaganing a'aw waa-
shimaaganishiiwid. Mii dash i'iw eshkosenijin inow odasemaan
o-miinaad inow ogichidaan waa-kanoodamaagojin. Mii dash
inow ogichidaan apagizondamaagod iniw asemaan naa
wiisiniwin naa gaye gaa-atood waa-apigaabawid a'aw waa-
shimaaganishiiwid. Mii dash imaa nanaandomaad iniw
Manidoon weweni da-ganawenimigod aaniindi go baa-ayaad
azhigwa zhimaaganishiiwid, gegoo da-ni-maazhisesig iwidi
baa-ayaad weweni da-bi-giiwed.

Ishke dash ingiw akiwenziiyibaneg imaa ani-gaagiigidowaad,
mii imaa gii-ni-dazhindamowaad, megwaa iwidi gii-paa-
ayaawaad endazhi-miigaading mii iwidi gii-noondawaawaad
iniw gimishoomisinaanin. Mii dash imaa weweni gii-
kanawenjigaazowaad endazhi-miigaading weweni gii-pi-
giiwewaad.

Ishke dash i'iw nagamon ayaamagad omaa gaa-achigaadeg, mii
i'iw ani-bazigwiitang a'aw waa-shimaaganishiiwid ani-
niimikang ani-naadamaagod. Naa-go gaye gakina eyaajig ani-
bazigwiiwaad gaye wiinawaa. Mii dash i'iw weweni da-baa-
ganawenjigaazod megwaa iwidi baa-zhimaaganishiiwid.

18 ONE THAT IS ABOUT TO ENTER THE ARMED SERVICES

We also have been given this additional ceremony that goes with the use of our ceremonial drums. The ceremonial drum is put to use when a young man or woman is going to join the armed services. The young person brings in their food and tobacco to where the ceremonial dance is being held.

The oshkaabewis lays out a mat on the west side of the ceremonial drum. The oshkaabewis then puts food and drink on top of the mat. Then the young man or woman walks around the drum and puts tobacco in the drum's tobacco box. The young man or woman gives the remaining tobacco to an ogichidaa that they have chosen to speak for them. Then that ogichidaa sends out the tobacco and food, and any other items that have been put there for additional support. The he asks the Manidoog to watch over the young man or woman wherever they may go while they are in the armed service and not to encounter any misfortune so that they come home safely.

When those old men used to talk at this particular ceremony, they talked about their experiences. While they were in the midst of the battle they would hear the ceremonial drum out there. This is where their help came from while they were in the midst of battle, and they returned home safely.

There is a song that has been placed there for this ceremony, and that is the song that the young man or woman gets up and dances, that takes care of them while they are in the armed services. Then everyone who is there at the dance will get up and dance to show their support. As a result, our young people

were taken care of while they were in the armed services and were able to come home safely.

19 OSHKI-BIINDIGANIND ABINOOJIIYENS OMAA ENDAZHI-NIIMI'IDING

Mii dash imaa wii-ni-dazhindamaan oshki-biindiganind a'aw abinoojiiyens imaa niimi'iding apii aabajichigaazod a'aw Manidoo-dewe'igan. Ishke dash inow ogitiziiman a'aw abinoojiiyens ezhichigenid, mii inow asemaan miinawaa i'iw wiisiniwin baandigadoonid omaa apii baakishimind a'aw Manidoo-dewe'igan. Mii-go omaa miinawaa gaabige achigaazonid odasemaan a'aw abinoojiiyens. Mii dash iwidi da-oshki-dagoshimoononid miinawaa iwidi enabiwaad ingiw Manidoog. Ishke imaa gayat niizhing gii-inikaawan inow odasemaan gaa-atamawimind a'aw abinoojiiyens iwapii gii-oshki-daangishkang i'iw aki miinawaa iwapii gii-miinind odizhinikaazowin.

Geget minochige a'aw Anishinaabe gaabige asaad asemaan mino-doodawaad inow oniijaanisan inow noomaya igo gaa-inendaagwadinig gii-pi-dagoshimoononid. Geget ominwendaanaawaadog ingiw Manidoog gaabige ani-mikwenimindwaa. Mii imaa ge-onjikaamagadinig a'aw abinoojiinh da-naadamaagoowizid oniigaaniiming.

Mii dash omaa nising weweni doodawaawaad inow Manidoon weniijaanisijig inow abinoojiiyensan. Geget gii-shawendaagozi a'aw Anishinaabe gii-miinigoowizid o'ow akeyaa da-ni-naadamaagoowizinid inow oniijaanisan. Ishke dash i'iw wiisiniwin baandigadoowaad, mii imaa boozikinaaganing achigaadeg. Mii i'iw wiisiniwin inow oninjiin ayaabajitood zhakamoonidizod awiya imaa echigaadeg boozikinaaganing.

Mii dash a'aw bezhig inow ogitiziiman eni-izhichigenid, akawe omaa ogizhibaashkawaan inow Manidoo-dewe'iganan, mii dash imaa asemaan asaad inow gimishoomisinaanin asemaa-onaaganing. Mii dash eshkosed a'aw asemaa, mii iwidi o-

19 THE FIRST TIME A BABY IS BROUGHT INTO A CEREMONIAL DANCE

I am going to talk about the first time a baby is brought into a dance where a ceremonial drum is being used. What the baby's parents do is bring in tobacco and food when a ceremonial drum is uncovered to be used. Here the tobacco goes out right away for the baby again. The baby's tobacco arrives over there again where those Manidoog sit. Prior to this, the baby's tobacco went to those Manidoog on two different occasions: the ceremony where the baby's feet were first placed on the earth and the ceremony when the baby was given a name.

It is good when Anishinaabe offer their tobacco right away. They are doing well by their baby who has just recently arrived. The Manidoog must be happy that they are being remembered right away. It is from here that the baby will be helped in his or her future.

This is the third time the parents are doing good to the Manidoog on behalf of their baby. The Manidoog really showed compassion to the Anishinaabe when they were given these ceremonies from which the baby is helped. Food that is brought in is put in a bowl. It is finger food that is put into that bowl.

This is what one of the parents does; he or she walks around the drum, and places the tobacco in the drum's tobacco dish. He or she will then hand the remaining tobacco to the person they have selected to talk on behalf of their baby.

ininamawaad waa-kanoodamaagowaajin. Mii dash imaa gaye
a'aw oshkaabewis atood anaakan awasayi'ii desapabiwining
iko wawenabiwaad ingiw niimi'iwewininiwag ningaabii'anong
iwidi akeyaa. Mii dash i'iw wiisiniwin baandigadoowaad
minikwewin gaye agijayi'ii achigaadeg imaa anaakaning.

Mii dash a'aw eni-gaagiigidod, mii iw ani-apagizondamawaad
inow Manidoon wayaakaabiitawaanijin inow
gimishoomisinaanin inow asemaan naa wiisiniwin gaa-pi-
biindigadoonid inow ogitiziiman a'aw abinoojiiyens. Mii dash
imaa nanaandomindwaa ingiw Manidoog da-
maamawinikeniwaad da-ni-ganawenimaawaad inow
abinoojiiyensan weweni da-izhi-ayaanid oniigaaniiming, mino-
ayaawin miinawaa mino-mamaajiiwin da-miinigoowizinid
inow abinoojiiyensan. Miinawaa inow ogitiziiman da-
wawiingeziwaad da-ganawenimaawaad inow
oniijaanisensiwaan da-ni-manezisigwaa gegoo
oniigaaniimiwaang, da-zhawendaagoziwaad gaye omaa bi-
waabanda'iwewaad ezhi-apiitendamowaad gaa-izhi-
miinigoowiziyang anishinaabewiyang.

Mii dash imaa da-onjikaamagadinig da-zhawendaagoziwaad
miinawaa weweni da-ganawenjigaazonid oniigaaniiming inow
oniijaanisensiwaan. Weweni gaye odaa-wii-
gikinoo'amawaawaan oniijaanisiwaan o'ow akeyaa gaa-
inendaagozid Anishinaabe da-ni-bimiwidood i'iw
obimaadiziwin. Mii-go imaa gaye ani-miigwechiwi'indwaa
ingiw Manidoog weweni omaa gii-pi-dagoshimoonod a'aw
abinoojiiyens. Geget chi-ina'oonwewizi a'aw Anishinaabe
miinigoowizid oniijaanisan. Ishke dash mii imaa
nanaandongeng ingiw Manidoog da-wiidookawindwaa ingiw
weniijaanisijig da-wawiingeziwaad da-gikinoo'amawaawaad
inow oniijaanisensiwaan i'iw akeyaa gaa-izhi-
miinigoowiziyang anishinaabewiyang. Mii ingiw

The oshkaabewis places a mat on the other side of the bench where the singers sit on the west side of the drum. The food that they have brought in along with the drink is placed on top of that mat.

Then the one who is doing the speaking sends the tobacco and the food brought in by the parents of the baby off to the Manidoog that sit around the ceremonial drum. The Manidoog are asked to put their hands together to help the child to be given good health and movement. The speaker also asks that the parents be efficient in taking care of their child and that they are not lacking anything in their future. He also asks that the parents be helped for showing their appreciation for what the Manidoog have given us as Anishinaabe.

It is from this ceremony the they will be given compassion and also from which the baby will be well taken care of in his or her future. They will also be given help to teach their child the way that the Manidoog intended the Anishinaabe to live their life. It is also here that the Manidoog are being thanked for the safe arrival of this baby. It is quite the gift for Anishinaabe to be given a baby. It is here also that help is requested from the Manidoog to help the parents be efficient in teaching their child the ways that we as Anishinaabe were taught to live our lives by the Manidoog. It is our children who will carry on the teachings we were given as a people.

gidabinoojiinyiminaanig ge-ni-bimiwidoojig niigaan gaa-izhi-miinigoowiziyang anishinaabewiyang.

Ishke niin omaa ani-gaagiigidoyaambaan, mii imaa da-gii-nanaandomagwaaban ingiw Manidoog da-naadamaagoowizinid inow ogitiziiman da-ni-ayaangwaamitoowaad da-gikinoo'amawaawaad inow oniijaanisensiwaan da-ni-mamanaajitoonid gakina omaa eyaamagak omaa akiing biinish gaye inow owiiji-bimaadiziiman miinawaa weweni da-bizindawaad naa weweni da-odaapinang egod inow ogitiziiman naa-go gaye inow gechi-aya'aawinijin nanaginigod owapii gegoo ani-maazhichiged. Mii-go gaye oda-wii-gikinoo'amawaawaan inow oniijaanisensiwaan zakab da-wii-izhi-ayaanid bizaan imaa da-nanaamadabinid aaniin igo apii eni-naazikaminid ani-manidooked a'aw Anishinaabe. Mii iw noongom wenitooyang. Mii iw nesidawinaagwak noongom, gaawiin a'aw Anishinaabe ogikinoo'amawaasiin inow oniijaanisan i'iw akeyaa gaa-izhi-gikinoo'amawaawaad mewinzha.

A'aw bezhig akiwenziiyiban gaa-ni-gaagiigidod, ogii-tazhindaan ishpiming imaa ombinind mamaajigaadenid a'aw abinoojiiyens, mii imaa waabanda'iwed ezhi-aanoodizid wii-niimid. Ani-giizhiitaad ani-gaagiigidod, mii dash a'aw oshkaabewis ani-maajiidood i'iw wiisiniwin, mii dash imaa ani-maada'ookiid da-ni-naabishkaagenid imaa eyaanijin. Weweni ani-gizhibaashkaamagadini i'iw wiisiniwin, weweni inikaamagadinig iwidi ingiw Manidoog wayaakaabiitawaajig inow Manidoo-dewe'iganan.

124

If I were doing the talking at this particular time, it is here that I would have asked the Manidoog to help the parents to work hard at teaching their child to respect everything on this earth, to be respectful to their fellow human beings, and also for the child to listen carefully and to accept what he or she is being told by his parents and elders when being scolded for his or her wrongdoings. That they also teach their child how to be calm within and to sit quietly as they attend ceremonies. That is what we are missing today. It is apparent today that the Anishinaabe are not teaching these things to their children as was done years ago.

One of the old men that spoke at this ceremony talked about when you lift a child up you can see his legs kicking, which shows how anxious he is to dance. When the talking is finished, the oshkaabewis takes the bowl of food and passes it around to the people present to accept the food on behalf of the Manidoog. The food is passed around the circle of people attending and in turn it goes to the Manidoog that sit in a circle around the drum.

20 ONAAGANAN ACHIGAADEG

Aaningodinong a'aw Anishinaabe gaye obiindiganaan inow odasemaan naa wiisiniwin, anooj igo akeyaa ani-nanaandomaad inow Manidoon da-naadamaagod. Nebowa igo ayaamagadini i'iw akeyaa ezhi-misawendang a'aw Anishinaabe da-ni-naadamaagod inow Manidoon, maagizhaa gaye inow wayaabishkiiwen owii-tibaakonigoon, maagizhaa gaye wii-paamaashi ingoji wii-ni-izhaad, naa-go gaye aanind nandodamaagewag da-mino-wiij'ayaandiwaad imaa endaawaad.

Gaawiin i'iw aakozid awiya dazhinjigaadesinoon owapii achigaadeg iniw onaaganan. Mii wiin iniw onaaganan jiigayi'ii gimishoomisinaaning echigaadeg. Mii gaye iwidi waabanong achigaadeg iniw onaaganan i'iw wiisiniwin etood ani-mikwenimaad inow odinawemaaganan gaa-aanjikiinijin. Mii dash i'iw anooj i'iw akeyaa nandodamaaged a'aw Anishinaabe da-ni-naadamaagoowizid, mii iwidi iniw onaaganan iwidi ningaabii'anong akeyaa ani-achigaadeg.

20 PUTTING DOWN FOOD OFFERINGS

Every now and then the Anishinaabe will bring in their tobacco and food, and have various requests of the Manidoog. There are several things that the Anishinaabe ask for help with from the Manidoog; as an example, they may ask for help on a court appearance, maybe they are planning to fly out somewhere, or maybe they are just asking that there be peace within their household and that everybody gets along.

These dishes are not put down to address people's illnesses. The dishes that are put close to the drum are those that address serious illnesses. There are also those bowls that are put down on the east side of the ceremonial drum when the Anishinaabe are remembering their close relatives. The dishes that are put in the west address all of the other needs of the Anishinaabe besides illness.

21 AANDAPININD A'AW GIMISHOOMISINAAN

Ayaapii iko aanjichigaazowan iniw owayaanan
geshkapijigaazonijin a'aw gimishoomisinaan. Ishke ingiw
akiwenziiyibaneg gaa-ikidowaad, giishpin imaa biigoshkaad
agijayi'ii ani-aabajichigaazonid inow gimishoomisinaanin
megwaa imaa endazhi-niimi'iding, mii-go da-
biimiskoshimindiban geyaabi da-ni-aabajichigaazopan biinish
da-ni-giizhiitaad niimi'idid a'aw Anishinaabe. Booch dash da-
ni-aanjichigaazonid iniw owayaanan.

Dabwaa-maajitaawaad ani-aandapinaawaad inow
gimishoomisinaanin, akawe wiisiniwin odaa-atoonaawaa ingiw
debendaagozijig biinish iniw odasemaawaan da-asaawaad. Mii
dash imaa ani-nanaandomindwaa ingiw Manidoog da-
naadamawindwaa ingiw waa-aandapinaajig inow
gimishoomisinaanin da-wawiingeziwaad da-ni-
wenipaniziwaad da-ni-aanji'aawaad iniw owayaanan inow
gimishoomisinaanin.

Ishke dash dabwaa-aabajichigaazonid odooshkiwayaanan,
akawe ingiw naagaanabijig ingiw genawendamaagejig odaa-
oshki-bakite'waawaan inow dewe'iganan. Mii iw ezhichigeng,
ishke dash mii owapii ani-aabajichigaadeg iniw
zhiibiniketaage-nagamonan. Ishke dash ani-maajii'amowaad
netamising iniw zhiibiniketaage-nagamon. Aano-go imaa
waakaabiitawaawaad ani-nagamowaad ingiw
niimi'iwewininiwag gaawiin obakite'waasiwaawaan iniw
gimishoomisinaanin. Ishke dash mii iwidi enabi'indwaa
genawendamaagejig wiidabindiwaad apabiwining gii-
wawenabi'indwaa. Azhigwa gaa-kiizhi'amaazowaad ani-
aabajitoowaad netamising i'iw nagamon, mii i'iw bi-
zhooshkwadabiwaad odapabiwiniwaan ani-naazikawaawaad
gimishoomisinaanin ingiw wedewe'iganijig.

128

21 CHANGING THE HIDE ON A CEREMONIAL DRUM

Every so often the hide that wraps around the ceremonial drum has to be changed. What our old men said is, if the hide should break on the topside of the drum while the dance is going on, the drum can be turned over and can be used on that side to finish out the dance. Then at some point the hide on that drum has to be changed.

Before they start to change the hide on the drum, the drum members need to put down their food and their tobacco offerings. This is where the Manidoog are asked to help those who will be changing the hide of the ceremonial drum and that they do it efficiently and without any difficulty.

Before the new hide is used on the drum, the drum keepers must be the first to hit the new hide. What is done before the drum keepers hit the drum for the first time is that the four songs known as the welcoming songs are used. Even though the singers are sitting around the drum they do not hit the drum as they sing the first welcoming song. The drum keepers are seated next to each other in chairs that have been put there for them. Once they have finished singing that first song, the drum keepers then slide their chairs up there closer to the drum.

129

Mii dash i'iw eko-niizhing eyaamagak i'iw zhiibiniketaage-
nagamon ani-maajii'amowaad ingiw niimi'iwewininiwag. Mii
gaawiin mashi obakite'waasiwaawaan inow dewe'iganan. Ani-
giizhi'amaazowaad, mii i'iw aabiding miinawaa ani-
giikabiwaad bi-naazikawaawaad iniw gimishoomisinaanin
ingiw wedewe'iganijig.

Mii dash ingiw niimi'iwewininiwag maajii'amaazowaad
miinawaa ani-aabajitoowaad eko-nising i'iw zhiibiniketaage-
nagamon ezhi-wiinjigaadeg. Mii dash ingiw ogimaag
giikabiwaad miinawaa. Mii dash imaa besho ayaawaad inow
gimishoomisinaanin.

Ishke dash i'iw eshkwesing i'iw nagamon eyaamagak, mii imaa
ani-maajii'amowaad ingiw niimi'iwewininiwag. Mii dash
o'owapii oshki-bakite'waawaad inow gimishoomisinaanin
ingiw ogimaag, mii dash gaye wiinawaa gakina ingiw
niimi'iwewininiwag bebezhig wendabiwaad ani-
maada'akokwewaad gaye wiinawaa.
Ishke iwidi chi-baaga'akokwaan bemiwidood miinawaa
naagaanabijig niimi'iwewininiwag ezhi-bakite'waawaad
gimishoomisinaanin. Azhigwa gaa-maada'akokwewaad, mii
dash ingiw niimi'iwewininiwag giiwedinong akeyaa wendabijig
imaa eko-niizhing i'iw mitig, mii dash ge-wiinawaa
wiinitamawaa ezhi-bakite'waawaad gimishoomisinaan. Ishke
dash gaye ingiw niimi'iwewininiwag wendabijig iwidi
waabanong eko-nising i'iw mitig, mii dash ge-wiinawaa
wiinitamawaa ezhi-bakite'waawaad gimishoomisinaanin. Mii
dash ge-wiinawaa eshkwebijig iwidi zhaawanong eko-niiwing
mitigong bakite'waawaad gimishoomisinaanin. Mii dash i'iw
ezhichigeng oshki-bakite'igaazod gimishoomisinaan a'aw
Manidoo-dewe'igan.

130

It is then that the singers sing the second welcoming song. They still have not hit that new hide. Once they have finished that second song, the drum keepers slide their chairs up once again a little closer to the ceremonial drum.

Then the singers begin to sing the third welcoming song. When that song is done the drum keepers slide their chairs up closer to the ceremonial drum. Now they are seated close to the ceremonial drum.

This is when the singers begin to sing the last welcoming song. Shortly after that the two drum keepers are the first to hit the drum. Then the rest of the singers hit the drum in the order that they are seated around the drum. The first one to hit the drum is the one that carries the big stick, and then the first stick singers that are seated in the west hit the drum. Once they have hit the drum, it is those singers that sit at the second stick in the north that also hit the drum. Then the singers who sit at the third stick on the east side hit the drum. It is then that the ones who sit last at the fourth stick in the south hit the drum. That is the ceremony that is done when the drum is hit for the first time after his hide has been changed.

22 DA-WII-MANAAJI'IND A'AW GIMISHOOMISINAAN

Mii dash omaa wii-ni-dazhimagwaa ingiw abinoojiinyag
ayaawaad imaa endazhi-niimi'idiiked a'aw Anishinaabe. Gii-
abinoojiinyiwiyaan, geget ingii-ayaangwaamimigoog ingiw
gaa-nitaawigi'ijig. Ingii-gikinoo'amaagoog da-ni-
manaajitooyaan o'ow akeyaa a'aw Anishinaabe gaa-izhi-
miinigoowizid.

Nigii-igoog, "Gego ganage babaamibatooken owapii ani-
baakishimind ani-aabajichigaazod a'aw gimishoomisinaan.
Ishke bangishinan imaa megwaa imaa babaamibatooyan imaa
ayaad gimishoomisinaan, geget gidaa-wenda-wiisagishin. Mii
iw ezhi-mashkawaadizid a'aw gimishoomisinaan. Bizaan imaa
nanaamadabin, zakab da-izhi-ayaayan. Mii eta-go apii ge-
bazigwiiyan wii-niimiyan maagizhaa gaye waakaa'igaansing
wii-izhaayan."

Ishke gaa-ikidowaad, "Azhigwa baakishimind a'aw
gimishoomisinaan, mii imaa ishpiming ayaawaad ingiw
Manidoog. Mii imaa wenzaabamaawaad wenjitawaawaad
odanishinaabemiwaan megwaa niimi'idiikeng. Ishke oda-
wenda-minwendaanaawaa ingiw Manidoog waabamikwaa
imaa bizaan igo nanaamidabiyan ganawaabiyan eni-izhichiged
a'aw Anishinaabe ani-niimi'idiiked. Gida-zhawenimigoog mino-
gwiiwizensiwiyan megwaa aabajichigaazod a'aw
gimishoomisinaan."

Ingiw weniijaanisijig naa gaye gaa-pi-biindiganaajig
oniijaanisiwaan imaa endazhi-niimi'iding daa-
ayaangwaamiziwag da-gikinoo'amawaawaad da-
manaaji'aawaad inow gimishoomisinaanin ebinijin. Daa-
naniizaanendamoog ingiw weniijaanisijig giishpin imaa anooj
eni-izhichigenid inow odabinoojiinyimiwaan megwaa imaa

132

22 THE CEREMONIAL DRUM MUST BE TREATED RESPECTFULLY

I want to talk about children being present at the ceremonial dances. When I was a child, I was constantly cautioned by those who raised me. I was taught to respect the teachings and ceremonies that we were given as a people.

They would say to me, "Do not even think of running around while the ceremonial drum is sitting there open. If you were to fall while you were running around as the ceremonial drum is sitting there open, you would really get hurt. That is how strong that ceremonial drum is. Sit there quietly and be still. The only time that you can get up is when you want to dance or go to the bathroom."

This is what was said, "Once the ceremonial drum is opened up, those Manidoog sit right above the drum. That is where they watch and listen to their Anishinaabe as they hold the ceremonial dance. The Manidoog will really like seeing you sitting there quietly and watching what the Anishinaabe do as they have their dance. They will have compassion for you for being on your best behavior while the ceremonial drum is being used."

The parents and the people who bring their children into the ceremonial dance should focus on teaching their children to respect the ceremonial drum that is sitting there. The parents should be concerned about the behavior of their children while at these ceremonial dances. Those ceremonial drums are the ones above all that they should have respect for. It is hard

133

endazhi-niimi'iding. Ishke mii inow naaniigaan ge-ni-
manaaji'aawaapanen inow gimishoomisinaanin. Ishke gaawiin
gikendaagwasinini ge-ni-izhichigenipan inow oniijaanisiwaan,
mii-go gaawiin oniigaaniimiwaang gegoo oda-
apiitendanziinaawaa wawaaj-igo owiiji-bimaadiziimiwaan. Mii
i'iw wenji-naniibikimindwaa ingiw abinoojiinyag, gemaa gaye
a'aw ogimaa daa-bazigwii o-wiindamawaad bizaan da-o-
wawenabinid inow abinoojiinyan.

to tell what their children will do in their future; they may not have respect for anything, including their fellow man. That is why children are disciplined at these ceremonial dances where even a drum keeper might get up and go tell the children to sit quietly.

23 ODAAWAA-ZAAGA'IGANIING NIIMI'IDIWAAD ENAKAMIGIZIWAAD

Ishke geget niminwendaan iko Odaawaa-zaaga'iganiing izhaayaan o-ganawaabiyaan apii niimi'idiikewaad ingiw Anishinaabeg iwidi. Geget niminwendaan waabandamaan i'iw akeyaa ezhi-manaaji'aawaad weweni ezhi-doodawaawaad inow niizh Manidoo-dewe'iganan eyaawaawaajin iwidi.

Ishke ingiw niimi'iwewininiwag megwaa waakaabiitawaawaad inow gimishoomisinaanin giishpin imaa ani-ziigwebisemagadinig i'iw aniibiish awegonen igo menikwewaad, mii imaa ani-noogitaawaad ani-gaagiigidong ani-gaagiizomindwaa ingiw Manidoog naa-go gaye inow gimishoomisinaanin ayaabaji'aawaajin.

Mii gaye iwidi ezhichigewaad, ishke ani-bangisidood awiya i'iw zhinawa'oojigan, gaawiin igo wewiib omaamiginanziinaawaa. Akawe asemaan omiinaawaan bezhig inow akiwenziiyan da-ni-gaagiizitaagozinid. Mii gaye gakina imaa ba-biindigejig, akawe imaa weweni ogizhibaashkawaawaan inow gimishoomisinaanin, naa-go gaye apii gegoo wii-ni-izhichigewaad imaa biinji-niimi'idiiwigamigong mii-go imaa weweni ani-gizhibaashkawaawaad inow gimishoomisinaan.

Ishke gaye iwidi Odaawaa-zaaga'iganiing odayaanaawaan iniw Manidoo-giigidowinan ani-aabajtoowaad azhigwa ani-giizhi-niimi'idiwaad. Ishke dash bezhig inow dewe'iganan, Mii inow eni-aabaji'aawaajin ani-zaagibagaag miinawaa ani-dagwaagig, Ogichidaa-dewe'igan izhi-wiinjigaazo a'aw gimishoomisinaan. Ishke dash ani-aabajichigaazod a'aw, mii iwapii ani-maajii'igaadeg a'aw makwa iniw onagamonan niizhinoon, miinawaa mashkode-bizhiki onagamonan, mii-go ezhi-niizhing gaye iniw. Ishke dash imaa megwaa imaa ani-aabajichigaadeg iniw nagamonan, mii imaa ani-wiindamawindwaa imaa

23 WHAT HAPPENS AT LAC COURTE OREILLES CEREMONIAL DANCES

I really enjoy going to Lac Courte Oreilles to watch what goes on at their ceremonial dances over there. I particularly enjoy seeing how respectfully they treat and take care of the two ceremonial drums that they have over there.

As the singers sit around the ceremonial drum that they are using, if they should spill their tea or whatever they are drinking near the drum, everything comes to a halt and someone gets up to talk and asks for understanding and compassion from the Manidoog and the ceremonial drum for what has happened

What they also do is, if one of the bells should fall off while someone is dancing, they do not go and pick the bell up right away. Tobacco is first given to one of the older men to ask for compassion and understanding. What also happens is that everyone who attends the dance comes in and walks clockwise around the ceremonial drum, and also at any time that they move while inside the dance hall, they also walk clockwise around the ceremonial drum.

Also over at the Lac Courte Oreilles ceremonial dances they have some special songs that they use before they end their dance. They have one drum that they use every spring and every fall. This drum is called *Ogichidaa-dewe'igan*. When this drum is used there are two songs honoring the bear that are sung. Then after that there are two more songs honoring the buffalo. When these songs are being used everybody that is in attendance is told to sit quietly as these songs are being used. The only ones that can get up to dance to these songs are those who have been especially gifted by the bear or the buffalo

137

eyaajig, bizaan imaa da-nanaamidabiwag megwaa ani-
aabajichigaadeg iniw nagamonan. Mii eta ge-niimikangiban
iniw nagamonan a'aw gaa-pi-zhawenimigojin inow makwan
maagizhaa gaye inow mashkode-bizhikiwan. Ishke bebakaan
izhichigewag ingiw Anishinaabeg danakamigiziwaad, mii eta-
go eni-dazhindamaan gaa-inaabishinaan iwidi endazhi-
niimi'idiikewaad iwidi Odaawaa-zaaga'iganiing.

Mii gaye imaa iko ani-nagamong i'iw bimwaagan a'aw gaa-
maakishkoozod gii-paa-izhaad iwidi endazhi-miigaading. Mii
imaa ani-miigwechiwi'indwaa Manidoog weweni-go gii-pi-
giiwewaad ingiw zhimaaganishag. Ishke aanind ingiw gaa-
maakishkoozojig geyaabi-go ani-ayaamagadini eni-
wanishkwe'igowaad naa eni-gagwaadagi'igowaad geyaabi.
Ishke dash ani-aabajichigaadeg i'iw nagamon, mii imaa ani-
nanaandomindwaa ingiw Manidoog da-naadamawaawaad.

Mii dash i'iw akiwenziiyi-nagamon gaye maajii'igaadeg. Daa-
wii-shawendaagozi dash a'aw akiwenzii eni-niimikang naa-go
gaye gakina gigichi-aya'aaminaanig. Daa-wii-
naadamaagoowiziwag ani-gikinoo'amaagewaad weweni i'iw
gaa-pi-waabandamowaad naa-go gaye gaa-izhi-
gikinoo'amawindwaa aazhita dash i'iw da-ni-ayaamagak gaa-
izhi-miinigoowiziyang anishinaabewiyang.

Mii dash gaye mii owapii babaamaadizii-nagamon ani-
aabajichigaadeg. Mii dash owapii ani-nanaandomindwaa ingiw
Manidoog da-ni-naadamaagoowiziwaad dash gaa-pi-
naazikaagejig weweni-go iwidi da-ni-dagoshinowaad gaa-onji-
bazigwiiwaad imaa gii-pi-naazikaagewaad. Mii imaa ani-
diba'amowaad i'iw nagamon da-ni-naadamaagoowiziwaad
ingiw waa-ni-giiwebizojig naa-go gaye ingiw waa-
pabaamaadizijig. Mii imaa inow omeshkwadooniganiwaan
achigaazonid a'aw gimishoomisinaan ogashkibidaaganan

138

through their dreams. In different communities the Anishinaabe do their ceremonial dances differently; I am only speaking about what I have seen done at the Lac Courte Oreilles ceremonial dances.

They also sing the song that has been put there to honor the wounded warrior. It is the song expressing our gratitude to the Manidoog for our wounded soldiers that were able to come home. A lot of our veterans that were wounded at war still carry the aftereffects of their traumatic experiences while at war, which still bother them to this day. As this song is being used, the song speaks to the Manidoog asking that they help our veterans that are still suffering.

Then there is the old man song that is used. That is the song that speaks to the Manidoog asking that they take care of the old man that dances this song and also all our other elders. That song also asks that our elders be helped to teach what they have seen and to pass on what they have been taught; that is the way that our teachings will continue to be there.

Then this is when the traveling song is used. This song speaks to the Manidoog asking that they watch over the visitors so that they return to their homes safely. When the song is over, those visitors and those who plan to travel pay for the song; it is from there that they will be helped. The money that they put up as an offering is placed into the tobacco pouch that hangs on the ceremonial drum and along with that they put their tobacco in the ceremonial drum's dish.

egoojininijin miinawaa inow odasemaawaan asaawaad imaa
asemaa-onaaganing.

Mii dash omaa owapii zhiibiniketaage-nagamonan
aabajichigaadeg, mii gaye iko ezhi-wiindang anamikodaadii-
nagamonan. Mii dash a'aw akiwenziiyiban gaa-ikidod, ani-
aabajitood a'aw Anishinaabe iniw nagamonan, mii imaa ani-
wawiinge-ina'oonwewizid gakina gaa-izhi-nanaandonged
miinawaa gaa-izhi-bagosenimaad inow Manidoon da-ni-
naadamaagod imaa gii-ni-biindaakoojiged megwaa imaa ani-
niimi'idiiked. Mii-go imaa ani-giizhi-niimi'idiwaad wiinawaa
iwidi Odaawaa-zaaga'iganiing. Mii iw wenji-dazhindamaan
iniw nagamonan omaa ani-aabajitoowaad, mii imaa
waabanjigaadeg ezhi-apiitendamowaad niimi'idiikewaad
mewinzha gaa-ni-aabajichigaadegin iniw nagamonan, geyaabi
wiinawaa ani-aabajitoowaad.

Ishke gaye ani-giizhi-niimi'idiwaad ani-giizhiitaang nagamong,
gaawiin gaabige bazigwiisiiwag ingiw niimi'iwewininiwag
imaa waakaabiitawaawaad gimishoomisinaanin. Akawe
obaabii'aawaan inow odabiigizigewininiimiwaan da-mamaanid
inow gimishoomisinaanin gaa-aabajichigaazonijin ani-
nanaa'inaanid, mii dash i'iw bijiinag ikwabiwaad imaa, mii-go
gaye gakina imaa gaa-pi-naazikaagejig, mii gaye wiinawaa
bizaan nanaamidabiwaad.

This is when the handshake songs are used; these songs are also known as welcoming songs. The old man said, when these songs are used the Anishinaabe are given everything they had asked for and desired of the Manidoog as they put down their offerings during the course of the dance. These songs are the ones that are used to end their ceremonial dances in Lac Courte Oreilles. The reason I speak of these songs is that it shows the respect they have for our ceremonial dances and that they still continue to use these songs to this day.

Also as the dance is ending and all the songs have been sung, the singers sitting around the ceremonial drum do not get up right away. They wait until the drum warmer has grabbed the drum and put it away; it is then that they get up and leave their seats. Even all of those that are in attendance at the dance sit there respectfully waiting for the drum to be picked up by the drum warmer and put away.

Ikidowinan / Ojibwe-English Glossary

Key to Ojibwe Word Class Codes

adv	adverb or other uninflected word
na	animate noun
nad	dependent animate noun
name	name
place	place name
ni	noun inanimate
nid	dependent inanimate noun
ni-v	participle form of verb as inanimate noun
pc	particle
pron dem	demonstrative pronoun
pron indf	indefinite pronoun
pron inter	interrogative pronoun
pron per	personal pronoun
pv	preverb
vai	animate intransitive verb
vai2	class 2 animate intransitive verb
vai+o	animate intransitive verb with object
vii	inanimate intransitive verb
vta	transitive animate verb
vti	class 1 transitive inanimate verb
vti2	class 2 transitive inanimate verb
vti3	class 3 transitive inanimate verb
vti4	class 4 transitive inanimate verb

Other Abbreviations

h/	animate object or possessor: him, her, it (animate); his, hers
s/he	animate subject: she, he, it (animate)
h/self	himself or herself
pl	plural

abi *vai* s/he is at home, is in a certain place, sits in a certain place

abinoojiinh *na* child

abinoojiinyiwi *vai* s/he is a child

abinoojiiyens *na* infant

abiigiz /abiigizw-/ *vta* warm h/ at fire (as something sheet-like, *e.g.,* a drum hide)

abiigizigewinini *na* ceremonial drum warmer, ceremonial drum heater; *a ceremonial drum position*

abiigizigewininiiwi-nagamon *ni* ceremonial drum warmer's song; ceremonial drum heater's song; *a ceremonial song*

abiigizigewininiiwi *vai* he is a ceremonial drum warmer, is a ceremonial drum heater

abiitan *vti* live in, occupy it; **ebiitamang** the earth we dwell on

achigaade *vii* it is put in a certain place (by someone), "they" put it in a certain place

achigaazo *vai* s/he is put in a certain place (by someone); "they" put h/ in a certain place

adaawe *vai+o* s/he buys (something)

adite *vii* it is ripe (of a fruit or berry)

adoopowin *ni* table

agana *adv* not to the extent; less

agaami-ziibing *adv* across the river

agaaming *adv* on the other side of a body of water (a lake, a river), across a body of water (a lake, a river)

agaasaamagad *vii* it is small

agijaya'ii *adv* on top of it

agiji- *pv* on top of

agim *vta* count h/, include h/ a member; **gaa-ogichidaakwe-agiminjig** add-on ogichidaakweg

aginzo *vai* s/he is counted, is a member

agoojigaazo vai s/he is hung (by someone), "they" hang h/ (*e.g.,* a feather)

145

agoojin *vai* s/he hangs; s/he is in the sky (*e.g.,* a star, the sun, the moon)

agoozh /agooN-/ *vta* hang h/ (*e.g.,* a feather, a drum)

agwajiing *adv* outside, outdoors

agwaaba'an *vti* scoop it up, ladle it out

agwaa'izekweshimo *vai* s/he dances the food offering song, does the taking the kettle off of the fire dance

agwaa'izekweshimo-nagamon *ni* food offering song, taking the kettle off of the fire song; *a ceremonial song*

agwaataa *vai* s/he goes ashore, comes ashore

a'aw *pron dem* that; *animate singular demonstrative; also* **aw**

akawaabandan *vti* wait in watch for it, expect it to come

akawe *adv* first (in time sequence), first of all, for now

akeyaa *adv* in the direction of, that way

aki *ni* earth, land, ground, country

akik *na* kettle, pot, pan

akiwenzii *na* old man

akiwenziiyi-nagamon *ni* old man song; *a ceremonial song*

akoozi *vai* s/he is a certain length, is a certain height, is so long, is so tall

akwaamagad *vii* it is a certain length, is a certain height, is so long, is so tall

Amikogaabaw *name* Larry Smallwood

Amikogaabawiikwe *name* Julie Shingobe

amo /amw-/ *vta* eat h/

anang *na* star

anaakan *ni* mat

ani- *pv* going away, going along, in progress, on the way, coming up in time; *also* **ni-**

animikodaadii-nagamon *ni* welcoming song; *a ceremonial song*

Anishinaabe *na* Ojibwe, Indian (in contrast to non-Indians), person, human

anishinaabe-niimi'idiwag /anishinaabe-niimi'idi-/ they have an Anishinaabe ceremonial dance

anishinaabewi *vai* s/he is Ojibwe, is Indian (in contrast to non-Indians), is human

anishinaabewinikaazo *vai* s/he has an Ojibwe name

aniibiish *ni* tea

anooj *adv* various, all kinds

apabiwin *ni* chair, seat

apagiji-ziigwebinigaade *vii* it is thrown in the garbage

apagizo *vai* s/he throws h/self down against something

apagizom *vta* send h/ (by voice) (*e.g.*, tobacco)

apagizondamaw *vta* send (it) to h/ (by voice) (*e.g.*, tobacco)

apagizondan *vti* send it (by voice) *(e.g.*, food, *inanimate* items)

apagizonjigaade *vii* it is sent (by voice); "they" send it (by voice) (*e.g.*, food, *inanimate* items)

apagizonjigaazo *vai* s/he is sent (by voice); "they" send h/ (by voice) (*e.g.*, tobacco)

apa'iwe *vai* s/he runs away from people to a certain place

apane *adv* always, all the time, continually

apegish *adv* I wish that ...

apenimo *vai+o* s/he relies on something, depends on something

apigaabawi *vai+o* s/he relies on (it) for spiritual support

apinikaazo *vai* s/he is named after somebody

apii *adv* when, then, at the time

apiichitaa *vai* s/he is engaged in an activity to a certain extent, is so far along in an activity

apiitakamigizi *vai* s/he is engaged in an event to a certain extent, is or goes so far along doing something

apiitendan *vti* value it to a certain extent, appreciate it

apiitendaagwad *vii* it is valued so high, ranks so high, is so important, is worthy, is appreciated

asemaa *na* tobacco

asemaa-makakoons *ni* the ceremonial drum's tobacco box

asemaa-onaagan *ni* the ceremonial drum's tobacco dish

asemaakaw *vta* make an offering of tobacco to h/

asemaake *vai* s/he makes a tobacco offering

asham *vta* feed (it) to h/

ashamoonsi *vai+o* s/he feeds people

ashange *vai* s/he feeds people, serves food

ashaweshin *vai* s/he lies on a slant, lies uneven

ashi /aS-/ *vta* put h/ in a certain place

ashi-bezhig *adv* eleven

ashi-niso-biboonagizi *vai* s/he is thirteen years old

ashi-niiwin *adv* fourteen

ashi-niizho-biboonagizi *vai* s/he is twelve years old

ashi-niizhwaaswi *adv* seventeen

ashi-zhaangaswaak miinawaa nisimidana ashi-niizhwaaswi gii-piboonagad *vii* it is the year 1937

ashi-zhaangaswaak miinawaa niizhwaasimidana ashi-niiwin gii-piboonagad *vii* it is the year 1974

asigaabikwe *vai* s/he collects money

asigisidoon *vti2* put it together, collect it

asigisin *vii* it accumulates

atamaw *vta* put (it) in a certain place for h/

ate *vii* it is in a certain place

atoon *vti2* put it in a certain place

awanjish *adv* even though, once

awasayi'ii *adv* beyond it; on the other side of it

awashime *adv* much more

awedi *pron dem* that over there; **awedi bezhig** that other one over there

awegonen *pron inter* what; *inanimate interrogative*

awenen *pron inter* who; *animate interrogative*

awesiinh *na* wild animal

awiya *pron indf* somebody, anybody; *animate indefinite*

aya'aansiwi *vai* s/he is young

ayaa *vai* s/he is (in a certain place); *with a lexical preverb* s/he is in a certain state; *with a directional preverb* s/he moves in a certain way

ayaamagad *vii* it is (in a certain place); *with a lexical preverb* it is in a certain state; *with a directional preverb* it moves in a certain way

ayaan /ayaam-/ *vti4* have it, own it

ayaangwaamim *vta* encourage, warn, caution h/

ayaangwaamitaagozi *vai* s/he is encouraging, is cautioning

ayaangwaamitoon *vti2* carefully do it, cautiously do it

ayaangwaamizi *vai* s/he is careful, is cautious

ayaapii *adv* every once in a while, every so often

ayaaw *vta* have h/, own h/

ayizhinoo' /ayizhinoo'w-/ *vta* point to h/ a certain way; *reduplication of* **izhinoo'**

ayizhinoo'amaw *vta* point to (it) for h/ a certain way; *reduplication of* **izhinoo'amaw**

azhe- *pv* go back

azhegiiwe *vai* s/he goes or comes back, returns

azhegiiwemagad *vii* it goes or comes back, returns

azhigwa *adv* now, at this time, already, then

aabajichigaade *vii* it is used (by someone), "they" use it

aabajichigaazo *vai* s/he is used (by someone), "they" use h/

aabaji' *vta* use h/

aabajitoon *vti2* use it

aabiding *adv* once, at one time

aabiji- *pv* continually, constantly

aabiinji' *vta* beat h/ up bad

aada'odiwag /aada'odi-/ *vai* outdo each other, defeat each other in a competition

aajimodakwe *vai* s/he tells a story about a wartime experience

aakozi *vai* s/he is sick, is ill

aakoziwin *ni* sickness, illness, disease

aana- *pv* in vain, without result

aandapizh /aandapiN-/ *vta* retie, rewrap h/

aanikebiitaw *vta* be seated next to h/, be seated in succession to h/

aanikoobijige *vai* s/he is a great-grandparent

aanikoosijigaade *vii* it is laid joining something else (by someone), "they" lay it joining something else (*e.g.,* as in a tail of a song)

aanind *adv* some

aaningodinong *adv* sometimes, occasionally

aanishim *vta* discourage h/

aaniin *adv* how?, why?, in what way?

aaniin igo *adv* however

aaniindi *adv* where?

aaniindi-go *adv* wherever

aaniish naa *adv* after all, well now; you see

aanjichigaazo *vai* s/he is changed; s/he is made different

aanji' *vta* change h/, make h/ over

aanjikii *vai* s/he changes worlds

aano-go *adv* anyhow, although, despite, but

aanoodizi *vai* s/he desires, is determined

aanoozim *vta* tell h/ you desire him/her to do something

aapiji *adv* very, quite

aayaabajichigaazo s/he is used (by someone), "they" use h/; *reduplication of* **aabajichigaazo**

aayaabajitoon *vti2* use it; *reduplication of* **aabajitoon**

aayaanjiwebinigaade *vii* the tune of it is changed (by someone), "they" change the tune

aazhita *adv* in return

aazhoge *vai* s/he goes across, crosses

Aazhoomog *place* Lake Lena, Minnesota

babagiwayaan *ni* shirt

babaamaadizi *vai* s/he travels about

babaamaadizii-nagamon *ni* traveling song; *a ceremonial song*

babaamendan *vti* be bothered by it

babaamibatoo *vai* s/he runs about

babaamiwizh /babaamiwiN-/ *vta* take, carry, guide h/ about

badakide *vii* it sticks up, stands up (from a surface)

badakidoon *vti2* set it up, erect it

150

badakijigaade *vii* it is stood up (from a surface) (by someone); "they" stand it up

bagidenim *vta* let h/ go from your mind

bagidin *vta* set h/ down, offer h/, release h/, let h/ go, allow h/

bagijigan *ni* offering

bagijige *vai* s/he makes an offering

bagijwebinan *vti* release it quickly, throw it down quickly

bagosenim *vta* wish for h/, hope for h/

bagwaj *adv* in the wilderness, out in the woods

bakaan *adv* different

bakaanad *vii* it is different

bakaanizi *vai* s/he is different

bakite' /**bakite'w-**/ *vta* hit, strike h/

bakite'igaazo *vai* s/he is hit, struck (by someone), "they" hit, strike h/

bakwenigaade *vii* a portion of it is removed (by someone); "they" remove a portion of it

bakwezhigan *na* bread

bakwezhigaans *na* cookie, cracker, roll

banangwewe *vai* s/he sounds flat (*e.g.,* a drum)

bangii *adv* a little; a little bit; few

bangishimo *vai* the sun sets

bangishimon *vii* it sets as the sun, is sunset

bangishin *vai* s/he falls

bangisidoon *vti2* it falls

bangiiwagizi *vai* there is a little bit of h/; *plural* there are few of them

banizi *vai* s/he misses out

bapazigwiitan *vti* stand up at it; *reduplication of* **bazigwiitan**

bawaazh /**bawaaN-**/ *vta* dream of h/

bazigwadin *vta* stands h/ up

bazigwii *vai* s/he stands up

bazigwiitan *vti* stand up at it

baa- *pv* about a place (local distributed)

151

baa-ayaad *vai* s/he is around, wanders about

baabii' *vta* keep waiting for h/

baabii'o *vai* s/he keeps waiting

baabiitoon *vti2* keep waiting for it

Baadaasige *name* David Matrious

baaga'akokwaan *ni* drumstick

baaga'akokwe *vai* s/he beats a drum

baakaakonan *vti* open it (something solid or of wood)

baakishin *vai* s/he is left open, is left uncovered

baakiiginigaade *vii* it is opened (sheet-like) (by someone), "they" open it

baakishim *vta* leave h/ uncovered

baamaashi *vai* s/he flies about

baanimaa *adv* later, after awhile

baapaakishim *vta* leave h/ uncovered; *reduplication of* **baakishim**

baapi *vai* s/he laughs

bebakaan *adv* all different

bebezhig *adv* one-by-one

bebezhigooganzhii *na* horse

Bebiskiniyaashiikwe *name* Linda Shabaiash

besho *adv* near, close

bezhig *adv* one

bezhigwan *vii* it is one; it is only one; it is the same

bi- *pv* this way, here, hither

bibine-bakwezhigan *na* flour

biboonagad *vii* it is a winter, it (a year) passes

bijiinag *adv* after awhile, recently, just now

bikwak *ni* arrow

bimaadizi *vai* s/he lives, is alive

bimaadiziwin *ni* life

bimaawanidiwag /bimaawanidi-/ *vai* they travel about as a group of people

bimi- *pv* along, going along, going by, going past, on the way

bimi-ayaa *vai* s/he goes, travels along

bimi-giizhigad *vii* the day goes along, passes

bimisemagad *vii* it (time) goes along, passes

bimiwanaan *ni* bundle, pack

bimiwidoon *vti2* carry it along, take it along; carry it on, conduct it

bimiwizh /bimiwiN-/ *vta* carry h/ along, take h/ along

bimwaagan *na* one who has been shot

Binesi *na-pl* Thunder-being; *Manidoo*

Binesi-dewe'igan *na* Thunder-being drum; *a type of ceremonial drum*

bitaakoshkan *vti* bump into it

bizaan *adv* quiet, quietly, still, at peace

bizhiki *na* bison, buffalo

bizhikiiwi-nagamon *ni* buffalo song; *used at ceremonial dance*

bizhishigwaamagad *vii* it is empty

bizindaw *vta* listen to h/

biibaagi *vai* s/he calls out, shouts

biigoshkaa *vai* s/he breaks, is broken

biimiskoshim *vta* turn h/ over (*e.g.*, a drum)

biindaakoojige *vai* s/he makes an offering of tobacco

biindaakoozh /biindaakooN-/ *vta* make an offering of tobacco to h/

biindaakwaan *na* snuff

biindigadamaw *vta* bring (it) inside for h/, take (it) inside for h/

biindigadoon *vti2* bring it inside, take it inside

biindigajigaade *vii* it is being brought inside (by someone), "they" bring it inside

biindigajigaazo *vai* s/he is being brought inside (by someone), "they" bring h/ inside

biindigazh /biindigaN-/ *vta* bring h/ inside, take h/ inside

biindige *vai* s/he enters, goes inside, comes inside

biindigeshimo *vai* s/he dances in a grand entry at a powwow

biingeyenim *vta* be astonished about h/

biinish *adv* until, up to; continuing on

biinish gaye *adv* and also

biinji- *pv* inside

biiwide *na* visitor, guest

biizh /biiN-/ *vta* bring h/

biizikan *vti* wear it, have it on (*e.g.,* clothes), put it on (*e.g.,* clothes)

biizikigan *ni* item of clothing

biizikoozh /biizikooN/ *vta* dress h/, put clothes on h/

booch *adv* it is necessary, it is certain, you have to

boonitoon *vti2* leave it alone, quit it

boozikinaagan *ni* bowl

Bwaan *na* a Dakota

Bwaan-akiing *ni* Dakota country

bwaanawitoon *vti2* be unable to do or manage it

Bwaani-dewe'igan *na* ceremonial drum, big drum; Sioux drum

Bwaanikwe *na* Dakota woman

chi- *pv* big, great; *also* **gichi-**

chi-baaga'akokwaan *ni* big-stick; *a specific ceremonial drum stick*

Chi-minising *place* Isle, Minnesota

chi-mookomaan *na* white man

chi-niimi'idiwag /chi-niimi'idi-/ *vai* they dance at a ceremonial dance; **chi-niimi'idim** there is a ceremonial dance

chi-niimi'idiike *vai* s/he puts on a ceremonial dance

Chi-waabashkikiing *place* swamp near East Lake community

da- *pv future tense in independent order:* will; *future and modal prefix in unchanged conjunct:* that, so that, in order to; *also* **ji-**

dabazhish *adv* low, down low

dabwaa- *pv* before

dagode *vii* it is cooked with something else

dagonan *vti* add it in, mix it in

dagoshimoonagad *vii* it arrives

dagoshimoono *vai* s/he arrives

dagoshin *vai* s/he arrives

dagosijigaade *vii* it is added to something (by someone); "they" add it to something

dagwaagin *vii* it is fall, is autumn

dakobizh /dakobiN-/ *vta* tie, bind h/

dakon *vta* hold h/, take hold of h/

dakonan *vti* hold, take hold of it

danakamigad *vii* it (an event) takes place, happens in a certain place

danakamigizi *vai* s/he has an event in a certain place

danakii *vai* s/he lives in a certain place

danaajim *vta* tell of h/ in a certain place

danizi *vai* s/he is in a certain place

dash *adv* and, but

dasing *adv* a certain number of times, so many times

daswaabik *adv num* a certain number of dollars; so many dollars

dazhi- *pv* in a certain place, of a certain place, there

dazhim *vta* talk about, discuss h/

dazhindan *vti* talk about, discuss it

dazhinjigaade *vii* it is talked, about, discussed (by someone), "they" talk about, discuss it

dazhinjigaazo *vai* s/he is talked about, is discussed (by someone), "they" talk about, discuss h/

dazhitaa *vai* s/he spends time in a certain place

dazhiikan *vti* work at or on it; be involved, occupied, engaged with it

dazhwegisidoon *vti2* lay it out spread flat

daa *vai* s/he lives in a certain place; **endaashaan** where I live, my home

daa- *pv* would, could, should, can, might *modal*

daangin *vta* touch h/ (with hand)

daanginibii'amaw *vta* touch h/ with (it) to mark or color h/ (*e.g.,* with paint, lipstick)

daangishkan *vti* touch it (with foot or body)

daawanabi *vai* s/he sits with h/ mouth open

de- *pv* sufficient, suitable, enough

debinaak *adv* carelessly, half-heartedly

debisewendam *vai2* s/he is content, feels satisfied

debwe *vai* s/he tells the truth, speaks the truth

desapabiwin *ni* bench

dewe'igan *na* drum

dibagindan *vti* compare it, judge by it

diba'amaw *vta* pay h/ for (it), pay (it) for h/

diba'an *vti* pay for it

diba'ige *vai* s/he pays things

dibaajinjigaazo *vai* s/he is told of, reported (by someone), "they" tell of, report h/

dibaakon *vta* judge h/

dibendan *vti* control it, be the master of it, own it, earn it

dibendaagozi *vai* s/he belongs, is a member

dibendaagwad *vii* it belongs

dibikad *vii* it is night

dibiki-giizis *na* moon

dibishkoo *adv* just like, even, equal, direct

doodan *vti* do something to it

doodaw *vta* do something to h/; **weweni doodaw** be respectful to h/

eko-ashi-bezhigong *adv* the eleventh

eko-ashi-ishwaaching *adv* the eighteenth

eko-ashi-naaning *adv* the fifteenth

eko-ashi-ningodwaaching *adv* the sixteenth

eko-ashi-nising *adv* the thirteenth

eko-ashi-niiwing *adv* the fourteenth

eko-ashi-niizhing *adv* the twelfth

eko-ashi-niizhwaaching *adv* the seventeenth

eko-ashi-zhaangaching *adv* the nineteenth

eko-ishwaaching *adv* the eighth

eko-midaaching *adv* the tenth

eko-naaning *adv* the fifth

eko-ningodwaaching *adv* the sixth

eko-nising *adv* the third

eko-niiwing *adv* the fourth

eko-niizhing *adv* the second

eko-niizhwaaching *adv* the seventh

eko-zhaangaching *adv* the ninth

endasing *adv* everytime

endaso-dagwaagi *adv* every fall, every autumn

endaso-zaagibagaa *adv* every spring

enigok *adv* with effort; harder

eshkam *adv* gradually, more and more, less and less

eta *adv* only

eyiizh *adv* both

gabe-dibik *adv* all night

gagwaadagi' *vta* bother h/, make h/ suffer

gagwaadagizi *vai* s/he has difficulties

gagwe- *pv* try

gagwedwe *vai* s/he asks questions, inquires

gagwejim *vta* ask h/

gakina *adv* all

ganabaj *adv* one thinks that, maybe

ganawaabandan *vti* look at, watch it

ganawaabi *vai* s/he looks, watches

ganawendamaage *vai* s/he takes care of things for people

ganawendan *vti* take care of it, watch over it

ganawenim *vta* take care of h/, watch over h/

ganawenjigaazo *vai* s/he is taken care of, protected, kept (by someone), "they" take care of, protect, keep h/

ganoodamaw *vta* speak for h/

ganoozh /ganooN-/ *vta* address h/, speak to h/

gashkapijigaade *vii* it is wrapped and tied in a bundle (by someone); "they" wrap and tie it in a bundle

gashkapijigaazo *vai* s/he is wrapped and tied in a bundle (by someone); "they" wrap and tie h/ in a bundle

gashkibidaagan *na* bag with a closeable top: tobacco pouch, bandolier bag

gashkigwaadan *vti* sew it

gashkigwaade *vii* it is sewn

gashkigwaaso *vai* s/he sews

gashkigwaazh /gashkigwaaN-/ *vta* sew h/ (*e.g.*, a bandolier bag)

gashki'ewizi *vai* s/he is able to do something, is capable

gashkitoon *vti2* be able to do it, succeed at it, manage it

gawizi *vai* s/he does something in vain; **gaawiin gawizisiin** s/he does not do without a result

gayat *adv* formerly, previously, some time ago

gaye *adv* as for, also, too, and

gaabige *adv* immediately, quickly, right away

gaadamaw *vta* hide (it) from h/

Gaagige-oshkiniigikwe *name* Forever Lasting Young Woman; *Manidoo*

gaagiigido *vai* s/he talks, speaks

gaagiizitaagozi *vai* s/he makes amends; s/he asks for forgiveness

gaagiizom *vta* apologize to h/; ask h/ for forgiveness

gaagwiinawi- *pv* not knowing, not able; *reduplication of* **gwiinawi-**

gaanjwebin *vta* push, force h/

gaasiinigaade *vii* it is wiped (by someone), "they" wipe it

gaawiin *adv* no, not

gaawiin aapiji *adv* not very

gaawiin gegoo *pron indf* nothing; *inanimate indefinite*

gaawiin ingwadinoo *adv* it does not matter; it is okay that...

gaawiin mashi *adv* not yet

gaawiin memwech *adv* it is not necessary

gaawiin wiikaa *adv* never

gaazo *vai* s/he hides

ge- *pv future tense preverb under initial change*

geget *adv* sure, indeed, certainly, really

gego *adv* don't

gego ganage *adv* don't in any way, don't you dare

gegoo *pron indf* something, anything; *inanimate indefinite*

gemaa *adv* or, or maybe

gete-anishinaabe *na* old time Indian, Indian of a former time

gete-niimi'idiiwigamig *na* old ceremonial dance hall, ceremonial dance hall of a former time

geyaabi *adv* still, yet

gezikwendan *vti* barely remember it

gibaabowe'igan *ni* pot lid

gibaakwa'odiiwigamig *ni* jail, prison

gichi-aya'aa *na* adult, elder

gichi-aya'aawi *vai* s/he is an elder

gidagiigin *ni* print cotton fabric

gidinwewininaan /inwewin-/ *ni* our (inclusive) language; Ojibwe

gidiskaakwanan *vti* release, disconnect, unhook it (something solid or of wood)

Giganaan *name* Moon; *Manidoo*

gigishimo *vai+o* s/he dances with (it)

gigishkan *vti* wear it; have it on (the body), bear it (on the body)

gigizhebaa-ashange *vai* s/he feeds people breakfast, serves breakfast

gigizhebaawagad *vii* it is morning

gijipizon *ni* belt; ceremonial drum feather belt

gijipizon-nagamon *ni* feather belt song; *a ceremonial song*

gikendan *vti* know it

gikendaagwad *vii* it is known (by someone), "they" know it

gikenim *vta* know h/, know of h/

gikinawaadabi' *vta* seat h/ in a designated spot

gikinoo'amaw *vta* teach it to h/

gikinoo'amaadiiwigamig *ni* school

gikinoo'amaage *vai* s/he teaches, instructs

gikinoo'amaagozi *vai* s/he goes to school

gikinoo'amaagoowizi *vai* s/he is taught

gikinoonowin *ni* year

gimishoomisinaan /-mishoomis-/ *nad* our (inclusive) grandfather

Gimishoomisinaan *nad* ceremonial drum; *inclusive possessed form of* /-mishoomis-/ grandfather

giniigaaniiminaang /-niigaaniim-/ *nid* our (inclusive) future

giniijaanisag /-niijaanis-/ *nad* your children; **giniijaanisinaanig** our (inclusive) children

ginwaabiigad *vii* it is long (as something string-like)

ginwenzh *adv* for a long time

gizhibaabizh /gizhibaabiN-/ *vta* twirl, spin h/

Gizhibaagwaneb *name* Skip Churchill

gizhibaashimo *vai* s/he dances around

gizhibaashimotan *vti* dance around it

gizhibaashkaw *vta* go around h/

gizhibaashkaa *vai* s/he goes around

gizhibaashkaamagad *vii* it goes around

gizhibaawizh /gizhibaawiN-/ *vta* carry h/ around

gizhibaawose *vai* s/he walks around in a circle

gizhibaawose' *vta* walk h/ around

giziibiigin *vta* wash h/ (by hand)

gii- *pv past tense*

giige' *vta* benefit h/

giige'idizo *vai* s/he benefits h/self

giigidowin *ni* speech, song (text)

giigoonh *na* fish

giikabi *vai* s/he scoots forward in a sitting position

giikaandiwag /giikaandi-/ *vai* they argue, quarrel with each other

giimoojichige *vai* s/he does something secretly

giin *pron per* you (singular) *second person singular pronoun*

giishkiga'igaazo *vai* s/he is chopped off (by someone), "they" chop h/ off

giishpin *adv* if

giiwashkwebii *vai* s/he is drunk

giiwe *vai* s/he goes home, returns

giiwebizo *vai* s/he drives home

giiwedin *ni* north wind, north; **giiwedinong** in the north

giiwenaazha' / giiwenaazha'w-/ *vta* tell h/ to go home

giiwenige *vai* s/he gives presents to relatives of someone deceased in completion of mourning on the anniversary of the death

giiwewizh /giiwewiN-/ *vta* take, carry h/ home

Giiweyaanakwad *name* Elmer Nayquonabe

giiwose-nagamon *ni* hunter's song; *a ceremonial drum song*

giizhi- *pv* finish, complete

giizhichigaazo *vai* s/he is finished (by someone), "they" finish h/

giizhiganike *vai* it is daytime for h/

giizhi'amaazo *vai* s/he finishes singing

giizhakamigad *vii* it (an event) is finished

giizhiikan *vti* complete it, finish with it; *reduplicated form*
 gaakiizhiikan

giizhiikaw *vta* finish, finish with h/

giizhiitaa *vai* s/he finishes, gets done

giizis *na* sun, moon, month

giizisijigaade *vii* it is completely laid out (by someone); "they"
 completely lay it out

-go *pc* [emphatic word]; *also* **igo**

gomaapii *adv* for sometime, some distance, after awhile

gotan *vti* be afraid of it, fear it

Gookomisakiinaan *name* Our grandmother the earth (Wenabozho's
 grandmother); *Manidoo*

gookomisinaan /**-ookomis-**/ *nad* our (inclusive) grandmother

Gookomisinaan *nad* Ladies' drum; *a type of ceremonial drum;*
 inclusive possessed form of /**-ookomis-**/ grandmother

goozhishenyag /**-oozhisheny-**/ *nad* your grandchildren;
 goozhishenyinaanig our (inclusive) grandchildren

Gwaaba'igan *place* Sawyer, Minnesota

gwiinawaabandan *vti* fail to see h/

igo *pc* [emphatic word]; *also* **–go**

i'iw *pron dem* that; *inanimate singular demonstrative; also* **iw**

i'iwapii *adv* at that time

ikido *vai* s/he says

iko *pc* used to, formerly, it was the custom to; *also* **–ko**

ikwabi *vai* s/he resigns a seat

ikwabi' *vta* remove h/ from a seat

ikwabi'idizo *vai* remove h/self from a seat

ikwe *na* woman, lady

Ikwe-dewe'igan *na* Ladies' drum; *a type of ceremonial drum*

ikwe-nagamon *ni* sidestep song

ikwe-niimi'idiwag /ikwe-niimi'idi-/ *vai* they dance sidestep

ikwewi *vai* she is female

imaa *adv* there

inabi *vai* s/he sits a certain way, sits there

inabi' *vta* seat h/ in a certain way

inagim *vta* set a certain price on h/, designate h/, intend h/ for a certain purpose

ina'oonwewizi *vai* s/he is given something as a gift

ina'oozh /ina'ooN-/ *vta* give h/ something as a gift in a certain way

inakamigad *vii* it is a certain event, happens a certain way

inakamigizi *vai* s/he does a certain thing, has such happen to h/

inanjige *vai* s/he eats a certain way

inawem *vta* be related to h/

inawemaagan *na* relative; **gidinawemaaganag** *nad* your relatives; **gidinawemaaganinaan** *nad* our (inclusive) relative; **gidinawemaaganinaanig** *nad* our (inclusive) relatives; **gidinawemaaganiwaa** *nad* your (plural) relative; **indinawemaaganidog** *nad* you my relatives; *vocative plural;* **odinawemaaganan** *nad* h/ relative(s); **odinawemaaganiwaan** *nad* their relative(s)

inawendaaso *vai* s/he is related in a certain way; **besho enawendaasojig** close relatives

inaabadad *vii* it is useful in a certain way, is employed in a certain way

inaabaso *vai* the smoke of the tobacco goes a certain way

inaabishin *vai* s/he sees things a certain way

inaajimotaw *vta* tell h/ of (it) a certain way

inaakodan *vti* decide it a certain way

inaakonige *vai* s/he decides things a certain way, agrees on something

inaapine *vai* s/he is sick in a certain way

inaasamabi *vai* s/he sits facing in a certain way

inaasamigaabawi *vai* s/he stands facing a certain way

indedeyiban /-dedey-/ *nad* my late father

inendam *vai2* s/he thinks a certain way; s/he decides, agrees

inendaagozi *vai* s/he is thought of a certain way, seems to be a certain way, has a certain destiny

inendaagwad *vii* it is thought of a certain way, seems to be a certain way; has a certain destiny

ingiw *pron dem* those; *animate plural demonstrative*

ingo-biboon *adv* one year; one winter

ingo-biboonagad *vii* it is one year

ingo-diba'iganed *vii* it is one o'clock

ingoding *adv* sometime, at one time

ingoji *adv* somewhere, anywhere, approximately, nearly

inigaachigaade *vii* it is treated badly, is abused, is hurt (by someone), "they" treat, abuse, hurt it

inigaa' *vta* treat h/ badly, abuse h/, hurt h/

inigaawendam *vai* s/he feels bad

inigokwekamig *adv* (in) abundance

inikaa *vai* s/he goes a certain way

inikaamagad *vii* s/he goes a certain way

ininamaw *vta* hand it to h/ a certain way

inini *na* man

iniw *pron dem* that; *animate obviative demonstrative;* those; *inanimate plural demonstrative; also* **inow**

inow *pron dem* that; *animate obviative demonstrative;* those; *inanimate plural demonstrative; also* **iniw**

inwe *vai* s/he speaks a certain language

inwewin *ni* language; **gidinwewininaan** our (inclusive) language

isa *pc* [emphatic word]; *also* **-sa**

ishke *pc* look!, behold!

ishkonigan *ni* reservation

ishkwaa- *pv* after

ishkwaa-ayaa *vai* s/he has passed, is dead

ishkwaa-naawakwe *vii* it is afternoon

ishkwaa'amaazo *vai* s/he finishes singing
ishkwaa'an *vti* finish singing it
ishkwaaj *adv* last; finally
ishkwaajanokii-giizhigad *vii* it is Saturday
ishkwaataa-nagamon *ni* song that ends the dance; *a ceremonial song*
ishkwe-ayi'ii *adv* at the end of it
ishkwebi *vai* s/he sits at the end
ishkwesin *vii* it lies at the end
ishkweyaang *adv* behind; in the past
ishkweyaange *vai* s/he is late, is running behind schedule
Ishkweyaash *name* [English name unknown]
Nechiiwaanakwad *name* Merlin Anderson
ishkose *vai* s/he is leftover; (*e.g.,* tobacco)
ishpiming *adv* in the sky, above
ishwaachiwag /ishwaachi-/ *vai* they are eight, there are eight of them
iw *pron dem* that; *inanimate singular demonstrative; also* **i'iw**
iwapii *adv* at that time; then
iwedi *pron dem* that over there; *inanimate singular demonstrative;* **iwedi bezhig** that other one over there
iwidi *adv* over there
izhaa *vai* s/he goes to a certain place
izhaamagad *vii* it goes to a certain place
izhi /iN-/ *vta* say to h/, speak so to h/
izhi- *pv* in a certain way, to a certain place, thus, so, there
izhi-ayaa *vai* s/he is a certain way
izhi-gwayak *adv* straight
izhi-wiindan *vti* call it a certain way, name it a certain way
izhi-wiinjigaade *vii* it is named a certain way (by someone); "they" name it a certain way
izhi-wiinjigaazo *vai* s/he is named a certain way (by someone); "they" name h/ a certain way

izhi-wiinzh /izhi-wiinN-/ *vta* call h/ a certain way, name h/ a certain way

izhibii'igaazo *vii* it is marked by ink a certain way (by someone), "they" mark it with ink it a certain way

izhichigaade *vii* it is made a certain way (by someone); "they" make it a certain way

izhichigaazh /izhichigaaN-/ *vta* make h/ a certain way

izhichigaazo *vai* s/he is made a certain way (by someone), "they" make h/ a certain way

izhichige *vai* s/he does things a certain way

izhinikaazo *vai* s/he is named a certain way

izhinikaazowin *ni* personal or family name

izhinizha' /izhinizha'w/ *vta* send h/ to a certain place

izhinizha'igaade *vii* it is sent to a certain place (by someone), "they" send it to a certain place

izhinoo' /izhinoo'w-/ *vta* point to h/ a certain way

izhinoo'igaazo *vai* h/ is pointed to a certain way (by someone), "they" point to h/ a certain way

izhitaa *vai* s/he engages in an activity a certain way

izhiwebad *vii* it happens a certain way; it is a certain event; it is a certain weather condition

izhiwebizi *vai* s/he behaves a certain way, has certain things happen to h/, fares a certain way

izhiwidamaw *vta* take, carry (it) to h/ at a certain place

izhiwijigaazo *vai* s/he is it taken, carried to a certain place (by someone); "they" take, carry it to a certain place

izhiwizh /izhiwiN-/ *vta* take, carry h/ to a certain place

jaagaakizo *vai* s/he burns

jaagide *vii* it burns up

jaagizo *vai* s/he burns

jiibaakwaadan *vti* cook it

jiibaakwaan *ni* cooking

jiibaakwe *vai* s/he cooks

jiibaakwewigamig *ni* kitchen

jiigayi'ii *adv* along it; by it

-ko *pc* used to, formerly, it was the custom to; *also* **iko**

madwewechige *vai* s/he makes things sound, plays (music)

majayi'ii *adv* something bad, negativity

maji-izhi /**maji-iN-**/ *vta* speak ill of or to h/

maji-izhiwebizi *vai* s/he misbehaves, behaves improperly, is naughty, is evil

makam *vta* take (it) from h/ (forcibly), rob h/ of (it)

makandamaw *vta* take (it) from h/, deprive h/ (of it)

makwa *na* bear

mamanaajitoon *vti* treat h/ with respect, handle it carefully; *reduplication of* **manaajitoon**

mamaw *vta* take (it) from, pick it up from h/

mamaajigaadeni *vai* s/he moves h/ legs

mamaajii *vai* s/he moves, is in motion

mamaanjigon *vta* hold h/ so h/ can't move, restrain h/

mami /**mam-**/ *vta* take h/

mamigaade *vii* it is taken (by someone), "they" take it, it is picked up (by someone), "they" pick it up

maminose *vai* s/he has things go well for h/, gets along well, has good luck; *reduplication of* **minose**

mamiikwaandan *vti* praise it

mamoon *vti2* take it

manaaji' *vta* treat h/ with respect

manaajitoon *vti* treat h/ with respect, handle it carefully

manezi *vai+o* s/he lacks (it)

Manidoo *na* spirit; *left untranslated as* **Manidoo**; *pl* **Manidoog**

Manidoo-dewe'igan *na* ceremonial drum

manidoo-giigidowin *ni* ceremonial song

manidooke *vai* s/he conducts a ceremony

manidoominensikaan *na* (item of) bead work

manidoowaadad *vii* it has a spiritual nature

manidoowaadizi *vai* s/he has a spiritual nature

manidoowichige *vai* s/he has or participates in a ceremony

manoomin *ni* wild rice

mashkawaadizi *vai* s/he is strong, is powerful

mashkawaamagad *vii* it is powerful

mashkode-bizhiki *na* bison, buffalo

mawadishiwe *vai* s/he visits people

mawine'ondiwag /mawine'ondi-/ *vai* they charge after each other

mazina'igan *ni* book

mazina'igani-onaagan *ni* paper plate

maa *adv* for some time, some distance; some amount; to a middling degree; *also* **gomaa**

maada'akokwe *vai* s/he starts to beat a drum

maada'ookii *vai+o* s/he passes (it) out

maada'oozh /maada'ooN-/ *vta* pass (it) out to h/

maadakamigad *vii* it starts (as an event)

maadaabaso *vai* h/ smoke is going out, starting off

maagizhaa *adv* maybe; I think that..., perhaps

maajaa *vai* s/he leaves, departs, starts off

maajitaa *vai* s/he starts an activity

maajii- *pv* start; begin; start off

maajiidoon *vti2* carry, take it away

maajiigin *vii* it starts growing, grows up

maajii'am *vai2* s/he starts a song

maajii'amaazo *vai* s/he starts to sing

maajii'igaade *vii* it is started

maajiijigaazo *vai* s/he is taken away (by someone), "they" take h/ away; s/he is taken along (by someone), "they" take h/ along

maakishkoozo *vai* s/he is shot and wounded

maamandoogwaason *ni* quilt

maamawichige *vai* help one another, do things together

maamawichigewin *ni* collaboration

maamawinikeni *vai* s/he puts his hands together

maamiganjige *vai* s/he eats a variety of things

maamigin *vta* collect them (*animate*) together, gather them (*animate*)

maamiginan *vti* pick it up, gather it

maamiigiwe *vai* s/he gives something, gives things away; *reduplication of* **miigiwe**

maamiijin *vti3* keep eating it; *reduplication of* **miijin**

maamiizh /**maamiiN-**/ *vta* give (it) to h/; *reduplication of* **miizh**

maanoo *adv* never mind; let it be; don't bother; don't care

maazhi-doodaw *vta* treat h/ badly

maazhichige *vai* s/he does wrong, does bad things

maazhise *vai* s/he has something bad happen to h/

megwaa *adv* while, as, during (the time)

menwaagamig *ni-v* a soft drink; pop; soda

meshkwadoonigan *na* money

michisag *ni* floor

midaaso-diba'iganed *vii* it is ten o'clock

midaaswaabik *adv* ten dollars

mikan *vti* find it

mikwendan *vti* remember it, recollect it, come to think of it

mikwenim *vta* remember h/, recollect h/, come to think of h/

minawaanigozi *vai* s/he is happy, is joyous, has a good time

minawaanigwendaagwad *vii* it is considered to be happy or joyful

mindimooyenh *na* old lady, old woman

minik *adv* a certain amount, a certain number, so much, so many

minikwe *vai+o* s/he drinks (it)

minikwewin *ni* alcohol, drink

Minisinaakwaang *place* East Lake, Minnesota

mino- *pv* good, nice, well

mino-ayaa *vai* s/he is good, is fine, is well

mino-ayaawin *ni* good health

mino-bimaadizi *vai* s/he lives well, leads a good life, has good health

mino-doodaw *vta* treat h/ well

mino-gwiiwizensiwi *vai* he is a well-behaved boy

mino-mamaajii *vai* s/he has good movement

mino-mamaajiiwin *ni* good movement

168

minochige *vai* s/he does well, does a good thing

minokan *vti* fit it well

minokaw- *vta inverse forms* it (something consumed) agrees with h/, makes h/ well; **ge-minokaagod**

minose *vai* s/he has things go well for h/, gets along well, has good luck

minwaabam *vta* like the look of h/

minwaabishin *vai* s/he sees something beautiful, likes what h/ sees

minwendan *vti* like it

minwenim *vta* like h/

minwii *vai* s/he moves easily, works without distraction, is efficient

misawaa *adv* no matter what; even though, even if, despite

misawendan *vti* desire, want it

Misi-zaaga'igan *place* Mille Lacs Lake; Mille Lacs Reservation, Minnesota

miskobii' /**miskobii'w-**/ *vta* color h/ red

miskwaa *vii* it is red

miskwi *ni* blood

mitig *na* a tree

mitigoons *ni* stick

mitigwaab *na* bow

Mitigwaabiiwinini *name* The Bow Man; Tree; *Manidoo*

Mizhakwad *name* Albert Churchill

mii *adv* it is thus that, it is that

miigaadan *vti* fight it

miigaadiwag /**miigaadi-**/ *vai* they fight each other; **endazhi-miigaading** in the midst of war

miigaazh /**miigaaN-**/ *vta* fight h/

miigiwe *vai* s/he gives something, gives things away

miigwan *na* feather

miigwechiwi' *vta* thank h/

miigwechiwitaagozi *vai* s/he gives thanks

miijim *ni* food

miijin *vti3* eat it; *reduplicated form* **maamiijin**

miikwa'an *vti* hit it dead center with something
miinawaa *adv* again, and, also
miinigoowizi *vai* s/he is given something as a gift in a spiritual way
miizh /miiN-/ *vta* give (it) to h/
mooshkina' *vta* fill h/ (with solids)
moozhag *adv* often, constantly, several times
nabagisag *na* board
Nabaanaabe *na* Mermaid; *Manidoo*
nagamo *vai* s/he sings
nagamon *ni* song
nagazh /nagaN-/ *vta* leave h/ behind
namanj *adv* I don't know how, I wonder how; *also* **amanj**
namanjinikaang *adv* left side
nanagin *vta* hold h/ back; prevent h/ (from doing something)
nanaa'in *vta* put h/ in order; put h/ away; fix, repair h/
nanaa'inigaazo *vai* s/he is put away (by someone); "they" put h/
 away; s/he is buried
nanaa'isidoon *vti2* correct, adjust, change it
nanaamadabi *vai* s/he sits, sits down; *reduplication of* **namadabi**
nanaandonge *vai* s/he requests things; *reduplication of* **nandonge**
nanaandom *vta* ask for, call, summon h/; *reduplication of* **nandom**
nando-bimaadiziike *vai* s/he is seeking good health (from a state of
 sickness)
nandodamaw *vta* ask, beg h/ for (it)
nandodamaage *vai* s/he asks, begs people for things
nandom *vta* ask for, call, summon h/
nandwewem *vta* go and ask for h/
naniibikim *vta* scold h/
naniizaanendam *vai* s/he is cautious of danger
naniizaanendaagozi *vai* s/he is considered dangerous
naniizaanenim *vta* think h/ dangerous
napaaj *adv* opposite
napodinens *na* macaroni
nawaj *adv* more

Nazhikewigaabawiikwe *name* Sophia Churchill-Benjamin

nazikwe'igaade *vii* it is combed (by someone), "they" they comb it

naa *adv* and; also; again; *also* **miinawaa**

naabibiitaw *vta* take h/ place, sit as h/ representative; participate in a ceremony in h/ seat

naabishkaw *vta* take h/ place, partake in a ceremony on behalf of h/

naabishkaage *vai* s/he accepts or takes something for someone, participates in an offering on someone else's behalf

naadamaw *vta* help h/

naadamaage *vai* s/he helps people

naadamaagoowizi *vai* s/he is helped (in a spiritual way)

naadin *vti3* go get it, fetch it, go after it

naajigaade *vii* it is fetched (by someone), "they" fetch it

naanaagadawendam *vai2* s/he considers, notices, thinks, reflects, realizes

naangitaa *vai* s/he ups and leaves

naaniigaan *adv* ahead, leading, at the front; *reduplication of* **niigaan**

naaniimi'idiinsiwi *vai* s/he conducts a small ceremonial dance (usually held by special request); *reduplication of* **niimi'idiinsiwi**

naano-giizhigad *vii* it is Friday

naawayi'ii *adv* in the middle

naawigatig *adv* in the middle of the forehead

naazikan *vti* go to it, approach it

naazikaw *vta* go to h/, approach h/

naazikaage *vai* s/he goes to people, approaches people

nebowa *adv* many, much; a lot

Nechii'awaasang *name* Mary Churchill-Benjamin

neniizh *adv* two each

netamising *adv* the first

Netaawaash *name* John Sam

Neyaashiing *place* Vineland, Minnesota

ni- *pv* going away, going along, in progress, on the way, coming up in time; *also* **ani-**

niboowise *vai* s/he has a stroke

nichiiwichige *vai* s/he (a Thunder-being) makes it storm

ningaabii'an *ni* west; **ningaabii'anong** in the west

ningodwaaso-diba'iganed *vii* it is six o'clock

nishi /niS-/ *vta* kill h/

nishwanaajichige *vai* s/he spoils, disrups things

nisidawinaagwad *vii* it is known, recognized, identified (by sight)

nisimidana *adv* thirty

nising *adv* three times

nisiwag /nisi-/ *vai* they are three; there are three of them

nisonik *adv* three arms length; three yards

niswi *adv* three

nitam *adv* first

nitamisin *vii* it lies in the first position

nitaawigi' *vta* grow, raise h/

nizhishenh /-zhisheny-/ *nad* my cross-uncle (mother's brother)

nizigos /-zigos-/ *nad* my cross-aunt (father's sister)

niibawi *vai* s/he stands

niibaa-dibikoke *vai* it is night time for h/

niibide- *pv* in a row

niibidegaabawiwag /niibidegaabawi-/ *vai* they stand in a row

niibidesijigaade *vii* it is laid in a row (by someone), "they" lay it in a row

niiganakide *vii* it stands first (from a surface)

niigaan *adv* ahead, leading, at the front; in the future

niigaanabi *vai* s/he sits first

niigaanabi' *vta* seat h/ first

niigaanabiitaw *vta* sit first for h/

niigaani-abiigizigewinini *na* head ceremonial drum warmer, head ceremonial drum heater; *a ceremonial drum position.*

Niigaani-Manidoo *name* Head Manidoo; *Manidoo*

niigaani-niimi'iwewinini *na* first stick, west stick; lead singer; *a ceremonial drum position*

niigaani-ogichidaakwe *na* head ogichidaakwe; *a ceremonial drum position*

niigaanin *vta* put h/ first

niigaanizi *vai* s/he is the leader

niigaanii *vai* s/he goes ahead, leads

niigaaniimagad *vii* it leads

niimi *vai* s/he dances

niimi' *vta* make h/ dance

niimi'idiwag /niimi'idi-/ *vai* they dance

niimi'idiike *vai* s/he conducts a ceremonial dance

niimi'idiiwigamig *ni* ceremonial dance hall, dance hall

niimi'iwewinini *na* singer

niimikan *vti* dance it

niimikigaade *vii* it is danced (by someone), "they" dance it

niin *pron per* I, me; *first person singular pronoun*

niinawind *pron per* we, us; *first person plural exclusive pronoun*

niindaa' *vta* send (it) to h/

niindaa'iwe *vai* s/he sends (it) to people

niisaakwa'an *vti* disassemble it (*e.g.,* a building)

niishtana *adv* twenty

niishtana ashi-bezhig *adv* twenty-one

niishtana ashi-bezhigong *adv* the twenty-first

niishtana ashi-bezhigwanoon *vii* there are twenty-one

niishtana ashi-niizhing *adv* the twenty-second

niiwewaan *adv* four sets; four pairs

niiwin *adv* four

niiwiwag /niiwi-/ *vai* they are four; there are four of them

niizh *adv* two

niizhing *adv* two times

niizhiwag /niizhi-/ *vai* they are two; there are two of them

niizhiwanoon /niizhiwan-/ *vii* they are two, there are two of them

niizho-diba'iganed *vii* it is two o'clock

niizhwaasimidana *adv* seventy

Noodin *name* Joe Shabaiash Sr.

noogibagizo *vai* s/he stops dancing

noogitaa *vai* s/he stops an activity, stops working

nookaamagad *vii* it is soft; **onaagaans nwaakaamagak** a plastic cup

noomage- *pv* for a long time; for a spell; for awhile; complety

noomaya *adv* recently; a while ago; a little while ago

noondan *vti* hear it

noondaw *vta* hear h/

noongom *adv* now, nowadays, today

o- *pv* go over to

odayi'iimaanan /*ayi'iimaan-*/ *ni* h/ clothing

odaamikan /*-daamikan-*/ *nid* h/ chin

odaanisan /*-daanis-*/ *nad* h/ daughter(s)

odaapin *vta* accept (it) from h/, take h/

odaapinan *vti* accept, take it

odaapinige *vai* s/he accepts, takes, picks up things

Odaawaa-zaaga'igan *place* Lac Courte Oreilles, Wisconsin

odedeyibanen /*-dedey-*/ *nad* h/ late father

ode' /*-de'-*/ *nid* h/ heart

odeshkanaa *vai* s/he has horns (of an animal)

odewe'igani *vai* s/he has a drum or drums

odish /*odiS-*/ *vta* come upon h/, visit h/, meet up with h/

ogichidaa *na* veteran, warrior; *pl* **ogichidaag**; *a ceremonial drum position*

Ogichidaa-dewe'igan *na* warrior's drum; *a type of a ceremonial (Dakota) drum*

ogichidaakwe *na* lady who belongs to a ceremonial drum; *pl* **ogichidaakweg**; *a ceremonial drum position*

ogichidaakwewi *vai* she belongs to a ceremonial drum

ogimaa *ni* boss; drum keeper

Ogimaawab *name* John Benjamin

ogitiziiman /*-gitiziim-*/ *nad* h/ parent or parents

ogoodaas /*-goodaas-*/ *nid* her dress

ogookomisan /*-gookomis-*/ *nad* h/ grandmother

o'ow *pron dem* this; *inanimate singular demonstrative*

o'owapii *adv* at this time, then

okanaapine *vai* s/he has arthritis, has rheumatism

okaad /-kaad-/ *nid* h/ leg

okosijigan *ni* bundle

okosijige *vai* s/he makes up a bundle

okwi'idiwag /okwi'idi-/ *vai* they get together

omaa *adv* here

ombin *vta* lift, raise h/

onabi *vai* s/he takes a seat, sits down

onabi' *vta* seat h/; appoint h/

onaabam *vta* select h/

onaagan *ni* dish, plate

onaagaans *ni* cup

onaagoshi-ashange *vai* s/he feeds people supper

onaagoshin /onaagoshi-/ *vii* it is evening

onaajiwan *vii* it is beautiful

ondabi *vai* s/he sits in a certain place

ondabi' *vta* seat h/ where h/ came from

ondinan *vti* get it from a certain place, obtain it from a certain place

ondinige *vai* s/he gets things from a certain place, obtains things from a certain place

oninj /-ninjy-/ *nid* h/ hand

oniigaaniim /-niigaaniim-/ *nid* h/ future; **oniigaaniiming** in h/ future; **oniigaaniimiwaang** in their future; **giniigaaniiminaang** in our (inclusive) future

oniijaanisan /-niijaanis-/ *nad* h/ a child or children; **oniijaanisiwaan** their child or children

oniijaanisensiwaan /-niijaanisens-/ *nad* their infant child or children

oniijaanisi *vai* s/he has a child or children, has a young one or young; **weniijaanisijig** parents

onji- *pv* from a certain place, for a certain reason; because

onjibaa *vai* s/he comes from a certain place

onjikaa *vai* s/he comes from a certain place

onjikaamagad *vii* it comes from a certain place

onjitaw *vta* listens to h/ from a certain place

onjii *vai* s/he comes from a certain place

onow /-now-/ *nid* h/ cheek

onzaabam *vta* watch h/ from a certain place

onzaam *adv* too, too much, excessively, extremely; because

onzaamibagizo *vai* s/he oversteps, overdoes a deliberate motion

onzaamiikan *vti* overwork it, overdo it

opwaagan *na* ceremonial pipe

opwaaganiiwinini *na* pipeman; *a ceremonial drum position*

opwaaganiiwininiiwi *vai* he is a pipeman; *a ceremonial drum position*

opwaagaans *na* cigarette

oshkaabewis *na* helper (in a ceremony); *a ceremonial drum position*

oshki- *pv* new, young, fresh, for the first time

oshki-aya'aa *na* someone young, someone new

oshkiwayaan *na* new (drum) hide

owapii *adv* at this time, then

owayaanan /-wayaan-/ *nad* h/ (the drum's) hide or hides

owiidabimaaganan /wiidabimaagan-/ *na* h/ partner(s)

owiij'aya'aan /-wiij'ayaa-/ *nad* h/ sibling(s)

owiij'ayaawaaganan /-wiij'ayaawaagan-/ *nad* someone h/ lives with

owiinizisan /-wiinizis-/ *nid* h/ hair; **owiinizisiwaan** their hair

owiiyawen'enyibanen /-wiiyawen'eny-/ *nad* h/ late namesake(s)

ozhibii'an *vti* write it, write it down

ozhibii'ige *vai* s/he writes (things), writes (things) down

ozhichigaade *vii* it is made (by someone), "they" make it

ozhitoon *vti2* make, build, create it

ozhiitaa *vai* s/he gets ready

ozisidoon *vti2* put it in place, arrange it

ozisijigaade *vii* it is put in place, arranged (by someone), "they" put it in place, arrange it

ozisinaagane *vai* s/he sets the table

oodetoo *vai* s/he has a community or town

wanichigaade *vii* it is lost (by somone), "they" lose it; it is made wrong (by someone), "they" make it wrong

wanichige *vai* s/he makes a mistake, makes things wrong

wani' *vta* lose h/

wanishkwe' *vta* distract, interrupt h/

wanitaaso *vai* s/he loses someone

wanitoon *vti2* lose, miss it

waniwebinige *vai* s/he speaks incorrectly, does something incorrect

waniike *vai+o* s/he forgets (it)

wasidaawendam *vai2* s/he is sad, is sorrowful, is grieving

wasidaawendamowin *ni* grief

wawaaj *adv* and even

wawenabi *vai* s/he is sitting down, stays seated

wawenabi' *vta* seat s/, sit h/ down

wawezhi' *vta* dress h/ up; wash h/ grief away in a ceremony

wawiyazh *adv* funny, comical

wawiinge- *pv* properly; carefully; completely; actual; real

wawiinge-onaagan *ni* real dinner plate (in contrast to a paper plate)

wawiingezi *vai* s/he is efiicient, is thorough

wayaabishkiiwe *na* white man

wayeshkad *adv* at first; in the beginning

waabam *vta* see h/; *reduplicated form* **waawaabam**

waabanda'iwe *vai* s/he shows something to people

waabanda'iwe-niimi'idiwag /waabanda'iwe-niimi'idi-/ *vai* s/he dances a show powwow (in contrast to a ceremonial dance)

waabanda'iwe-niimi'idiwin *ni* show powwow (in contrast to a ceremonial dance)

waabanda'iwe-niimi'idii-dewe'igan *na* show powwow drum (in contrast to a ceremonial drum)

waabanda'iwe-niimi'idiike *vai* s/he conducts a show powwow (in contrast to a ceremonial dance)

waabandan *vti* see it

waabanjigaade *vii* it is seen (by someone), "they" see it

waabanjige *vai* s/he sees things

waabanong *adv* in the east; to the east

waabashkiki *ni* swamp

waabooyaan *ni* blanket

waabooyaanike *vai* s/he makes a blanket

waakaabiitan *vti* sit around it in a circle

waakaabiitaw *vta* sit around h/ in a circle

waakaa'igaans *ni* bathroom; restroom

waakaashimo *vai* s/he dances around in a circle

waakaashimoo-nagamon *ni* special song the ogichidaakwe dance; *a ceremonial song*

waakaashimotan *vti* dance around it in a circle

waakaashimotaw *vta* dance around h/ in a circle

waakaashkaw *vta* walk around h/ in a circle

waasa *adv* far, distant

waashkobang *ni-v* something sweet, cake

Waasigwan *name* [English name unknown]

waawiindamaage *vai* s/he explains about (it) to people

waawiizhaange *vai* s/he asks (people) along (to join an activity); *reduplication of* **wiizhaange**

webaabaawe *vii* it is removed (by use of water)

Wenabozho *name* a Manidoo who once lived among us as half man; *Manidoo*

wenda- *pv* really; completely; just so; especially

wenda-noomage-apaginigod *ni-v* street drugs

weniban *adv* disappeared!; gone!; missing!

wenipanad *vii* it is easy, is cheap

wenipanizi *vai* s/he does something easily

wenjida *adv* especially

weweni *adv* in a good way, properly, correctly, carefully, safely

wewiib *adv* hurry, in a hurry, quickly

wii- *pv* be going to, want to, will

wiidabim *vta* sit with h/

wiidabindan *vti* sit with it

wiidabindiwag /wiidabindi-/ *vai* they sit together

wiidookaw *vta* help h/

wiidoopam *vta* eat with h/, share food with h/

wiij'anokiim *vta* work with h/

wiij'ayaandiwag /wiiji'ayaandi-/ *vai* they live together

wiiji- pv with; in company with; one's fellow; **owiiji-bimaadiziiman** h/ fellow human being; **owiiji-bimaadiziimiwaan** their fellow human being; **niwiiji-bimaadiziim** my fellow human being; **giwiiji-bimaadiziim** your fellow human being

wiiji' *vta* associate with h/, play with h/

wiijishimotaw *vta* dance with h/, accompany h/ in a dance

wiijii'iwe *vai* s/he goes with, accompanies people

wiijiindan *vti* go with it, accompany it

wiijiiw *vta* go with h/, accompany h/

wiikaa *adv* ever

wiikwajitoon *vti2* try to do it, make an effort to do it

wiikwam *vta* draw on h/ (pipe) with mouth, smoke h/ (pipe)

wiin *pc* [contrastive particle]

wiin *pron per* he, she; her, him; *third person singular pronoun*

wiinawaa *pron per* they, them; *third person plural personal pronoun*

wiindamaw *vta* tell h/ about (it)

wiindamaage *vai* s/he tells about (it) to people, explains (it) to people

wiindamaagoowizi *vai* s/he is told

wiindan *vti* name it, mention the name of it

wiineta *pron per* only she, only her, just her; only he, only him, just him; *third person singular pronoun*

wiinitam *pron per* her turn, her next; his turn, him next; *third person singular pronoun*

wiinitamawaa *pron per* their turn, them next; *third person plural pronoun*

wiinjigaade *vii* it is named (by someone), "they" name it

wiinjigaazo *vai* s/he is named or called (by someone), "they" name or call h/

wiinzh /**wiinN-**/ *vta* name h/, mention h/ name, give h/ a name

wiisagishin *vai* s/he gets hurt (on something), gets hurt falling

wiishkoban *vii* it is sweet; **waashkobang** sweets, cake

wiisini *vai* s/he eats

wiisiniwin *ni* food

wiiwakwaan *ni* cap, hat

wiiyaas *ni* meat

wiizhaam *vta* invite h/ (to join an activity), ask h/ along

wiizhaange *vai* s/he asks (people) along (to join an activity)

zagaakwa'igaade *vii* it is fastened, pinned (by someone), "they" fasten, pin it

zagaakwa'igaans *ni* safety pin

zaginiken *vta* hold h/ arm

zakab *adv* at peace, quiet

zaka'an *vti* light, ignite it; set it on fire

zaka'igaazo *vai* s/he is set on fire, lit (by someone), "they" set h/ on fire, light h/

zanagad *vii* it is difficult, it is hard (to manage)

zazegaa'o *vai* s/he dresses up

zazegibagizo *vai* s/he dances hard, gives it his all dancing; *reduplication of* **zegibagizo**

zazekidoo *vai* s/he is engaged in an activity to the fullest; *reduplication of* **zekidoo**

Zaagajiw *name* George Boyd

zaaga'igan *ni* lake

zaagibagaa *vii* the leaves come out; it is spring

zaagi' *vta* love, treasure h/

zaasakokwaan *na* (piece of) frybread

zaasakokwaani-bakwezhigan *na* (piece of) frybread

zenibaanh *na* ribbon

zhakamoonidizo *vai* s/he feeds h/self

zhawendaagozi *vai* s/he is shown compassion, is pitied (by someone), "they" show compassion to, pity h/

zhawenim *vta* have compassion for, pity h/

zhaabowe *vai* she sings an accompaniment, sings backup

zhaawanong *adv* in, to, from the south

zheshenik *adv* empty-handed

zhimaaganish *na* soldier

zhimaaganishiiwi *vai* s/he is a soldier

zhinawa'oojigan *ni* dance bell

zhiibiniketaw *vta* shake h/ hand, extend hand (in greeting) to h/

zhiibiniketaage-nagamon *ni* handshake song; *a ceremonial song*

zhiigwaakwan /zhiigwaakwan-/ *vta* exclude h/, rule h/ out

zhiiwaagimizigan *ni* syrup; maple syrup

zhooshkonamaw *vta* slide (it) to h/, transfer (it) to h/

zhooshkwadabi *vai* s/he slides over sitting

ziibi *ni* river

ziigwebinigaade *vii* it is spilled, poured out, dumped out (by someone), "they" spill it, pour it out, dump it out

ziigwebisemagad *vii* it empties, spills

ziikaapo /ziikaapw-/ *vta* smoke h/ up, smoke h/ completely

ziindaakosijigaade *vii* it is wedged in (by someone); "they" wedge it in

ziinzibaakwadowaapine *vai* s/he has diabetes

Printed in the USA
CPSIA information can be obtained
at www.ICGtesting.com
JSHW021512121023
50032JS00004B/5